2000

2000

On the cover:
The Breezy Common (cat. no. 28)

MONOTYPES BY

MAURICE PRENDERGAST

IN THE

TERRA MUSEUM OF AMERICAN ART

CECILY LANGDALE

PUBLISHED BY
TERRA MUSEUM OF AMERICAN ART
CHICAGO 60611

The Prendergast monotypes in the Terra Museum of American Art, which are reproduced in this book, and the book itself, are dedicated to the memory of Adeline Richards Terra.

It was through her artistic vision and sense of beauty that she conceived of, and inspired the acquisition of these monotypes, which she often described as most extraordinarily beautiful.

It is gratifying to have now brought Adeline's vision to reality for the public to enjoy.

Daniel J. Terra

Library of Congress Catalog Card Number: 84-52620
ISBN 093-2171-00-1

Foreword

It is a pleasure of special stimulation to learn more about an artist we thought familiar and well-documented. In the case of this book, and the exhibition it attends, devoted to the monotypes of Maurice Prendergast, we welcome not only new information and insights but also the discovery afresh of the extraordinary and delicate beauty of his work in this medium.

Prendergast's artistic achievement, viewed almost a century later, was one that fused a sequence of contrasting elements. Traveling abroad on several occasions during his career, Prendergast came particularly to know the work of the Nabis, at the same time that his style remained close to the mood of his American impressionist colleagues. Whether painting the playgrounds of Salem, Massachusetts, or of Venice, he captured a loving nostalgia for idyllic landscapes, which we associate with a world of the past, even as he acknowledged the city as a commanding environment of the modern world. His artistic sources ranged from ancient frescoes and mosaics through Giotto and Titian to Puvis de Chavannes, Whistler, Signac, and Matisse. Among his own contemporaries he was associated with The Eight, a group that included several Ash Can painters, all championing modern urban subject matter.

American artists have frequently looked abroad or to the past for inspiration, but Prendergast invested his style with a marked American spirit of joy and optimism. Technically, too, he joined a select group in the American tradition—most notably Homer, Sargent, Whistler, and Hopper—who were forceful as painters equally in oil and watercolor. Indeed, although Prendergast recognized the respective differences between the two media, his style in both uniquely balanced effects of transparency and opacity. His pursuit of the monotype brought him to another kind of juncture or fusion, that between painting in watercolor and making a print. Within this demanding technique Prendergast produced work at a level of quality and volume which has ranked him with such other modern practitioners as Degas, Gauguin, Pissarro, and Milton Avery.

Prendergast is believed to have made some two hundred monotypes in the ten-year period from about 1891 to 1901. One hundred and fifty are still known, and of this extant group fifty-two are now in the collection of the Terra Museum of American Art. As both this publication and exhibition of the objects themselves attest, this concentration is a consummate case of the whole being more than the sum of the parts. Cecily Langdale, a leading authority on and connoisseur of the material, has usefully divided this study into three sections. A biographical summary traces Prendergast's influences, contacts, and travel. Discussion of the monotype process follows, setting forth a summary of their chronology, style, and technique. In turn each work receives analytic commentary which cumulatively weaves together factual information with artistic significance.

Once introduced so sympathetically to the intimate power of this art form, we come to appreciate Maurice Prendergast's individual mastery of joining line and color, even more, of

matching discipline and control with immediacy and lightness of touch. Most remarkably of all, by painstakingly making the separations for the color plates directly from the works themselves, this publication captures Prendergast's delicacy of colors—just consider his grace notes of rose and olive—in a way truly worthy of the unassuming, exquisite originals.

John Wilmerding
Deputy Director
National Gallery of Art

Acknowledgments

For their assistance in ways too numerous to mention, I wish to express my gratitude to: Gloria Cooper; Richard Cowdery, Eleanor Green; Robert Flynn Johnson; David Kiehl; Mary Elizabeth Laidlaw; Tony Mesok; Mrs Charles Prendergast; Susanne Schnitzer; Marjorie Shelley; and David M. Sokol.

I must particularly thank Françoise Boas, who is responsible for the appearance of this publication; Dr Richard Wattenmaker, who read the manuscript and offered many exceedingly helpful suggestions; Melinda Kahn Tally, who assisted at every step of the way; Daniel J. Terra, who with courage and enthusiasm built this extraordinary collection of Maurice Prendergast monotypes; and my husband, Roy Davis, whose name ought to be on the title page with mine.

Cecily Langdale
September 2, 1984

I. Maurice Prendergast—Biography

Maurice Prendergast is one of America's most dearly loved artists. He paints an idyllic world of holidays and festivals, of parks and beaches, populated by graceful women and charming children in fashionable attire, and much of his popularity indubitably derives from this irresistible subject matter; a viewer must indeed be hard of heart to resist its appeal. Its extraordinary attractiveness and accessibility have perhaps obscured the fact that Prendergast's importance lies, not only in the freshness of his enchanting vision, but at least as much in the manner in which he records that vision. Prendergast was probably America's first post-Impressionist painter; growing out of the traditions that fostered such disparate artists as Whistler, Puvis de Chavannes, Bonnard, Cézanne, Matisse, and Roussel, he forged a style utterly his own.

Because until now Prendergast's pictures have been seen relatively seldom outside the United States, his international reputation as an early twentieth century master is only beginning to burgeon. In the past, he usually has been linked, by what might be termed an historical accident, with The Eight, or the Ash Can School. Those American realist painters, famous for their views of urban life, are the descendants of Manet. Prendergast is an anomaly in that company for his work is more advanced than theirs by two artistic generations; his *œuvre* is more properly discussed in the context of the French post-Impressionist movement.

Maurice Brazil Prendergast was born on October 10, 1859 in St. John's, Newfoundland. He and his twin sister Lucy Catherine were the first children of Maurice Prendergast, the Irish owner of a trading post in St. John's, and his wife, Mary Malvina Germaine Prendergast. A year later, in 1860, a second set of twins was born.[1] Two years after Maurice's birth, the elder Maurice's business failed, and he took his family to Boston, the city of his wife's origin, and that in which the artist was to spend most of his life. There, another son was born to the couple on May 27, 1863; this fifth child was Charles James Prendergast, who was to become an exceptionally gifted artist, celebrated in his own right.

Both Maurice and Charles attended the Rice Grammar School on Dartmouth Street in Boston; Maurice was enrolled there from 1865 until 1873 when, having completed the eighth grade, he left school at the age of fourteen to go to work. His first position was at Loring and Waterhouse, a dry goods shop where he wrapped packages. Van Wyck Brooks later gave what is perhaps a romanticised account of this period of the artist's youth: "He always had a pencil in his hand, and, whenever he could spare a moment from the paper and string, he sketched the women's dresses that stood about the shop. Nothing amused his eye more than a pretty dress, blue, green, yellow, or old rose, as one saw in all his pictures to the end of his life, the beach parties and fairy-tale picnics with their charming wind-blown figures and little girls with parasols and flying skirts."[2] Maurice's

second job was as an apprentice to a commercial art firm; there he learned to paint show cards. He continued to draw in his leisure hours, going on weekend excursions to Day's Woods, filling his sketchbooks with landscape views. As his brother Charles later jested: "In those days Maurice was hell on cows!"[3] Those early pictures are literal representations of their subjects; conventional in approach, they are utterly uncharacteristic of the artist's mature manner and completely devoid of his personal idiosyncracies.

In 1886, Maurice Prendergrast made his first voyage across the Atlantic; accompanied by Charles, he visited England and Wales. A watercolor done at this time, *Cottage Landscape, Hawarden*[4], is evidence that his style was unaffected by this stay abroad; it is a straightforward rendering of a thatch roofed house set amidst a group of trees.

The length of this first trip is not recorded, but the artist was certainly back in Boston by the spring of the following year. He returned to the painting of show cards, and began to save for a second European venture.

It was not until 1891 that Maurice, with the help of his brother, had at last accumulated sufficient funds (the exact amount is said to have been $1,000.[5]) to go to Paris to study art. He had arrived in France by January of that year, becoming a student at the comparatively late age of thirty-one. *Old Woman, Paris*[6], a watercolor executed in that month, is a conventional, rather finished portrait head.

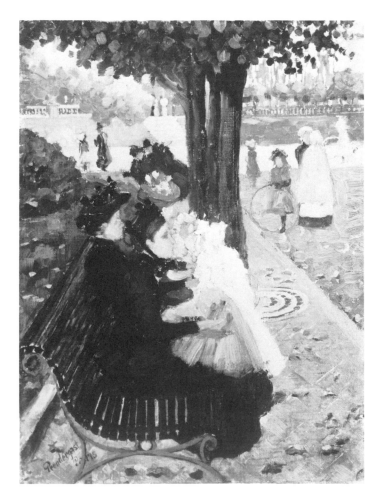

fig. 1.
Maurice Prendergast,
The Tuileries Gardens, Paris,
collection of
the Terra Museum of American Art

It was, however, to be the last of Maurice Prendergast's undistinguished work. The artist's response to Paris was an instantaneous one: he blossomed in its atmosphere and his unique style developed with dramatic celerity, maturing by leaps and bounds, so that virtually his next pictures are immediately recognizable as the work of the artist we know.

He probably studied at Colarossi with Gustave Courtois and certainly enrolled in 1892, at least briefly, at the Académie Julian, where his instructors were Jean-Paul Laurens, Joseph-Paul Blanc, and Benjamin Constant. Classes were large, and instruction was often perfunctory; indeed, these ateliers were little more than overcrowded factories. It was outside their walls that Prendergast received his true education.

The Canadian artist James Wilson Morrice acted as an important catalyst in this process of learning. Soon after Prendergast's arrival in Paris, the two men met and struck up a friendship. As Charles Prendergast later described it: "My brother and Morrice studied at Julian's Academy at about the same time. They were very much in sympathy with each other's work."[7] Although six years younger, Morrice was the more sophisticated of the two; he had been longer resident in Paris than the American and was more at ease there. Together they viewed exhibitions, and Morrice introduced Prendergast to the work of those artists whom he admired. They gathered with other painters and writers at the Montparnasse café the *Chat Blanc* and Prendergast met Morrice's international circle of friends, which included the Australian Charles Conder, and the Englishmen

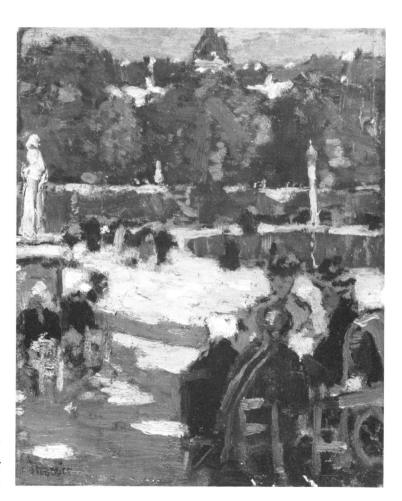

fig. 2.
James Wilson Morrice,
Luxembourg Gardens, Paris,
collection of
the Art Gallery of Ontario

Walter Richard Sickert and Aubrey Beardsley. Together, they also sketched the streets of Paris and went on painting expeditions (on at least one of which, in 1891, they were joined by Conder) to the coastal towns of Concarneau, Dinard, and St. Malo. It was at this time that Morrice introduced Prendergast to a practise that he himself favored, that of painting on *pochades* or small wood panels. The two artists were instinctively attracted to much the same type of subject: comely women and pretty children in decorative attire; Parisian parks and cafés; the bustle of crowds on the city's boulevards; the festive atmosphere of Breton and Norman beaches. Indeed, much of their work of this period is strikingly similar in feeling; a comparison of *The Tuileries Gardens, Paris* (fig. 1)[8] by Prendergast to *Luxembourg Gardens, Paris* by Morrice (fig. 2)[9] illustrates this similarity.

Prendergast's first French work is Whistlerian in inspiration. Such a painting as *Dieppe* of about 1891[10], like a number of Whistler's beach scenes, is thinly painted in closely related tones of muted greys; it is also similar to those beach studies in its compositional organization: it is divided into three horizontal bands. Many of Prendergast's monotypes also display Whistlerian characteristics. Such single figure compositions as *Lady with Handkerchief* (no. 4), *Green Dress* (no. 5), and *Red Haired Lady with Hat* (no. 6) bear comparison to certain full length portraits by Whistler. In addition, there are strong parallels to Whistler's shopfront pictures (fig. 3)[11] in Prendergast's series of monotypes of street scenes, of which the two impressions of *Primrose Hill* (nos. 7 and 8) and *Street Scene* (no. 11) are prime examples.

Interestingly, tradition has it that Whistler in turn knew and admired Maurice Prendergast's work even at this early date.[12] What is known is that Prendergast's first published pictures were illustrations for George Thomson's "The Sketchbook in the Street", which appeared in *The Studio* of 1893, where they were attributed to a Michael Dignam. As Van Wyck Brooks recounted the episode: "Prendergast was living with a fellow-student, a young English sculptor named [Robert] Stark, and one day a friend of Stark's...dropped in to see them. Prendergast's sketch-books were lying about, and this young man put one in his pocket, and later, in London, he showed the sketches to Whistler, saying that he himself had done them. Whistler, struck by the talent they revealed, arranged with *The Studio* to publish a group of them."[13]

In Prendergast's pictures of the early and middle 1890s, one may find traces of ideas assimilated from souces of inspiration other than Whistler, notable among them the Nabis and Japanese prints. By the late nineteenth century, Japanese prints had become exceedingly popular in France, and their influence pervasive. In both the painting *Lady on the Boulevard (The Green Cape)* (fig. 4)[14] and the monotype *Lady with Umbrella* (no. 3), the subject is a standing female figure, and both pictures are Oriental in the intricate silhouettes of those figures, in the mannered elegance of their postures, and in the simplification of the palettes.

Much of Prendergast's work of the 1890s displays strong affinities with that of the French group known as the Nabis (or prophets). The painting *Franklin Park (Boston)* (fig. 5)[15] and the monotypes *Promenade* (no. 27) and *The Breezy Common* (no. 28) are unmistakably Nabi-like in their compositions: objects are treated as flat patterns of shape and color, which are thoughtfully deployed across a single plane.

In late 1894 or early 1895, Prendergast departed from Paris to go back to Boston; when he had left his native city four years earlier he had been a self-taught amateur; now he was returning as a superbly assured mature artist. His professional career opened virtually immediately with a series of commissions from the Boston publishers, Joseph Knight Company, for whom in 1895 he did 142

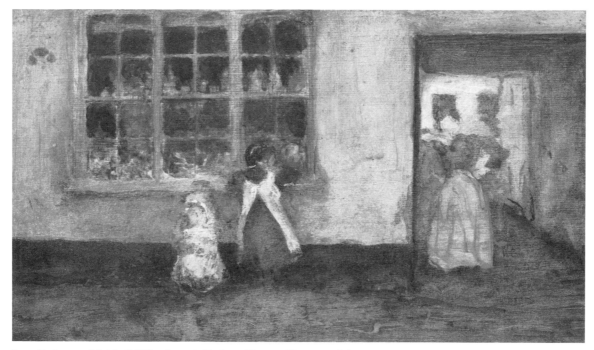

fig. 3. James McNeill Whistler, *A Chelsea Shop*, collection of the Terra Museum of American Art

illustrations for Sir James M. Barrie's *My Lady Nicotine*.[16] At about the same time, he also illustrated their edition of (Sir Thomas) Hall Caine's *Shadow of a Crime*, and made advertisement posters for it as well as for Joseph Knight Company's Round Table Library.

In April 1895, Prendergast sent two watercolors[17] to the *52nd Annual Exhibit* of the Boston Art Club; this marked the commencement of a practice the artist was to continue for the rest of his life, that of exhibiting his pictures frequently.

The next several years were extremely productive ones for him. While he certainly painted the occasional oil, it was a period during which his concentration was focused upon the media of watercolor and monotype. Between 1895 and 1898, Prendergast produced a substantial percentage of his monotype *oeuvre*. Also from this time is his series of brilliantly sparkling watercolors of New England beaches and piers, representative of which is *South Boston Pier* (fig. 6).[18] The enchanting *Boston Sketchbook*[19] (see fig. 7 [p. 43] and fig. 8 [p. 57]) comes from this period as well.

In the Terra Museum collection are three of the rare paintings of the later nineties: *Evening on a Pleasure Boat* (fig. 9), painted in about 1895-1897 and first exhibited in early 1898[20]; *Franklin Park (Boston)* (fig. 5), also from about 1895-1897, and also first shown in early 1898[21]; and *Telegraph Hill* (fig. 10), again from about 1897-1898.

In the summer of 1898, Prendergast departed on his third European trip, which is said to have been financed by Mrs. Montgomery Sears, the Boston artist and patron.[22] After stopping in France, at St. Malo, he went on to Italy, where he was to remain until the autumn of the following year. He spent most of this period in Venice, but also travelled as far south as Naples. His glorious watercolor views of Venice, Siena, Rome, and Capri (oddly enough, he seems to have done no work in

Florence, Padua, or Orvieto, which he also visited[23]) today are among the most famous and treasured of his pictures; superb examples are *Monte Pincio, Rome* (fig. 11)[24] and *The Grand Canal, Venice* (fig. 12).[25] In these enchanting pictures a sense of place is wonderfully evoked; having looked at Prendergast's Venetian or Roman views, one forever sees those cities through his eyes. In Venice, Prendergast made the happy discovery of two painters with whom he had a strong aesthetic affinity: the quattrocento masters Vittore Carpaccio and Gentile Bellini. A glance at such pictures as those in Carpaccio's St. Ursula cycle[26] or Bellini's *Processione in Piazza San Marco*[27] immediately reveals the kinship of spirit linking the two to Prendergast. All three delight in painting glittering processions of gaily bedecked crowds arrayed before accurately delineated architectural backdrops. Those crowds are composed of individuals, each one differently attired and idiosyncratically posed. The subject, for Prendergast as well as for the earlier painters, is often a specific festival (as, for example,

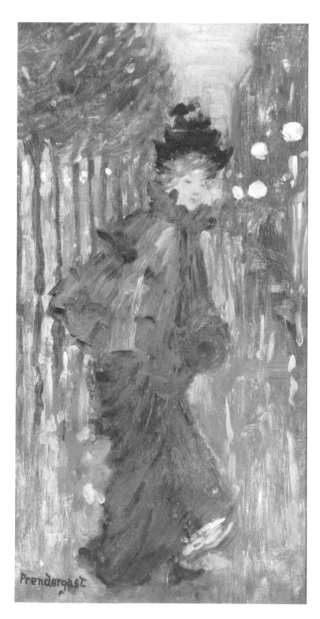

fig. 4.
Maurice Prendergast,
Lady on the Boulevard (Green Cape),
collection of
the Terra Museum of American Art

14

in the monotype *Festa del Redentore* [no. 38]); even when the subject is a specific one, the scene is replete with subordinate incident, vividly detailed.

Prendergast had arranged that his pictures continue to be shown in America although he, himself, was still abroad. On his return to Boston in the fall of 1899, he resumed his intensive exhibition schedule and, the following year, he had his first two major shows, one, in January 1900 (jointly with his friend, the Boston artist Herman Dudley Murphy), of 30 watercolors and monotypes at the Art Institute of Chicago, and the other, two months later, of more than 60 pictures (again, watercolors and monotypes) at the Macbeth Gallery in New York; the latter was both a commercial and a critical success. In 1901-1902, he had another museum exhibition, yet again composed of watercolors and monotypes, at the Detroit Museum of Art and then at the Cincinnati Museum Association[28], and he won his first award, the Bronze Medal for Watercolor at the Pan-American Exposition in Buffalo, New York.

Although he continued to live in Boston until 1914, after the turn of the century Prendergast started to make frequent trips to New York, and he became engaged in the artistic life of that city. Dating from this period are his brilliant watercolors of Central Park in New York and of such Boston landmarks as the West End Library. As in the Italian views, here too there is often the combination of quickly drawn, lively figures and carefully executed architecture; however, a slightly lowered tonal range is characteristic of many of these later pictures.

Prendergast executed his final monotypes in about 1901-1902 and, while he continued to work in watercolor all his life, soon after the beginning of the century he became increasingly absorbed by the complexities of the technique of oil painting, the medium upon which he concentrated during the remainder of his artistic career. His oils of the preceding decade (among them *The Tuileries Gardens, Paris* [fig. 1], *Evening on a Pleasure Boat* [fig. 9], and *Franklin Park* [*Boston*] [fig. 5]) as a rule are relatively small in size; they are spontaneous expressions, somewhat thinly and broadly painted. Soon after 1900, the evolution of his mature style began, a style which was to be characterised by increasingly densely interwoven surfaces, deliberately and slowly built up with patterns of varied brushstrokes. Because Prendergast tended to work and rework his canvases, it is usually difficult to date them. A notable exception to this rule is *Opal Sea* (fig. 13)[29], for which there is a *terminus post quem* of late 1909 or early 1910 because it was then photographed in its finished state in the artist's studio by Charles Hovey Pepper.[30] *Opal Sea* might be called a transitional picture: although it is substantially larger than the earlier oils, the figures are still relatively small in relation to the overall composition. Those figures have begun to lose their individual definition; their edges have broken down and they are woven into their surroundings. There is a greatly increased generalization of costume and setting (though the latter is said to be City Point, Boston, with Governor's Island and Deer Island in the distance). The viewer is aware of the rhythmic patterns of brushstrokes; there is a new interest in paint *qua* paint.

Prendergast's first professional association with the Ash Can School came in 1904 when he exhibited at the National Arts Club in New York along with other members of that group, Arthur B. Davies, William Glackens, Robert Henri, George Luks, and John Sloan. Several years later, Henri, in an act of protest against the juried shows of the National Academy of Design, began to organize what was to be an historic event: the 1908 exhibition of The Eight at William Macbeth's New York gallery. The Eight was composed of Davies, Glackens, Henri, Luks, Prendergast, Sloan, Ernest Lawson, and Everett Shinn. Prendergast had again visited France the previous summer and his

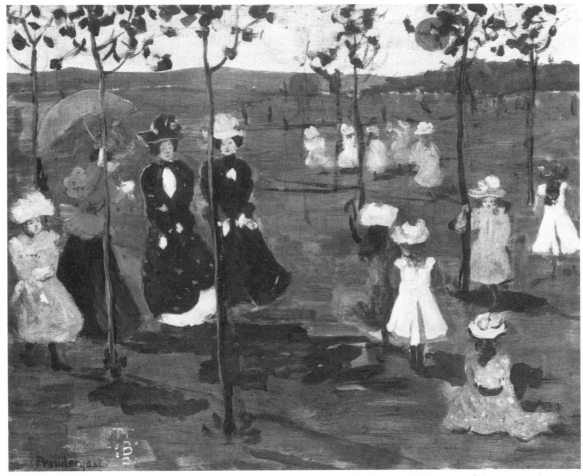

fig. 5. Maurice Prendergast, *Franklin Park (Boston)*, collection of the Terra Museum of American Art

contribution to the show included a number of views of St. Malo done on that trip. Much of the critical response to these pictures was negative or at least extravagantly couched: they were referred to as "a jumble of riotous pigment," "an explosion in a color factory," "whirling arabesques that tax the eye."

Both at home and while travelling, Prendergast continued to study the work of other artists; his notebooks are filled with sketches after, and notations about, the pictures of, amongst others, Giotto, the Ferrarese school, Titian, Puvis de Chavannes, van Gogh, Gauguin, Matisse, Raoul Dufy, Signac, and Roussel, from each of whom he obtained stimulating and fruitful ideas.

While on that 1907 visit to France, Prendergast wrote an enthusiastic letter to his friend and student Esther (Mrs Oliver) Williams in which he mentioned Morisot, Gonzales, "the younger Bohemian crowd," Vallotton, and Vuillard, exclaiming: "All these exhibitions worked me up so much that I had to run up and down the boulevards to work off steam!...I am so chocked full of the exhibitions here I don't know what influence it will have after I am once more home."[31] One of the artists most important to him was Cézanne, about whom he commented to Mrs Williams: "Cézanne

had a watercolor exhibition…which was to me perfectly marvelous. He left everything to the imagination. [The watercolors] were great for their simplicity and suggestive qualities…I think Cézanne will influence me more than the others…"[32]

In 1909, Prendergast made yet another trip to France, visiting Paris, St. Malo, and Dinard, and, in the autumn of 1911, he went for the last time to Italy, to join his brother Charles who had preceded him. Although he remained in Venice until January of the following year, it was not a productive period for him: "I had hardly started to work after having a delightful time showing my brother around…I was taken sick and sent to the hospital…[for two months]. My sketching period this time has been disastrous."[33]

Soon after his return from that Venetian stay, Prendergast, who was a member of the Society of American Painters and Sculptors, became involved in the organization of the 1913 International Exhibition of Modern Art, better known as the Armory Show. He was appointed a member of the selection committee, and also contributed seven of his own pictures—four watercolors and three paintings—to the exhibition. Two of those three paintings are identifiable today: they are *Landscape with Figures*[34] and *Crepuscule*[35]; both illustrate the direction in which the artist was moving and are very close indeed to his full-blown "tapestry" style. The subject is the same in both pictures: figures and animals in a landscape, with trees behind them, and water behind the trees. They are not, however, specific people on a specific shoreline; rather, it is an idyllic fantasy land which is depicted. The format is much larger than it once was and the figures, while remaining relatively small in relation to the canvas size, have become less swirling and curvilinear, more static than they once were; their stances have been manipulated for compositional purposes and their individual identities are lost. Color is somewhat less descriptive than it once was, and, by defining spatial relationships and orchestrating an overall unity of surface, it now operates as a structural element. The brushstrokes are shorter and more consistently patterned, and the surface is drier and more heavily impastoed than in his earlier oils.

The Armory Show afforded Prendergast another opportunity to study Cézanne's paintings and at about this time, perhaps inspired by the example of that master, he painted several portraits and still lifes, one of which is *Still Life with Apples* (fig. 14).[36]

Prendergast made his last European trip—to France—in 1914. Upon his return, he and his brother Charles made a change their artist friends had been urging for years: they moved from Boston to New York, to 50 Washington Square, the studio building in which their close friend William Glackens lived. Despite this relocation, Maurice frequently returned to New England during the summers; letters and sketchbook notations reveal visits to, amongst other places, Marblehead, Nahant, Rockport, Salem Willows, Gloucester, and Annisquam.

The following year, he had a major exhibition of paintings and watercolors at the Carroll Gallery, from which John Quinn and Dr Albert Barnes, two of the leading American collectors of the day, both purchased works, Quinn acquiring at least a dozen.

The Grove (fig. 15)[37] dates from about this time and is a fine example of the artist's fully developed tapestry style. Its subject matter is that which had occupied Prendergast for years (since at least as early as *Opal Sea* [fig. 13]) and was to continue to do so for the remainder of his career: a frieze of figures idling on a shore (here they are all female and all clothed; in other oils, there are sometimes also female nudes, animals, and even the occasional man) with trees, water, and sailboats behind. The figures are now quite large and they are noticeably elongated; each overlaps,

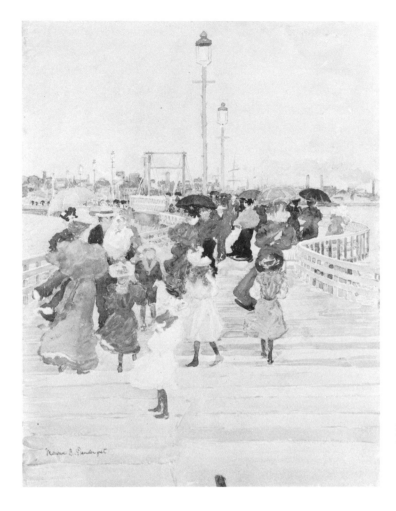

fig. 6.
Maurice Prendergast,
South Boston Pier,
collection of
Smith College Museum of Art

or is linked by gesture to, the next, and their shapes and scale are manipulated for compositional reasons. Despite these formal links, the figures appear unrelated emotionally, each seemingly isolated and unaware of the presence of the others. Colors are opaque, harmonious, and rich. The surface is dry and dense, built up of layer upon layer of pigment. There is a great insistence upon the two-dimensionality of that surface; it is woven together as if it were a fabric (hence, the term "tapestry") by heavily impastoed, short, rhythmic brushstrokes, affording the composition weight, density, and organic strength. It is a vision of a magical, lyrical world, one in which time has no meaning.

Until the end of his artistic career, Prendergast continued to work in watercolor, and his subject matter in that medium parallels that of the late paintings. The color in those last watercolors is like that in the early ones in its great clarity and freshness; however, that color is now applied in free, loose, broad brushstrokes. In their intensity, these pictures are reminiscent of those of Matisse or of Nolde.

Because of a deterioration in health, Prendergast's artistic production seems to have been curbed toward the end of his life. Nonetheless, his pictures were in demand and he continued to

exhibit widely and succcessfully. His final one man show was held at the Brummer Gallery in New York in April of 1922; it included half a dozen watercolors and 30 paintings (one of them[38] very probably *The Grove* [fig. 15]). In the last two years of his life, he contributed works to exhibitions in Buffalo, Chicago, Dallas, Detroit, New York, Pittsburgh, Rochester, St. Louis, and Toronto. In 1923, he was awarded the Corcoran Bronze Medal and the William A. Clark Prize by the Corcoran Gallery, which he was too ill to go to Washington to accept. Maurice Prendergast died in New York on February 1, 1924, his reputation as a modern master now secure.

Notes

1. a boy and a still born girl; neither the boy nor Maurice's twin Lucy Catherine lived to maturity.

2. *Addison 1938*, p. 33.

3. as quoted in *Boston 1960–1961*, p. 20.

4. *Boston 1960–1961*, illus. as no. 49, p. 140. The drawing is inscribed: Paris/Jan./91.

5. *Addison 1938*, p. 34.

6. *Boston 1960–1961*, no. 50, illus. on p. 140.

7. to Donald W. Buchanan, author of *James Wilson Morrice, A Biography* (1936).

8. collection of the Terra Museum of American Art.

9. collection of the Art Gallery of Ontario. As Dr. Richard Wattenmaker has noted, the Morrice painting has never been conclusively dated; therefore, it is not certain that it is actually contemporaneous to the Prendergast oil.

10. collection of the Whitney Museum of American Art, illus. in *Maryland 1976* as no. 7, p. 87.

11. *A Chelsea Shop*, c. 1880, collection of the Terra Museum of American Art.

12. *Addison 1938*, p. 35.

13. *Ibid.*, p. 35.

14. collection of the Terra Museum of American Art.

15. collection of the Terra Museum of American Art.

16. published by Joseph Knight Company in 1896, but copyrighted by them in 1895.

17. no. 12, *La Porte St. Denis* and no. 114, *Fishing Boats, Tréport, France*.

18. collection of the Smith College Museum of Art.

19. collection of the Museum of Fine Arts, Boston, facsimile published as *Boston Sketchbook*; although the book was inscribed by the artist with the year 1899, most of its sheets actually date to several years earlier.

20. at the American Society of Artists, New York, *20th Exhibition*, no. 319.

21. *Boston 1898*, no. 24.

22. *Boston 1960–1961*, p. 28.

23. *Ibid.*, p. 30.

24. collection of the Terra Museum of American Art.

25. collection of the Terra Museum of American Art.

26. collection of the Galleria dell'Accademia, Venice.

27. collection of the Galleria dell'Accademia, Venice.

28. *Allen 1982–1983*, p. 35, note 2.

29. collection of the Terra Museum of American Art.

30. According to *Maryland 1976*, p. 115, Pepper inscribed the back of this photograph with the dates 1903 to 1906.

31. dated October 10, 1907, Esther Williams papers, Archives of American Art.

32. *Ibid.*

33. *Ibid.*, letter of December 18, 1911 to Esther Williams.

34. collection of the Munson-Williams-Proctor Institute, illus. in *Maryland 1976* as no. 72, p. 121.

35. *Ibid.*, illus. as no. 73, p. 143, collection of Miss Antoinette Kraushaar.

36. collection of the Terra Museum of American Art.

37. collection of the Terra Museum of American Art.

38. no. 15.

II. The Monotypes

A monotype is a print. Of all the forms of printmaking, it is, technically speaking, the least complicated one. To make a monotype, the artist paints, most commonly in either printer's ink or in oils, upon a smooth, non-absorbent surface such as glass or metal; that surface is known as the plate. He then places a piece of paper upon that plate and transfers the painted image to it by applying pressure with a press, a roller, or an implement such as a spoon.

The name by which this medium is known is both inaccurate and misleading. "Monotype" (from the Greek monos = alone, typos = blow or impression) means single impression and, indeed, so the technique is wrongly defined by the dictionary.[1] In fact, this transfer process may be repeated once, or perhaps twice, producing two or even three impressions or "pulls". However, those two or three pulls will not be identical; the first will be the strongest, and each succeeding one will be progressively fainter. The degree of change is variable and is determined by two factors: the amount of pigment on the plate and the amount of pressure applied during the process of transfer.

In order to prevent blurring of the image in transfer, one must paint only thinly on the plate; however sparingly that paint is applied, the pressure used during the process of transfer nonetheless causes the slightly diffused edges which are a distinguishing characteristic of the monotype.

This transfer of the oil onto the paper in a very thin layer imparts two other traits to the medium: those are a flatness of surface and a pervasive luminosity, the latter a result of the visibility of the underlying paper, which casts light through the pigment.

Because of the rapidity with which paint dries[2], oil monotypes (such as Prendergast's) must be speedily executed; this imposition of speed tends to result in broadly painted, spontaneous statements revelatory of the less formal aspects of an artist's thought processes.

Monotype, for a number of reasons, is an enjoyable technique with which to work. Unlike most other media, it requires little in the way of time commitment from the practitioner; on the contrary, it imposes upon him a speed of execution. Alterations to the image on the plate are quite simple to make (only provided they are done with sufficient celerity), by the addition or subtraction of pigment with one's finger, with a brush, or with the end of a brush. Finally, and not least of all, an intriguing element of surprise is involved: in the transfer of pigment from plate to paper, there may occur unpredictable alterations which are beyond the intention of the artist.

Because it involves a transfer process, and because the product of that process is a flat image, monotype is generally categorized as a print medium. It is, however, something of a hybrid, combining as it does those elements of printmaking with others of painting.

Monotype differs from other print media in several fundamental respects. Firstly, modes of printmaking such as etching, engraving, and lithography all demand special equipment; they are all complex and painstaking disciplines, both in regard to the creating of the image, and to the

subsequent printing of it (printing which, in fact, is frequently not done by the artist himself). Conversely, the making of an oil monotype requires very little paraphernalia, and none of that exotic or elaborate: paper and paint, a sheet of glass, and a spoon are all that are necessary; nor is there anything arcane about the process, for the artist sets the image down on the plate more or less as if he were doing a painting. Secondly, those other forms of printmaking allow for essentially identical multiples of an image because the matrix remains. Such is not the case with monotype; if, after the first pull is taken, enough pigment remains on the plate to make a second impression (or even a third, the absolute conceivable maximum), that second impression will be perceptibly different in intensity from the first.

Probably as a consequence of those differences, the monotype traditionally has received scant attention in general discussions of prints, and has often been disavowed by theorists and practitioners of printmaking (for example, print exhibitions have frequently welcomed submission of work in all categories with the explicit exception of monotype[3]). In recent years, however, this situation has changed and there has been a surge of interest in the medium on the parts of both artists and scholars, perhaps first inspired by the major exhibition of Degas monotypes held in 1968.[4] In the years since, there have been various shows, several of them general[5], and others concentrating upon individual artists, among them Paul Gauguin[6], Camille Pissarro[7], Milton Avery[8], and Maurice Prendergast himself.[9] Finally, in 1980-1981, a definitive survey exhibition of the medium was organized jointly by The Metropolitan Museum of Art and the Museum of Fine Arts, Boston.[10] The history of the monotype seems to begin in Italy in the mid-17th century, where its first known practitioner was the Genoese artist Giovanni Benedetto Castiglione, some two dozen examples of whose work in the medium are extant today.[11] After Castiglione, there was a more than 200 year hiatus before the appearance of another figure of major stature: the English artist and poet William Blake who, at the end of the 18th century, made a series of prints using subjects taken from Shakespeare, Milton, and the Bible. In this history, Blake was, like Castiglione, an isolated figure and he, as it were, reinvented the monotype process for himself. Not until virtually another century had passed did there start to be any kind of widespread interest in the medium; it is then that an historical continuum begins to be perceptible. Among the first generation of important artists to work seriously in monotype are Pissarro, Gauguin, and, most notably, Edgar Degas, whose large and influential *oeuvre* may consist of as many as 450 prints.[12] Although the medium attracted a substantial number of artists, most of them engaged in only haphazard and brief experimentation, rather than in any serious and sustained exploration of the potential of the technique.

The monotype *oeuvre* of Maurice Prendergast ranks as one of the supreme artistic accomplishments in that medium; both qualitatively and quantitatively, it is of the very first importance.[13] In a period lasting little more than a decade, between about 1891 and 1902, Prendergast created a very substantial body of monotypes that is both extraordinarily high and noticeably consistent in quality. It has been estimated that he made about 200 prints, and recent systematic investigation would seem to indicate that this calculation is a reasonably accurate one. Of the 151 Prendergast monotypes known today[14], 132 are separate images, and another 19 are cognates. It is therefore clear that

the Terra Museum collection of 52 Prendergast monotypes—that is to say, more than one-third of the artist's known output—offers an unparalleled opportunity to study his aesthetic achievement in the medium.

There are two sources (other than the pictures) to which to turn for knowledge about how Prendergast made his monotypes. One of those sources is the artist himself. In a letter of 1905 to his student and friend Esther (Mrs Oliver) Williams, he instructed her: "Paint on copper in oils, wiping parts to be white. When picture suits you, place on it Japanese paper and either press in a press or rub with a spoon till it pleases you. Sometimes the second or third plate [sic] is the best."[15]

The second source is Van Wyck Brooks, whose informant was Maurice's artist brother Charles. Brooks described the proceedings: "He could not afford a regular press and his quarters in Huntington Avenue were so cramped that he had no room for a work-bench. So he made his monotypes on the floor, using a large spoon to rub the back of the paper against the plate and thus transfer the paint from the plate to the paper. As he rubbed with the spoon, he would grow more and more excited, lifting up the paper at one of the corners to see what effects the paint was making. The clattering of the big spoon made a great noise on the floor; and soon he and Charles would hear the sound of a broomstick, pounding on the ceiling below. That meant the end of the day's work."[16]

Examination of the monotypes themselves substantiates these two descriptions. The medium in which Prendergast worked always seems to have been oil paint. The support he customarily chose was Japanese tissue[17], a paper ideal for the purpose for several reasons: it is malleable; it is receptive[18]; and its surface sheen[19] imparts to it an attractive luminosity. In many of Prendergast's monotypes, no plate marks whatsoever are discernible on the paper; in those instances where plate marks are visible, they tend to be relatively faint ones, certainly not the sharp depressions a press would create. Consequently, it may be assumed that Prendergast utilized a spoon or like implement, rather than a press, in order to effect the transfer of image from plate to paper. A spoon is obviously superior to a press in considerations of economy and space. It has the further advantage of offering the user a greater degree of control than the press does; a spoon permits the application of different amounts of pressure to different areas of the paper, while a press exerts an equal amount of pressure overall.

It is not known whether Prendergast was specifically taught how to do monotypes and, if so, by whom; given the relative simplicity of the technique, it would certainly have been feasible for him to have learned it by observation alone. Prendergast was enrolled at the Académie Julian in Paris in the early 1890s, at about the time he started to work in the medium; it is not impossible that monotype was included in that school's curriculum: a hint that this might have been the case is given by Christian Brinton[20] when he notes that most of the members of the New York Monotype Club, formed early in this century, had been at the Académie Julian.

That the monotypes of Degas were the inspiration for those of Prendergast has been suggested. While Degas' stature and fame as a monotypist make this a glamourous and plausible theory, it is one which does not really survive examination. There is very little similarity between the work of the two artists either technically or stylistically. Except for a group of oil landscapes dating from the early 1890s, Degas' monotypes are all monochromatic, executed in black (or occasionally brown) printer's ink, in both dark-field and light-field technique. He first worked in monotype in about 1874-1875, and it seems to have been for him a private and experimental medium. It was Degas' usual practise to take two pulls from a plate, retaining the first pull and using the faint second pull as

fig. 7.
Maurice Prendergast, *Boston Sketchbook*, p. 43,
collection of the Museum of Fine Arts, Boston

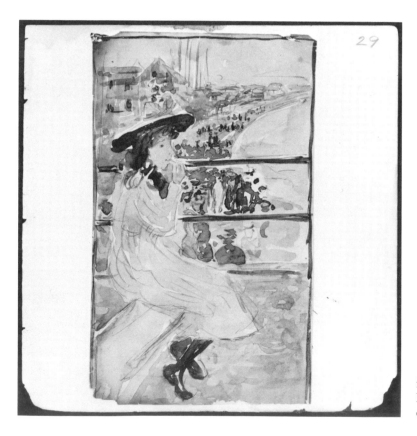

fig. 8.
Maurice Prendergast, *Boston Sketchbook*, p. 57,
collection of the Museum of Fine Arts, Boston

a tonal underpainting over which he then worked in pastel; fully one quarter of his pastels are on top of those cognates. Moreover, Prendergast's opportunities to see Degas monotypes (unless he was able to do so privately) were severely limited, for Degas virtually never exhibited them.[21]

Prendergast's monotypes are fully integrated into his *oeuvre*; from the very first, they are unmistakably his own, and display many of the characteristics and concerns familiar to us from his work in other media. That is not to say, however, that he treats the monotype as if it were something other than it is, for his prints reveal the artist's unusual sensitivity toward the special advantages, and his dexterous adaptation to the particular limitations, of the technique. Prendergast is conspicuously at ease in the medium. To create an image, he first applies pigment to the plate; he may then refine that image by manipulating the pigment while it is still on the plate in any of several fashions. He may remove relatively broad areas of paint by wiping them away with a cloth or a brush, as he has done, for example, in *Children at Play* (no. 18), where the white of the kites at the upper left is, in fact, the paper itself. He frequently creates fine lines by removing paint with the end of his brush handle; this technique is particularly evident in *Children in Street* (no. 9), where it is consistently used to outline the figures; it is again extensively employed in *Spring in Franklin Park* (no. 16), there to accent the foliage as well as to delineate the figures. After printing the monotype, Prendergast may work directly on the paper. His additions are usually made in pencil, as in *Lady with Handkerchief* (no. 4), in which the woman's features, her veil, and the outline of her muff are all drawn in; on at least one occasion, the alterations are in watercolor: in *Lighthouse* (no. 50), very substantial areas have been worked, including most of the figure of the boy at the left of the composition.

Prendergast, whatever medium he uses, is always an inspired and memorable colorist. In his monotypes, he frequently employs color with a remarkable economy. While they are never actually monochromatic, the prints are often preconceived in terms of one dominant and unifying hue: *In the Park* (no. 47) and *Reflection (Fishing Party)* (no. 48) are both predominantly green, while in *Skipping Rope* (no. 12) and *Dress Rehearsal* (no. 21) the prevailing tone is a rusty red.

Such use of color is only one of Prendergast's organizational tools. Another means he employs is that of an artfully planned distribution of shapes across the picture plane. Objects function on two levels: the literal and the abstract. A parasol is more than simply a parasol; it is also a circular form which plays a specific role in the compositional ordering of the picture. That these calculations are conscious ones is a thesis substantiated by an examination of the pictures themselves. In *Promenade* (no. 27), the rhythmic sequence of open umbrellas forces the viewer's gaze across the composition. In both *Children in Street* (no. 9) (and its second pull, *Going to School* [no. 10]) and *Children at Play* (no. 18), the figures are arranged in a zigzag pattern which compels the observer's eye to move from the bottoms to the tops of those pictures. In *The Breezy Common* (pulls one and two, no. 29 and no. 30) the compositional elements are a group of three large figures (two women and a child) in the foreground and a flock of children in the background, both deployed before an expanse of green grass and a bit of blue sky. In another monotype of the same title (no. 28), the same components (group of children, grass, sky, and large foreground figures—though here only one woman and a child) are shifted about slightly, in order to change their relationships to each other and to the shape of the paper (here, the composition is a vertical one, while in the first instance(s) it is horizontal). Two other monotypes by Prendergast, also called *The Breezy Common*[22], are further variations on the same theme. Incidentally, a flock of children such as those in the backgrounds of these pictures reappears in *Children at Play* (no. 18).[23] In Prendergast's circus and ballet prints, certain elements

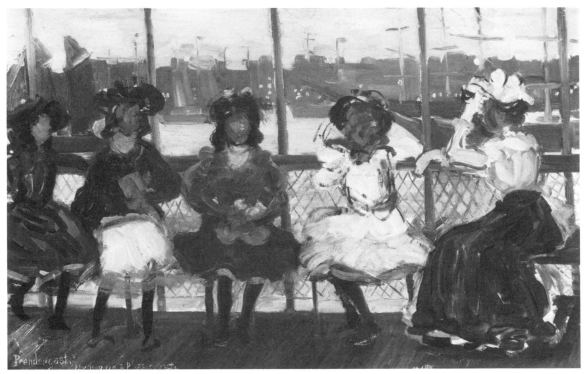

fig. 9. Maurice Prendergast, *Evening on a Pleasure Boat*, collection of the Terra Museum of American Art

recur: clowns in voluminous costumes, girls in tutus, balloons, cymbals, drums. In all four such monotypes in the Terra Museum collection, *Circus Scene with Horse* (no. 19), *Bareback Rider* (no. 20), *Dress Rehearsal* (no. 21), and *Nouveau Cirque (Paris)* (no. 52), there is a counterpoise between strong verticals (posts and flagpoles) and insistently circular forms (drums, tutus, the round spots on the clowns' costumes). However, changes are rung in the positioning of those components from picture to picture; even between *Dress Rehearsal* and *Rehearsal*[24], a monotype which is extremely closely related to it, there are noticeable differences.

Prendergast began to make prints in about 1891, that is to say at the moment of his arrival in Paris and the start of his professional career. His first two dated monotypes are the 1891 *Fall Day*[25] and *Bastille Day (Le Quatorze Juillet)*[26] of 1892. There is nothing tentative about either of these pictures; both are assured and sophisticated, and marked as early efforts by their dates alone. From the start then, his prints are mature and decidedly personal creations; they are utterly "Prendergastian". No artist creates in a vacuum, and this is not to say that Prendergast had no sources of inspiration. Certainly, especially in the earlier monotypes, one may identify particular influences; however, from the beginning, those influences are fully subsumed into his own manner.

One of these sources of inspiration is James McNeill Whistler, an artist whose influence was internationally potent. During the 1880s and 1890s, Whistler created a large number of shopfront pictures in oil[27], in watercolor, and in etching and lithograph as well; *A Chelsea Shop* (fig. 3)[28] is representative of the series. In these pictures, the backdrop is the façade of a building, often of brick, which is enlivened by numerous doors and windows; interesting geometrical patterns are formed by

the configuration of the brickwork and by the counterplay of the verticals and horizontals of the doors and windows. Frequently, there are several small figures, but they are always clearly subordinate to the shopfront itself. Space is shallow: there is very little foreground. Several of the Prendergast monotypes in the Terra Museum collection have many of the same characteristics and bear an obvious relationship to these works by Whistler; among them are *Primrose Hill* (no. 7) and its second pull, *Primrose Hill No. 2* (no. 8), *Street Scene* (no. 11), *Jumping Rope* (no. 13), and *Venetian Well* (no. 35).[29]

Certainly there are also obvious parallels between such Prendergast single figure monotypes as *Red Haired Lady with Hat* (no. 6), *The Opera Cloak* (no. 33), *Woman in White Muslin Dress* (no. 42), *Lady in Hat and Green Cape* (no. 43), *Lady with a Muff* (no. 45), and *Lady in Pink* (no. 51) and such Whistler full length portraits as *Arrangement in Brown and Black: Portrait of Miss Rosa Corder*[30], *Portrait of Lady Meux in Furs*[31], *Arrangement in White and Black*[32], *Arrangement in Black: La Dame au brodequin jaune-Portrait of Lady Archibald Campbell*[33], and *Rose et Vert, L'Iris: Portrait of Miss Kinsella* (fig. 17).[34] Even some of the titles themselves—*Arrangement in Brown and Black, Arrangement in White and Black, Arrangement in Black, Rose et Vert*—signal another similarity: Prendergast's monotypes and Whistler's paintings are both often thematic in color.

The Whistler firework oils *Nocturne: Black and Gold-The Fire Wheel*[35] (which was exhibited in Paris in 1892 at the Société Nationale des Beaux-Arts, where Prendergast certainly might have seen it) and the celebrated *Nocturne in Black and Gold: The Falling Rocket*[36] may well have been

fig. 10.
Maurice Prendergast,
Telegraph Hill,
collection of
the Terra Museum of American Art

the inspiration for at least two of Prendergast's Venetian monotypes, *Festa del Redentore*[37] and *Fiesta, Venice*.[38]

Finally, the Prendergast monotype *Figures Along the Shore* (no. 14) bears comparison to such Whistler paintings as *Battersea Reach from Lindsey Houses*[39] and *Harmony in Blue and Silver: Trouville*.[40] Like those pictures, this is flattened in composition and its foreground figures are placed in front of a radically simplified background; that background is little more than horizontal strips of color.

Another source of inspiration for Prendergast is the Japanese print. In 1853, Japan was opened to the West by Commodore Matthew C. Perry; trade commenced between East and West, and a craze for things Japanese immediately swept Europe and America: clothing, furniture, objects all bear witness to this taste for *japonisme*. Artists were certainly not immune; a shop selling Orientalia opened in Paris in 1863, and numbered among its customers Edouard Manet, Henri Fantin-Latour, James Jacques Tissot, and James McNeill Whistler.[41] Japanese prints were "discovered" by European artists, and their influence was pervasive. In 1893, a large exhibition of the prints of Hiroshige and Utamaro was held in Paris at the Durand-Ruel Galleries and Prendergast may well have seen it. Whether he did or not, a number of his monotypes testify to his awareness of such prints.

Among the monotypes which provide such testimony are Prendergast's relatively early single figure compositions, for example *Lady with Umbrella* (no. 3), *Green Dress* (no. 5) and *Red Haired Lady with Hat* (no. 6). The subject itself—that is, a beautiful and fashionably attired woman—is one that frequently found favor with Japanese printmakers (fig. 19).[42] The monotypes are rather Oriental in several additional respects. They are vertical in format. Shapes are defined and strong abstract patternings created by the juxtaposition of one simple color against another. Poses are stylized; the ladies' stances are mannered and elegant. The positionings of the figures on the sheets are artfully calculated, and their intricate silhouettes are crisply outlined against plain backgrounds. Costume details—bustles (rather similar in effect to obis), leg-of-mutton sleeves, serpentine boas, unfurled umbrellas (a particularly Japanese motif)—are lovingly noted. In Japanese prints, the women always have elaborate hair arrangements; here, analogously, they wear large and ornate hats. In such monotypes as *Lady with Umbrella* (no. 3) and *Red Haired Lady with Hat* (no. 6), the artist's signature takes the form of a complicated monogram which is carefully positioned on the sheet; it thus becomes a compositional element rather as calligraphy does (although to a far greater extent) in Japanese prints.

It is not only the single figure monotypes that give evidence of Prendergast's interest in Japanese prints. Such compositions as *Children in Street* (no. 9) (and its second impression *Going to School* [no. 10]), *Figures Along the Shore* (no. 14), and *Children at Play* (no. 18) are also characterized by upright format, simplification of color, strong abstract patterning, and elaborate, calligraphic signatures.

Pierre Bonnard was known as "the very Japanese Nabi." A great deal of Prendergast's work of the 1890s displays strong resemblances to that of the French group called the Nabis and, specifically, to that of Bonnard. That group (so named by Sérusier from the Hebrew word for prophet) included among its members the painters Bonnard, Edouard Vuillard, Maurice Denis, Paul Sérusier, and Félix Vallotton. They met at the Académie Julian in 1888 (only several years before Prendergast was to study there), and their first inspiration was the work of Paul Gauguin. Their aesthetic theory was that: "any painting—before being a battle steed, a nude woman, or some

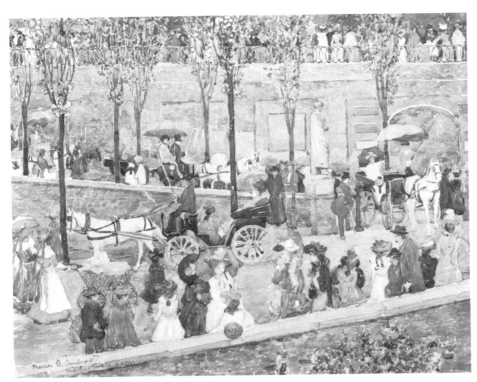

fig. 11.
Maurice Prendergast,
Monte Pincio, Rome,
collection of
the Terra Museum of American Art

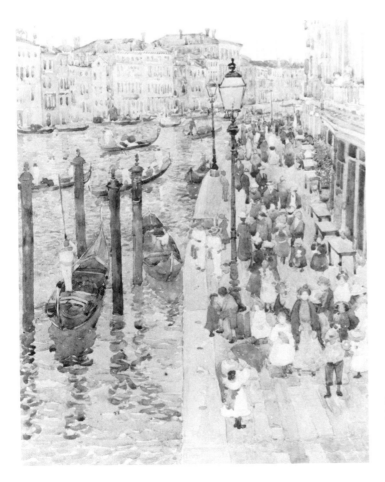

fig. 12.
Maurice Prendergast,
The Grand Canal, Venice,
collection of
the Terra Museum of American Art

anecdote—is essentially a flat surface covered with colors arranged in a certain order."[43] Denis described the Nabis' preference for "expression through decorative quality, through harmony of forms and colors, through the application of pigments, to expression through subject. They believed that for every emotion, for every human thought, there existed a plastic and decorative equivalent, a corresponding beauty."[44] By the early 1890s, the Nabis were beginning to attract attention as they started to show their work in Paris, for example at the *Salon des Indépendants*; and in late 1891, their first exhibition as a group was held at the gallery of the dealer Le Barc de Boutteville.

Among those Prendergast monotypes which are unmistakably Nabiesque are *Skipping Rope* (no. 12), *Children in Red Capes* (no. 15), *Children at Play* (no. 18), *The Breezy Common* (no. 28), and *The Breezy Common* (nos. 29 and 30, two pulls from the same plate). All of these pictures are characterized by a use of simplified colors and artfully arranged decorative patterns of flattened shapes. The monotype *Children in Red Capes* (no. 15) is quite strikingly similar in feeling to two works by Bonnard, the tempera *Children Leaving School*[45] and the lithograph *The Laundry Girl* (fig. 18)[46]. It should be noted that *The Laundry Girl* is dated 1896, therefore postdating the Prendergast monotype by one year; hence, this is not a case of Bonnard influencing Prendergast but one of a communality of aesthetic response.

Assigning a chronological order to Prendergast's monotypes is a task which presents considerable difficulties; the results are, at best, educated conjecture. There is a dearth of documentation; while the artist himself did occasionally date his monotypes (as a rule in the plate, rather than afterwards on the paper), it was by no means his unvarying practice to do so.[47] Of the 151 identified prints,

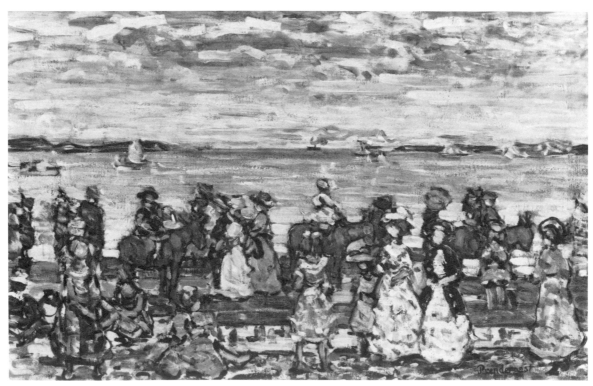

fig. 13. Maurice Prendergast, *Opal Sea*, collection of the Terra Museum of American Art

only 24 bear dates, leaving a balance of 127 which are undated.[48] In this respect, the Terra Museum collection offers a representative sample, for dates appear on only six of its 52 pictures.[49] The earliest dated print is *Fall Day*[50] of 1891 and the last is *The Riders*[51] of 1902. *Esplanade* (no. 1) is an extremely interesting picture, for, while left undated by Maurice, it does bear an inscription in the hand of Charles Prendergast identifying it as "the first color print made by Maurice B. Prendergast"[52] and it must date to about 1891. In itself, this documentation is a rather meagre foundation on which to erect a chronology of the monotypes. The evidence appears sparser yet after examination, upon the realization that the 24 dated prints are not evenly distributed over the dozen years during which Prendergast was active as a monotypist; nine were executed in 1895, and eight in 1901.[53]

There are factors in addition to the scarcity of dated works which complicate attempts to order the undated prints. One is that Prendergast worked in monotype for little more than a decade—not a long enough time span to justify expectations of dramatic stylistic changes. The other is that an artist's stylistic evolution is frequently less orderly and logical than one might assume.

The 1891 *Fall Day*, because it is the first dated monotype, is a key picture and the basis on which a number of related works have been ordered. It should be noted that that date is inscribed, not in the plate, but in pencil on the paper. Hence the possibility exists that Prendergast added that inscription at a later time, and, in doing so, made a mistake. On balance, an error of any magnitude seems improbable, but the fact remains that it *could* have occurred.

Street Scene (fig. 16)[54], a recently discovered picture, illustrates the dangers inherent in any attempt to date Prendergast's undated prints. One of the monotypes to which *Street Scene* is most closely related stylistically is *Fall Day*. The difficulty is that the latter is Prendergast's earliest dated monotype and *Street Scene* is dated (in the plate, so there is no possibility of error) 1900, placing it very late indeed, near the end of the artist's monotype *oeuvre*.

These provisos duly noted, it is nonetheless possible to discern a coherent chronological order to Prendergast's prints. As a very general proposition, it may be argued that the earlier pictures are carefully plotted, and are composed of static, flat forms, while the later ones are more spontaneous, made up of flowing, interlocking shapes. Even to state the change thus is virtually to overstate it, for the evolution is an extremely subtle one. It is not impossible to place the undated monotypes within this chronological framework. First of all, there are certainly a number of instances in which undated prints are extremely similar to dated ones; when that is the case, it is not unreasonable to assume that the two are contemporaneous. For example, *Early Evening, Paris* (no. 2) must come from about the same time as the 1892 *Bastille Day (Le Quatorze Juillet)*[55] for the two are alike in several respects: both are urban night views illuminated by street lamps; although the dominant foreground figure of *Early Evening, Paris* does not recur in the other monotype, the groups of smaller figures are similarly handled in the two pictures; even the elaborate monograms with which they are signed are virtually identical. (In fact, *Esplanade* [no. 1], Prendergast's "first color print," though clearly less advanced in execution than *Early Evening, Paris*, is enough like it that it cannot vastly predate that picture.) *Children at Play* (no. 18) and the *Springtime* element of *Three Sketches: Springtime, Lady in Red, Little Girl in Red* (no. 17) in palette and composition are very like a dated monotype of 1895, *Children Playing in the Park*.[56] The undated *Bareback Rider* (no. 20) and *Dress Rehearsal* (no. 21) must have been done at much the same time as the 1895 *Circus Scene with Horse* (no. 19) to which they are obviously closely related. After the turn of the century Prendergast did several single figure monotypes which he dated, among them *Lady with a Muff* (no. 45) of 1900 and

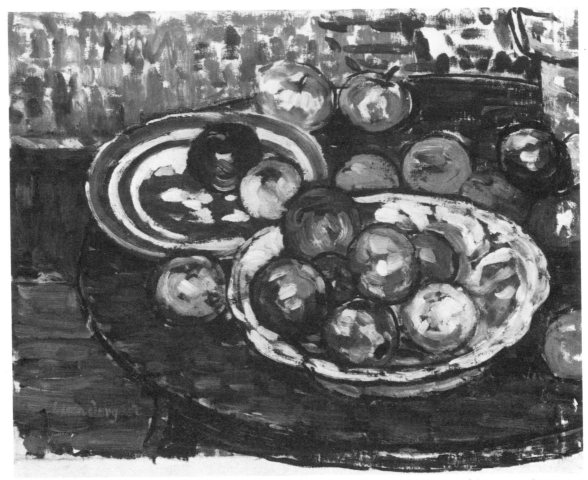

fig. 14. Maurice Prendergast, *Still Life with Apples*, collection of the Terra Museum of American Art

Woman with Parasol[57] and *Lady in Blue*[58] of 1901; presumably such prints as *Woman in White Muslin Dress* (no. 42), *Lady in Hat and Green Cape* (no. 43), and *Woman in Blue Dress with White Boa and Large Red Hat* (no. 44) come from about the same period. *Summer Day* (no. 49) is inscribed 1901; surely *In the Park* (no. 47), *Reflection (Fishing Party)* (no. 48), and, most of all, *Lighthouse* (no. 50) are similar enough to be securely dated to the same time. Indeed, a figure in *Summer Day*—the little girl with her arm raised—reappears virtually unchanged (though reversed) in *Lighthouse*.

It is not only the dated monotypes which provide assistance in the placing of undated ones; because Prendergast's works in other media are frequently analogous with the monotypes, dated or datable paintings and watercolors also offer clues. Watercolors of the very early 1890s such as *Lady in a Green Dress*[59] and *Lady on a Wet Day (Paris)*[60] plainly correspond to such monotypes as *Lady with Umbrella* (no. 3), *Lady with Handkerchief* (no. 4), *Green Dress* (no. 5), and *Red Haired Lady with Hat* (no. 6). *Early Evening, Paris* (no. 2) is extremely near in conception to two oils known to have been done in about 1892, *Evening Shower, Paris*[61] and *Lady on the Boulevard (Green Cape)* (fig. 4).[62] Indeed, the latter painting corresponds more closely yet to another monotype, *Green Cape*[63]; those two pictures are mirror images of each other. Because the orientation of the print is the reverse of that of the painting, one may assume either that it was done after, and with reference to, the oil (in

other words, the composition painted on the plate was identical to that of the painting; the reversal occurred when it was transferred to the paper), or that they both had a common, now unidentified, prototype.

The monotype *Crescent Beach* (no. 22) is also one of a pair of virtually identical compositions; its counterpart is a watercolor[64] in the *Boston Sketchbook* (fig. 8). The watercolor sketch was, of course, taken from life[65]; the monotype was done from that sketch and, as a consequence, its image is reversed. Aside from that reversal and an alteration in the placement of the young girl's hand (held to her lips in the watercolor, resting in her lap in the monotype), the two compositions agree in almost every detail. Because the watercolor was done in about 1895-1896[66], we may assign that date to the monotype as well.

Another page in the same *Boston Sketchbook*[67] (fig. 7) serves as the prototype for *The Breezy Common* (nos. 29 and 30, first and second pulls from the same plate); that watercolor and the monotypes all date from about 1895-1897.[68]

The model for the woman and horse in both *Bareback Rider* (no. 20) and in a closely related monotype of the same title[69] is a pencil drawing of about 1895 in another book known as the *Large Boston Public Garden Sketchbook*.[70]

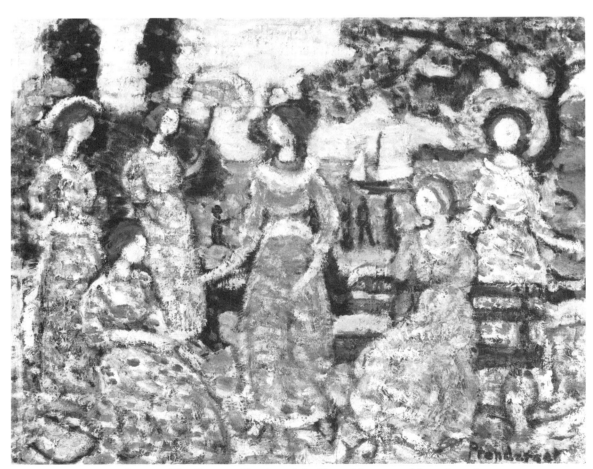

fig. 15. Maurice Prendergast, *The Grove*, collection of the Terra Museum of American Art

The monotype *Evening, South Boston Pier* (no. 23) is very similar indeed to two watercolors both of which are titled *South Boston Pier*; although one of them[71] is undated, the other (fig. 6)[72] is inscribed with the year 1896. While the three pictures are not identical in composition, they are like enough to assure that they must have been done at much the same time. All three are upright in format, and their verticality is echoed and stressed by the forms of the struts of the bridge and of the lampposts. Acting as a counterpoise to that verticality is the emphatically serpentine shape of the bridge itself.[73]

Another cluster of nearly related pictures includes the monotype *Monte Pincio (The Pincian Hill)* (no. 39) and three watercolors, the dated *Afternoon, Pincian Hill* of 1898[74] and the undated *Afternoon, Pincian Hill*[75] and *Monte Pincio, Rome* (fig. 11).[76] A comparison of these pictures provides an interesting insight into Prendergast's methods of composition. The Phillips and Terra watercolors are both horizontal in format and, although they differ in size, they are otherwise virtually identical, varying only in the most minor of details. The Honolulu version, which is vertically shaped, is also essentially identical—but only to their left halves; its sheet is the same height but little more than half as wide as the Terra sheet. It undoubtedly began as another complete horizontal view of Monte Pincio and then was "recomposed" by the artist, who cropped it into its present form. This technique of composing by subtraction is one frequently employed by Prendergast. The monotype composition is a simplified version of that of the watercolors, for it focuses upon the carriage seen in the center of those pictures. Here too, the landau drawn by a white horse faces left and is filled with women and children and that carriage stands before the brick retaining wall of the road leading to the Pincian Gardens. Now, however, that road leads up to the right rather than to the left.

In the watercolors, gaily attired strollers crowd the road; here, the crowd is replaced by a procession of red-robed ecclesiastics. (A similar group of ecclesiastics appears in another Roman monotype, *The Spanish Steps* [*Rome*].[77]) This view echoes a description which Prendergast found and marked in his Baedeker: "The Pincio is a favorite evening resort of both natives and foreigners, and high life appears with its carriages and liveried servants. The seminarists wear black gowns marked with distinctive colors, the Germans and Hungarians are robed in red."[78]

Because of its kinship with a group of watercolors, one of which is dated, we know *Monte Pincio (The Pincian Hill)* (no. 39) to have been executed in about 1898. That kinship is not the only testimony to its date, for evidence is also provided by the subject matter itself and this and certain other monotypes may be dated on the basis of geography. Prendergast was in Paris from 1891 until late 1894 or early 1895, when he returned home; therefore, monotype views of Boston and its environs almost certainly postdate that Parisian sojourn. Such pictures include *Crescent Beach* (no. 22); *Evening, South Boston Pier* (no. 23); *Street Scene* (no. 25); *The Breezy Common* (nos. 28, 29, and 30); and *Telegraph Hill* (no. 31). His first trip to Italy took place in 1898-1899, supplying a firm *terminus ante quem* for the views of Venice (for example, *Venice* [no. 34]; *Venetian Well* [no. 35]; *Venetian Court* [no. 36]; *Bella Ragazza; Merceria* [no. 37]; and *Festa del Redentore* [no. 38]) and of Rome (among them *Monte Pincio* [*The Pincian Hill*] [no. 39]; and *On the Corso, Rome* [no. 40]). Finally, two monotypes of Central Park[79] cannot have been done by the artist before his first painting trips to New York in 1900.[80]

Early exhibition records are also often helpful in dating certain monotypes for they offer a *terminus post quem* for those pictures listed. In some instances, descriptions are vague: *A Print* is, of course, unidentifiable. In other cases, titles are rather specific and may be linked to known pictures

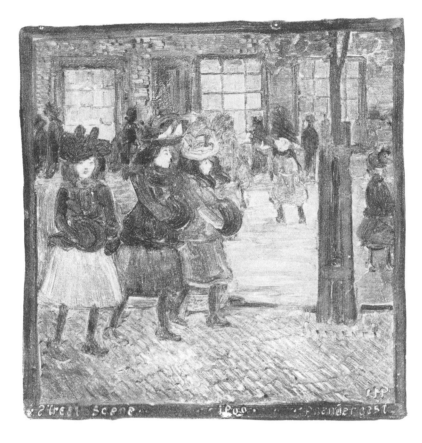

fig. 16.
Maurice Prendergast,
Street Scene,
collection of
The Art Institute of Chicago

with considerable confidence. Among the latter are three works called *Primrose Hill* exhibited in 1901-1902 at Detroit and Cincinnati[81]; there is a strong likelihood that either *Primrose Hill* (no. 7) or *Primrose Hill No. 2* (no. 8) (or both) was among those pictures. Either *Skipping Rope* (no. 12) or the other pull from the same plate of that title[82] is surely the monotype shown in Boston in 1898.[83] In the same Boston exhibition was a print called *Three Little Girls in Red*[84], indubitably a reference to one of two pulls from the same plate, either *Children in Red Capes* (no. 15) or *Children in Red*.[85] *The Opera Cloak* (no. 33) (or the other impression of that title from the same plate[86] is yet another picture surely shown in Boston in 1898[87]. *Telegraph Hill* (no. 31) was almost certainly shown at Boston in 1901.[88] Also in the 1901 Boston exhibition was *Venetian Wells*[89], probably either *Venetian Well* (no. 35) or a different monotype of the same name.[90] Four monotypes titled *The Circus* were included in the 1901-1902 Detroit and Cincinnati exhibition[91]; *Circus Scene with Horse* (no. 19), *Bareback Rider* (no. 20) and *Nouveau Cirque (Paris)* (no. 52) may well have been among that group. Also seen at Cincinnati were three works called *Evening on the Pier*[92]; one of those references is probably to *Evening, South Boston Pier* (no. 23).

Soon after his return to Boston from London in late 1894 or early 1895, Prendergast commenced to exhibit his pictures. The first known occasion on which he showed his monotypes was in 1898, when he sent perhaps half a dozen prints (the exact number is uncertain) to the *11th Annual Exhibit* of the Boston Water Color Club. In January 1900 the artist had a major exhibition, his first at a museum; held at the Chicago Art Institute, it included 15 monotypes. Almost immediately thereafter, he had another significant show, composed of watercolors and monotypes, this time at

the Macbeth Gallery in New York. The following year, he submitted several prints to the Boston Water Color Club's *14th Annual Exhibit*. The last occasion on which Prendergast himself showed these works occurred in 1901-1902, when an important exhibition of his watercolors and monotypes was held at the Detroit Museum of Art and the Cincinnati Museum Association, in which were included at least 36 prints.[93] The fact that Prendergast showed as many of his monotypes as often as he did is a sure indication that his interest in the medium was more than a desultory one; certainly, he considered these pictures finished works of art in their own right, in no way subordinate in seriousness to his watercolors. Indeed, in the catalogues for some of these early shows, works in the two media are listed together, with no attempt made to differentiate between them.

It is logical that Prendergast himself stopped showing his monotypes when he did; the date of that last exhibition—1901-1902—corresponds fairly exactly to that at which he actually ceased working in the medium. He never again in his lifetime showed his prints, nor were any included in

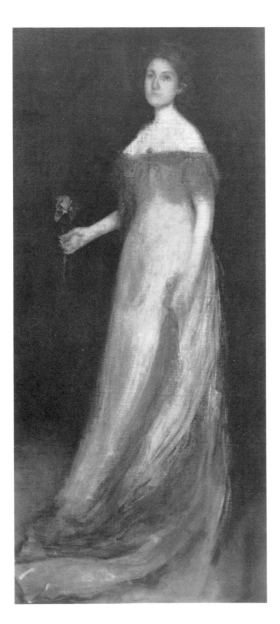

fig. 17.
James McNeill Whistler,
Rose et Vert, l'Iris: Portrait of Miss Kinsella,
collection of the Terra Museum of American Art

the large memorial exhibitions arranged in the decade after his death, at C.W. Kraushaar Galleries in New York in 1925, at The Cleveland Museum of Art in 1926, and at the Whitney Museum of American Art in New York in 1934. Not until 1936 were they again displayed, when Kraushaar organized an exhibition of Prendergast monotypes; the following year a similar show was held at the Corcoran Gallery of Art in Washington and, since that time, there have been several further exhibitions dedicated specifically to his work in that medium.[94] His monotypes have been included in all the subsequent major Prendergast retrospective shows[95] as well as in several important exhibitions devoted to a survey of that medium.[96]

"Sometimes the second or third plate [*sic*][97] is the best."[98] So remarked Maurice Prendergast to his friend Mrs Oliver Williams in the course of instructing her in the art of monotype making. His statement is probably the origin of a frequently repeated assumption about Prendergast's own practise: that is, that it was his habit to take two impressions from a plate and to discard the first, preferring to retain only the second, more subdued picture. It is not known if this is what he actually did or whether, instead, he tended to make only one impression; certainly the artist's statement to Mrs Williams would appear to support the former hypothesis. One of these two alternatives surely is correct for what we do know is that, in proportion to the totality of Prendergast's monotype *oeuvre*, the number of duplicate pulls is really rather small. Of the 151 known prints, there are 132 different images and only 19 cognates[99]; that is to say, there are 113 "unique" prints, of each of which there is only one recorded version.

Some of Prendergast's monotypes are brilliant in color and others, perhaps the majority, are rather subtle. *Figures Along the Shore* (no. 14), *Telegraph Hill* (no. 31), *Marine Park* (no. 32), and *In the Park* (no. 47) are vibrantly hued, while *Lady with Handkerchief* (no. 4), *Evening, South Boston Pier* (no. 23), *Street Scene* (no. 25), *Windy Day* (no. 26), and *Woman in White Muslin Dress* (no. 42) are all somewhat muted. As it happens, each of these examples is apparently unique, so that there is no other pull with which to compare it. One might naturally assume that those pictures in the former group are all first pulls and those in the latter cognates. However, such an assumption is by no means necessarily correct, as an examination of pairs of monotypes will confirm.

Differences in strength between first and second impressions are not always very great; indeed, they may be slight enough to be undetectable in photograph. *Skipping Rope* (no. 12) and the other pull of the same title[100], are not very different in intensity, and the certainty that the Terra Museum picture is the cognate only comes when the two pictures are actually seen side by side.[101]

The intensity of an impression is not wholly dependent upon whether or not it is a first pull; it may, in fact, be a reflection of the amount of pressure applied during the transfer process. Because Prendergast did not use a press, this was a factor over which he had a considerable degree of control. Both of the *Skipping Rope* pictures (no. 12 and its first pull) are relatively muted in appearance and one may assume that the artist exerted only modest pressure during the first, and rather more during the second, transfer.[102] Pressure is probably a deciding factor in the appearance of *Red Haired Lady with Hat* (no. 6) and its counterpart of the same name.[103] Both pulls are very strong; they are roughly alike in intensity, and one may suppose that less pressure was applied during the first and substantially more was used during the second transfer, approximately equalizing their appearances.

Because the intensity of a Prendergast monotype is surely intentional, it is erroneous to assess the quality of a print according to its strength. Degree of intensity is not a valid criterion of excellence

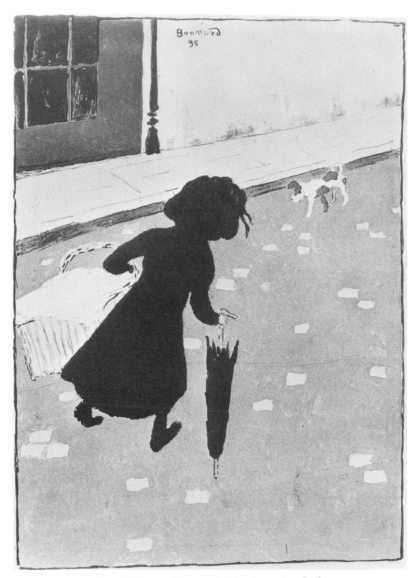

fig. 18. Pierre Bonnard, *The Laundry Girl*,
collection of The Museum of Modern Art

and a strong print is certainly not superior to a more subtle one. Neither is a first impression better than its cognate. In those instances in which there are two pulls, the artist probably retained both because he esteemed both, and because he judged each a successful work in its own right.

It is instructive to compare first and second impressions from the same plate. In some pairs, the two are identical except in their degree of strength (and even that, as we have seen, does not always vary substantially); included in this category are *Children in Street* (no. 9) and *Going to School* (no. 10); *Primrose Hill* (no. 7) and *Primrose Hill No. 2* (no. 8); *Children in Red*[104] and *Children in Red Capes* (no. 15); *Children in the Park*[105] and *Children at Play* (no. 18); *The Breezy Common* (no. 29) and *The Breezy Common* (no. 30); *Fishing Party*[106] and *Reflection (Fishing Party)* (no. 48).

In certain instances, there are differences other than degree of intensity between two pulls. After transferring the image from plate to paper, Prendergast would on occasion work on the paper

itself, most frequently in pencil, although occasionally in watercolor. As already noted, both impressions of *Skipping Rope* (no. 12 and its first pull) are relatively muted and, generally speaking, do not differ dramatically in intensity. However, a close examination of the second pull reveals a considerable amount of pencil work. Several areas are enforced in graphite, among them the dress of the second child from the right, and the hair of the third and fourth girls from the right. The result of these changes is a subtle alteration in the compositional emphasis of the picture. It is not just in identified second pulls that pencil additions are found. In *Lady with Handkerchief* (no. 4), a unique print, the subject's face, her veil, and the outline of her muff are defined in pencil. Similarly, the woman's features are detailed in pencil in *The Opera Cloak* (no. 33); that picture, incidentally, is the first of two pulls.

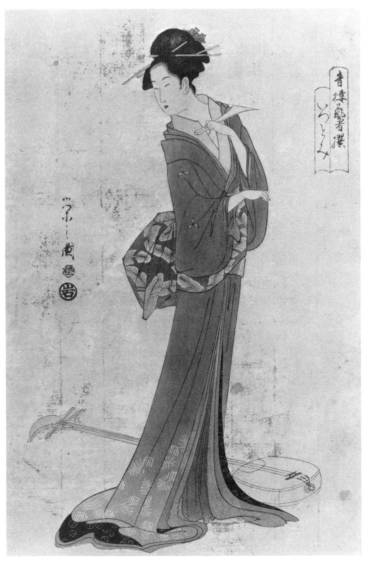

fig. 19. Chobunsai Eishi,
The Courtesan Itsutomi Holding the Plectrum
for a Samisen Which Lies Behind Her,
collection of the Victoria and Albert Museum

Lighthouse (no. 50) is also the first of two impressions; it is, as well, the unique example of a monotype to which extensive additions in watercolor have been made. Its cognate, *Beach Scene with Lighthouse (Children at the Seashore)*[107], which has been examined only in photograph, appears to have been left exactly as it was when transferred from the plate; there are no discernible watercolor or pencil alterations. In *Lighthouse*, many areas have been reworked, among them the face, hat, and dress of the little girl facing forward at right center; the shirt and hair of the small boy at right; most of the boy at left; much of the cloak of the woman at left; virtually all of both groups of three figures in the background; and the sailboats on the horizon. A comparison of this picture with its unretouched second pull reveals that these repaintings all occur within the outlines of forms already established in the plate; that is to say, those boundaries have been colored in. In the cognate, the dress of the girl at right center appears to be very pale in color, so pale that it may, in fact, be the paper itself showing; in the first pull, that dress is painted white and a tucker and its folds are delineated with strokes of black.

As a rule, any changes that Prendergast made to his monotypes were of the nature of those just discussed, that is, compositional additions done in pencil or watercolor on the paper. On one occasion, however, the artist printed a monotype and then reworked the plate itself before making another impression. *Street Scene* (no. 11) is the first impression and *Street Scene, Boston*[108] the cognate. While the pictures are rather similar in general effect, in reality it is only their broad outlines which remain the same. The repainting is very extensive indeed; there are seemingly countless variations in detail, so many that only precise measurement and painstaking comparison of the two pulls confirm that they are indeed both from the same plate. A boy's black jacket is transformed into a pink shirt; one child's red dress becomes a pink-tinged white skirt and black and white striped blouse, while another little girl's dark dress and white pinafore become a white frock; other black dresses are transmuted into pink and blue ones; the artist's signature, once prominently displayed in a window lintel, is obliterated; several figures standing in windows vanish; and, most noticeably, two new children appear, their figures created by the wiping away of pigment from the plate. These are merely the most obvious of the alterations, for almost no area has been left untouched.

While *Street Scene* and *Street Scene, Boston* probably differ more than any other first pull and cognate, they do exemplify, albeit in a slightly exaggerated way, all of the pairs of impressions in Prendergast's monotype *oeuvre*; they are first and second pulls from the same plate and, concurrently, they are manifestly separate and unique works of art. In every instance, there are variations between the two components of a pair; sometimes those variations occur naturally during the transfer process (i.e., the second pull is less intense than the first) and sometimes they are a result of alterations made by the artist to one or the other of the pictures. Prendergast seems to have retained two impressions from one plate relatively infrequently. On those occasions when he did, his decision to do so was most certainly a conscious one, based upon his estimation of each pull as an independent and a uniquely meaningful work.

Prendergast made his first monotype in about 1891, at the very inception of his professional artistic career, and his last one approximately a dozen years later, probably in 1902[109], when he seems to have abruptly halted his experiments in printmaking. It was a period of intense artistic activity for Prendergast, one in which he produced a very considerable body of monotypes, perhaps 200 in number. While one may only conjecture why he then stopped doing them, it is presumably

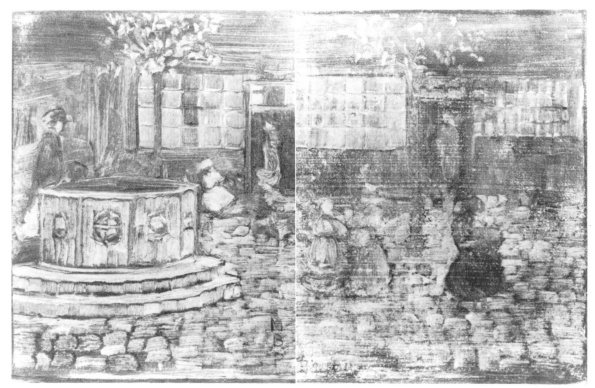

fig. 20. Maurice Prendergast, left: *Venetian Well* (no. 34); right: *Venetian Court* (no. 35)

because the medium no longer answered his needs. What those needs were is revealed by a consideration of his activities in other media.

During the 1890s, the artist concentrated his creative efforts upon monotype and watercolor; indeed, some of his most celebrated watercolors (among them *Monte Pincio, Rome* [fig. 11] and *The Grand Canal, Venice* [fig. 12], both in the Terra Museum of American Art collection) date from that era. To be sure, he did do the occasional oil, but paintings of that decade are comparatively rare. Characteristic examples are three works in the Terra Museum collection, *The Tuileries Gardens (Paris)* (fig. 1), *Evening on a Pleasure Boat* (fig. 9), and *Franklin Park (Boston)* (fig. 5); all three pictures are rather spontaneously executed and somewhat thinly painted; that is, the application of paint is, broadly speaking, like that in the monotypes. Soon after the beginning of the new century, however, a shift of direction is detectable. While Prendergast certainly never ceased to work in watercolor, he now focussed his attentions increasingly upon oil painting, and the first hints of his mature manner—what is termed his "tapestry" style—became apparent at probably much the same time that he ceased making prints. That tapestry style is distinguished by densely painted surfaces, deliberately and painstakingly woven out of patterns of varied brushstrokes; and such a surface is the precise antithesis of that of a monotype.

During the course of a dozen years of vigorous creativity, Prendergast produced a monotype *oeuvre* which is one of the supreme aesthetic treasures of the medium. In terms of size alone, this body of work is of considerable distinction, for it is one of the biggest in the annals of the monotype. Of far greater consequence than their quantity, however, is their quality. In these pictures is the

distillation of the artist's magical vision. They portray an enchanted domain in which life is idyllic and every day a holiday; it is a world of circuses and boat races and festivals, one inhabited by frolicking children and captivating, fashionable women. The greatest significance of this *oeuvre* lies in the fact that it represents a brilliant and intense exploration of the possibilities and the boundaries of the monotype medium; it is a very profound achievement indeed. Nowhere may the magnitude of that achievement be more fully appreciated than in the Terra Museum of American Art holdings, the single largest collection of the monotypes of Maurice Prendergast.

Notes

1. *The Random House Dictionary of the English Language: The Unabridged Edition* (New York, 1966): "the only print made from a metal or glass plate on which a picture is painted in oil color, printing ink, or the like."
2. the drying time may range from perhaps half an hour to not much more than two hours at the most, dependant upon the medium used, that is, linseed oil, or turpentine, or a combination of the two.
3. *Metropolitan 1980*, p. IX.
4. *Fogg 1968*.
5. e.g., *Smithsonian 1972* and *Pearl 1979*.
6. *Philadelphia 1973*.
7. *Boston 1973*.
8. *AAA 1977*.
9. *Davis & Long 1979*.
10. *Metropolitan 1980*.
11. *Ibid.*, pp. 4-5, 8: 22 monotypes and two second pulls, dating from between about 1640 and 1660.
12. the estimates range between 300 (*Fogg 1968*, p. vii) and 450 (*Field 1978*, p. 143).
13. some sense of the esteem in which that *oeuvre* is now held may be derived from a statistical survey of the Metropolitan/Boston exhibition in which there were seven Prendergast monotypes; the only artists more fully represented were Degas with 13 and Castiglione with 10 pictures; Picasso was seen in seven examples, Pissarro in six, and Matisse in four.
14. of that number, 145 are actually located or are at least known in photograph, and another six are identified from verbal description so complete as to preclude the possibility of conflation.
15. *Boston 1960-1961*, p. 34.
16. *Addison 1938*, p. 36.
17. commonly called Japan paper.
18. Japanese tissue is not sized; one of its components is neri, a binder made of vegetable starch, which increases the hardness of the paper so that it is receptive but not absorbent.
19. often created by the burnishing of that surface; the paper Prendergast regularly used also incorporates random bits of glistening mica.
20. *Brinton 1910*.
21. according to *Metropolitan 1980*, p. 96, he did show four "dessins faits avec l'encre grasse et imprimés" at the third Impressionist exhibition of 1877; he may possibly also have included a few of his oil landscapes in his 1892 Durand-Ruel exhibition, where they would, of course, have been accessible to Prendergast. Degas certainly did exhibit many of those pastels which are executed over cognates but those pictures retain nothing of the character of monotype.

22. collections of Mr and Mrs Raymond J. Horowitz and the Philadelphia Museum of Art, illus. in *Davis & Long 1979* as nos. 59 and 60.

23. and yet again in *Children at Play*, collection of The Brooklyn Museum, and *Balloons: Park on Sunday*, private collection, *Ibid.*, illus. as nos. 57 and 61.

24. *Ibid.*, illus. as no. 42, collection of The Museum of Modern Art.

25. *Ibid.*, illus. as no. 11, private collection.

26. *Ibid.*, illus. as no. 20, collection of The Cleveland Museum of Art.

27. *e.g., The General Dealer*, Museum of Art, Rhode Island School of Design, illus. in *Whistler 1971* as no. 39, pl. 50; *Chelsea Shops*, Freer Gallery of Art, illus. in *Whistler 1980* as no. 146, pl. 222.

28. collection of the Terra Museum of American Art.

29. examples in other collections include *Fall Day*, private collection, illus. in *Davis & Long 1979* as no. 11; *Street Scene* (fig. 15), collection of The Art Institute of Chicago; *The Lady with Dog—Primrose Hill*, collection of Mr and Mrs Ira Glackens, illus. as no. 12, *Ibid.*; *Street Scene, Boston*, private collection, illus. as no. 17, *Ibid.*; and *Afternoon*, collection of the Corcoran Gallery of Art, illus. as no. 18, *Ibid.*.

30. Frick Collection, New York, illus. in *Whistler 1980* as no. 203, pl. 146.

31. *Ibid.*, illus. as no. 230, pl. 145, whereabouts unknown.

32. *Ibid.*, illus. as no. 185, pl. 154, collection of Freer Gallery of Art.

33. *Ibid.*, illus. as no. 242, pl. 170, collection of the Philadelphia Museum of Art.

34. collection of the Terra Museum of American Art.

35. collection of the Tate Gallery, illus. in *Whistler 1980* as no. 169, pl. 152.

36. *Ibid.*, illus. as no. 170, pl. 153, collection of Detroit Institute of Arts.

37. collection of John Brady, Jr., illus. in *Davis & Long 1979* as no. 73.

38. *Ibid.*, illus. as no. 74, private collection.

39. collection of Hunterian Museum and Art Gallery, University of Glasgow, illus. in *Whistler 1980* as no. 55, pl. 33.

40. *Ibid.*, illus. as no. 64, pl. 38, collection of Isabella Stewart Gardner Museum, Boston.

41. M de Soye's establishment in the rue de Rivoli, *Whistler (1980)*, p.lx.

42. Chobunsai Eishi, *The Courtesan Itsutomi Holding the Plectrum for a Samisen Which Lies Behind Her*, collection of the Victoria and Albert Museum.

43. Maurice Denis, *Théories, 1890-1910*, p. 1 (article published in 1890), quoted in *Bonnard 1948*, p. 15.

44. *Ibid.*, p. 25 (article published in 1895), quoted in *Ibid.*, p. 15.

45. illus. in *Bonnard 1964* on p. 30, as collection of Lauder Greenway.

46. collection of The Museum of Modern Art.

47. this is true not just of the monotypes but of the paintings and watercolors as well.

48. although very few of the monotypes are dated, many are signed, usually in the plate; of the 52 prints in the Terra Museum collection, 38 bear plate signatures. Only two Terra monotypes (nos. 36 and 43) are completely unsigned; however, a certain number of those signatures inscribed on the sheets themselves (for example, those on nos. 1, 13, 24, 26, 35, and 38) may well, in fact, be in a later hand.

49. the dated pictures are *Figures along the Shore* (no. 14); *Children in Red Capes* (no. 15); *Spring in Franklin Park* (no. 16); *Circus Scene with Horse* (no. 19); *Lady with a Muff* (no. 45); and *Summer Day* (no. 49).

50. private collection, illus. in *Davis & Long 1979* as no. 11.

51. *Ibid.*, illus. as no. 103, private collection.

52. oddly enough, another Prendergast monotype is identically inscribed by Charles; that picture, *Lady in Pale Green Dress, Blue Hat, and Scarf*, appeared at Sotheby Parke Bernet, Inc., sale, November 13-14, 1979, illus. as lot 488. While at least one of the brother's two inscriptions is obviously erroneous, it is not possible to be certain which that is; both pictures clearly date to the very beginning of Maurice's monotype career and both are executed on atypically absorbent paper. The fact that the image of *Esplanade* is the slightly less crisp of the two might argue for its preceding the Sotheby picture; on the other hand, its composition is noticeably more complex than that of *Lady in Pale Green Dress, Blue Hat, and Scarf*.

53. the years 1891, 1892, 1897, 1898, and 1902 are each represented by one example, 1900 by two, and 1893, 1894, 1896, and 1899 by none at all. Again, the Terra Museum collection is representative; four of the six dated pictures (nos. 14, 15, 16, and 19) come from 1895, one from 1900 (no. 45), and one from 1901 (no. 49).

54. collection of The Art Institute of Chicago.

55. collection of The Cleveland Museum of Art, illus. in *Davis & Long 1979* as no. 20.

56. *Ibid.*, illus. as no. 30, present whereabouts unknown.

57. *Ibid.*, illus. as no. 88, collection of The Museum of Modern Art.

58. *Ibid.*, illus. as no. 89, collection of the Museum of Fine Arts, Boston.

59. *Ibid.*, illus. as fig. 2, p. 39, private collection.

60. collection of Miss Antoinette Kraushaar, illus. in *Davis & Long 1975* as no. 31.

61. private collection, illus. in *Maryland 1976* as no. 5, p. 82.

62. collection of the Terra Museum of American Art.

63. collection of John Brady, Jr., illus. in *Davis & Long 1979* as no. 21.

64. p. 57.

65. according to Peter Wick ("Critical Note" in *Boston Sketchbook*, p. 11): "Maurice never went out without his pocket sketchbook, a habit he claimed to have cultivated in Paris after the example of Degas."

66. *Ibid.*, p. 16: "Page 57 is the key to the identification of Revere Beach. The pensive young redhead clothed in violet is seated on Ocean Pier, with the four-mile stretch of Crescent and Revere Beaches to the north . . . One assumes a date of 1896, just before the clearing of the beach and construction of the new esplanade."

67. p. 43.

68. although the *Boston Sketchbook* is inscribed by Prendergast with the date 1899, stylistic evidence indicates that most of the drawings it contains were done several years earlier.

69. collection of The Cleveland Museum of Art, illus. in *Davis & Long 1979* as no. 39.

70. Robert Lehman Collection, The Metropolitan Museum of Art, illus. in *Boston Public Garden Sketchbook* as p. 33.

71. private collection, illus. in *Davis & Long 1979* as fig. 4, p. 80.

72. collection of Smith College Museum of Art.

73. there is also a fourth, horizontally oriented view—a pastel—of the subject, *South Boston Pier: Sunset*, illus. in *Boston 1960-1961* as no. 57, collection of Mr and Mrs Donald G. Crowell.

74. *Ibid.*, illus. as fig. 8, p. 112, The Phillips Collection.

75. *Ibid.*, illus. as fig. 7, p. 112, collection of the Honolulu Academy of Arts.

76. collection of the Terra Museum of American Art.

77. *Ibid.*, illus. as no. 76, collection of The Cleveland Museum of Art.

78. *Baedeker's Italy from the Alps to Naples*, pp. 208-209, quoted in *Maryland 1976*, p. 95.

79. *Central Park*, private collection, illus. in *Davis & Long 1979* as no. 102; *Central Park*, collection of the Museum of Fine Arts, Boston, illus. as no. 104, *Ibid.*.

80. *Boston 1960-1961*, p. 38.

81. as nos. 46, 47, and 48.

82. collection of Mr and Mrs Paul Mellon, illus. in *Davis & Long 1979* as no. 22.

83. as no. 87.

84. as no. 85.

85. collection of the Museum of Fine Arts, Boston, illus. in *Davis & Long 1979* as no. 27.

86. *Ibid.*, illus. as no. 66, collection of A. Maynard.

87. as no. 84; it was again exhibited: *Cincinnati 1901-1902*, as no. 29.

88. as no. 1, *Telegraph Hill I*.

89. as no. 59; a picture of that title was also shown: *Cincinnati 1901-1902*, as no. 53.

90. collection of Addison Gallery of American Art, illus. in *Davis & Long 1979* as no. 70.

91. as nos. 41, 42, 43, and 44.

92. as nos. 33, 34, and 57.

93. in the catalogue for that exhibition, nos. 29-64 are listed as monotypes. The last of the watercolor entries, no. 28, is titled *Venetian Wells*. It seems likely that that picture was, in fact, the monotype *Venetian Well* (no. 34), which bears the pencil notation #28.

94. *Kraushaar 1956; Bard 1967; Davis & Long 1979*.

95. *Addison 1938; Kraushaar 1950; Boston 1960-1961; Maryland 1976*.

96. *Smithsonian 1972; Metropolitan 1980*.

97. obviously, Prendergast intended to say pull.

98. quoted in *Boston 1960-1961*, p. 34.

99. in that *oeuvre*, there is no instance of more than two pulls from a given plate.

100. collection of Mr and Mrs Paul Mellon, illus. in *Davis & Long 1979* as no. 22.

101. this is an instance in which photographic evidence is actually misleading; in photograph, the Terra Museum picture looks distinctly stronger than the Mellon version.

102. although there are no records of more than two impressions of a given print, it is not impossible that, in some instances, what we assume to be first and second pulls are really second and third pulls. If such is ever the case, then, obviously, the first pull is lost.

103. present location unknown; illus. in Sotheby Parke Bernet, Inc., sale, November 13-14, 1979, as lot 489; the two pulls have never been examined together; therefore, it is only an assumption that the Sotheby picture is the first and the Terra Museum picture the second impression.

104. collection of the Museum of Fine Arts, Boston, illus. in *Davis & Long 1979* as no. 27.

105. *Ibid.*, illus. as no. 31, collection of Mrs Jacob M. Kaplan.

106. collection of the Museum of Fine Arts, Boston, illus. in *Boston 1960-1961* as no. 141 on p. 18.

107. private collection, illus. in *Bard 1967* as no. 43.

108. private collection, illus. in *Davis & Long 1979* as no. 17.

109. the last dated monotype is *The Riders* of 1902, illus. as no. 103, *Ibid.*, as private collection.

The Monotypes

1. *Esplanade*

6½ x 5¾ inches (16.5 x 14.6 cm.) (image and paper)
Inscribed (at lower left, probably in a later hand): M B P; (on the back, in the hand of the artist's brother, Charles Prendergast): The first color print made by Maurice B. Prendergast.
Executed about 1891

Exhibited: Davis & Long, 1979, no. 1, illus. on p. 35, illus. in color on p. 17 (as private collection)

Ex coll: estate of the artist, until 1982; to Daniel J. Terra

Esplanade is probably Maurice Prendergast's first monotype. Even at this early date, its subject—a fashionably attired woman—is one utterly characteristic of the artist. However, the pose of that figure is perhaps more static and its outline less crisp than in later pictures. The print is also executed on an atypically absorbent paper (the support for most of Prendergast's monotypes is a relatively hard Japanese tissue) into which the pigment has soaked; as a consequence, outlines are somewhat blurred. Forms are further obscured because the tonal values are extremely close: the woman's purple grey skirt is almost the color of the night sky behind her and is barely distinguishable from it; even her red jacket and parasol and her blue boa merge into that background.

Although Charles Prendergast identified this monotype as the artist's "first color print," he similarly inscribed another work, *Lady in Pale Green Dress, Blue Hat, and Scarf*.[1] Like *Esplanade*, that picture is executed on a somewhat absorbent paper; however, its composition is slightly less ambiguous because there the figure, in a bright yellow green dress, is fairly sharply silhouetted against the dark background.

Esplanade is less advanced in technique but otherwise very closely related to another monotype, *Charles River Esplanade*.[2] Their compositions are extremely similar; in both, a woman with parasol stands on an esplanade, a railing and then water behind her. They are night views illuminated by a single globed street light and in both the artist has drawn lines to indicate reflections on the water by removing pigment with the end of his brush handle.

1. present location unknown, sale, Sotheby Parke Bernet, Inc., November 13-14, 1979, illus. as lot 488.
2. private collection, illus. in *Davis & Long 1979* as no. 2.

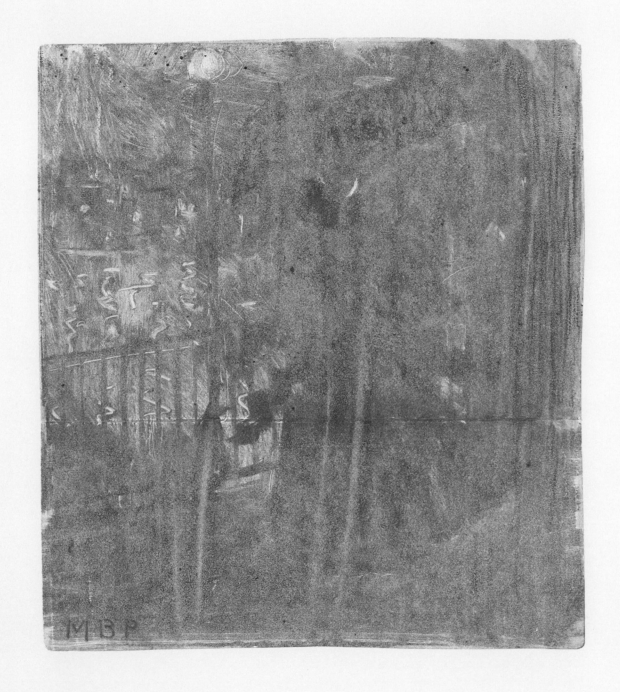

2. *Early Evening, Paris*

5¾ x 4¼ inches (14.6 x 10.8 cm.) (image)
Signed (at lower right, in the plate): MBP (monogram)
Probably executed about 1892

Exhibited: Bard, 1967, no. 34 (as *Early Evening*); Associated American Artists, Inc., New York, 1980, no. 4, illus. (as *Early Evening*)

Probably exhibited: Kraushaar, 1956 (as *Early Evening*, catalogue unnumbered)

Possibly exhibited: Chicago, 1900, no. 81 (as *Crossing the Street*); Boston, 1901, no. 60 (as *Crossing the Street*)

Ex coll: Kraushaar Galleries, New York; to private collection, New York, probably from the mid 1950s until about 1979; Associated American Artists, Inc., New York, as of 1980 until 1982; to Davis & Langdale Company, New York, 1982; to Daniel J. Terra

Like *Esplanade* (no. 1), this is a night scene dominated by a single standing female figure. However, it is more advanced in execution than that picture and certainly postdates it. *Early Evening, Paris* may be compared to, and must have been done at much the same time as, the dated monotype of 1892, *Bastille Day (Le Quatorze Juillet)*[1], to which it bears a strong similarity. Both are urban night views of lamplit streets thronged with people; the Cleveland picture lacks the large foreground woman of this composition, but its small figures are like those in the background here. Both pictures have ornately calligraphic monograms; indeed, those monograms are identical except that one is the mirror image of the other.

Early Evening, Paris is also very like a painting in the Terra Museum collection, *Lady on the Boulevard (Green Cape)* (fig. 4); in both, a stylishly attired lady in elaborate hat and cape stands in an illuminated boulevard. Similar as these two works are, the oil is even more closely linked to another monotype, *Green Cape*[2], the composition of which is the precise reverse of its own.

1. collection of The Cleveland Museum of Art, illus. in *Davis & Long 1979* as no. 20.
2. *Ibid.*, illus. as no. 21, collection of John Brady, Jr.

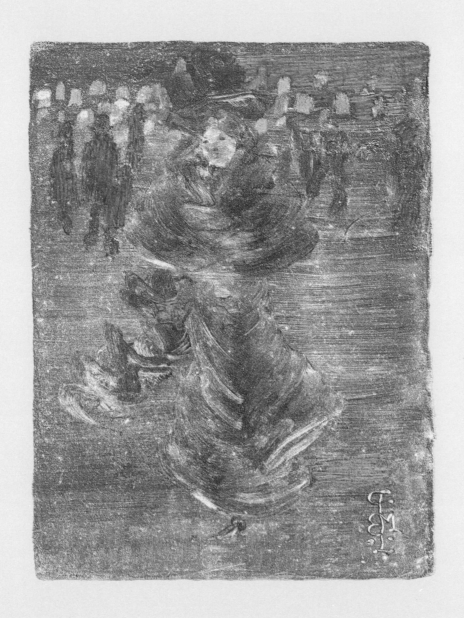

3. *Lady with Umbrella*

9⅛ x 4¹⁄₁₆ inches (23.2 x 10.3 cm.) (sight); 11¹⁄₁₆ x 5½ inches (28.1 x 14 cm.) (paper)
Signed (at lower right, in pencil): MBP (monogram)
Probably executed about 1891–1894

Exhibited: Davis & Long, 1979, no. 3, illus. on p. 37 (as Davis and Long Company)

Ex coll: estate of the artist, until 1977; to Davis & Long Company, New York, from 1977 until 1979; to private collection, from 1979 until 1982; to Davis & Langdale Company, New York, 1982; to Daniel J. Terra

Yet again, the subject chosen is that of a single standing figure of a woman. Now, unlike those in *Esplanade* (no. 1) and *Early Evening, Paris* (no. 2), this figure is sharply outlined against the neutral background of the paper itself. *Lady with Umbrella* is virtually monochromatic: the woman's dress, her boa, parasol, and hair are all greyish black; there are touches of brown on the parasol rim, and her hat is brownish black. In contrast to the radical simplification of the palette is the extravagant convolution of the silhouette. The intricate shape of the hat, the sinuous outline of the boa and leg-of-mutton sleeve, that sleeve line echoed by the scalloped edge of the umbrella: all this is artfully detailed.

A source of inspiration for *Lady with Umbrella* is surely the Japanese print (see, for example, fig. 19[1]). The monotype reveals that Oriental inspiration in several ways: by the emphatic verticality of the paper, the mannered pose of the figure, the elaborate monogram—not just a signature, but a compositional element in itself, its attenuated shape repeating those of the figure and of the paper— and by the careful placement of both figure and monogram on the sheet.

1. Chobunsai Eishi, *The Courtesan Itsutomi Holding the Plectrum for a Samisen Which Lies Behind Her*, collection of the Victoria and Albert Museum.

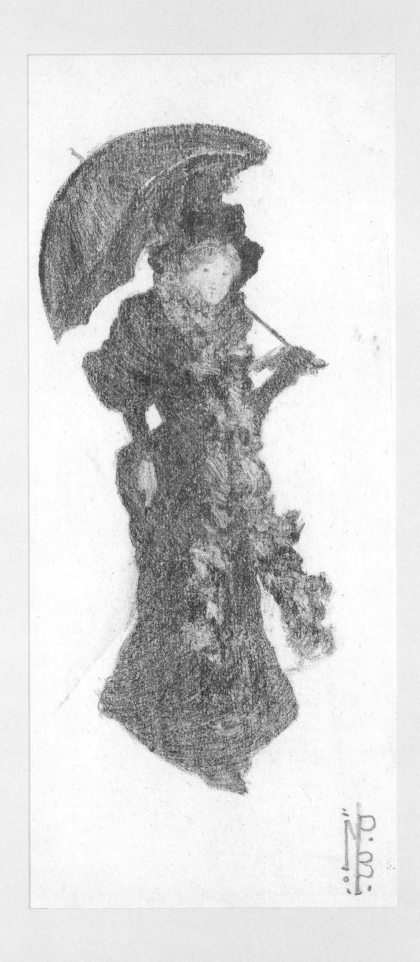

4. *Lady with Handkerchief*

9⅛ x 4³⁄₁₆ inches (23.2 x 10.6 cm.) (sight); 11¹⁄₁₆ x 5½ inches (28.1 x 14 cm.) (paper)
Signed (at lower right, in pencil): MBP (monogram)

Probably executed about 1891–1894
Exhibited: Davis & Long, 1979, no. 6, illus. on p. 40 (as Davis and Long Company)

Ex coll: estate of the artist, until 1977; to Davis & Long Company, New York, from 1977 until 1980; to private collection, from 1980 until 1982; to Davis & Langdale Company, New York, 1982; to Daniel J. Terra

Lady with Handkerchief dates from exactly the same time as *Lady with Umbrella* (no. 3) and, like that picture, reveals the artist's familiarity with Japanese prints (see fig. 19[1]). The two monotypes are similar in shape, in composition, and in palette; here, the lady is garbed in a pale brown suit and muff, and her hat, veil, and glove are brownish black. The intricate monogram signature is identical to that of no. 3. There is considerable graphite work on the sheet; pencil is used to define the features of the face and to strengthen the veil and the right outline of the muff. Pigment has been wiped away, disclosing the faint tan color of the paper itself, to form the shape of the handkerchief.

1. Chobunsai Eishi, *The Courtesan Itsutomi Holding the Plectrum for a Samisen Which Lies Behind Her*, collection of the Victoria and Albert Museum.

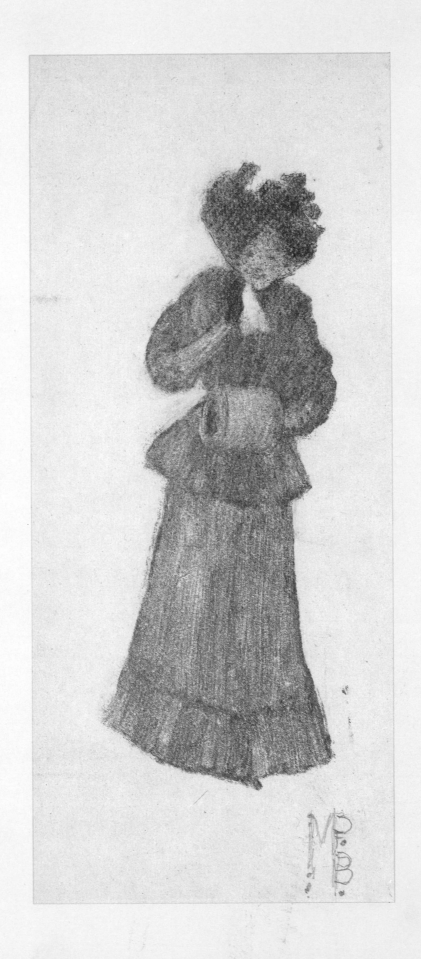

5. *Green Dress*

9⅞ x 5 inches (25.1 x 12.7 cm.) (plate); 11 x 8⁷⁄₁₆ inches (28 x 21.4 cm.) (sight)
Signed (at lower left, in green crayon over pencil): M/B/P
Probably executed about 1891–1894

Exhibited: Davis, 1963, no. 12; Davis & Long, 1979, no. 7, illus. on p. 41 (as private collection)

Possibly exhibited: Cincinnati, 1901–1902, as no. 61, 62, or 63 (as *Girl in Green*)

Ex coll: estate of the artist, until 1963; to Davis Galleries, New York, 1963; to private collection, from 1963 until 1982; to Davis & Langdale Company, New York, 1982; to Daniel J. Terra

This back view of a standing woman surely dates from much the same time as *Lady with Umbrella* (no. 3) and *Lady with Handkerchief* (no. 4), pictures with which it shares many general characteristics. The subject—a modishly attired lady—is the same, as is the scale of the figure, and the careful delineation of costume detail; the complicated shapes of puffed sleeve, curling boa, and flower-like hat are distinctly outlined against the plain background of the white paper itself. The palette of *Green Dress* differs from that of the other two pictures in that it is noticeably brighter; here, the brown haired woman's dress is bright green, her boa a slightly darker green, and her decorative hat crimson.

While there is no known exact prototype for this composition, such subjects abound in Prendergast's work of the early 1890s. *Lady on a Wet Day (Paris)*[1], a finished watercolor of an isolated standing woman, bears an obvious relationship to *Green Dress*. Similar figures also appear repeatedly in the sketchbooks of this time, for example, in the *Boston Sketchbook*[2] and in the *Boston Public Garden Sketchbook*.[3]

1. collection of Miss Antoinette Kraushaar, illus. in *Davis & Long 1975* as no. 31.
2. e.g., pp. 33, 69, 95.
3. e.g., pp. 2, 5, 8, 9, 10.

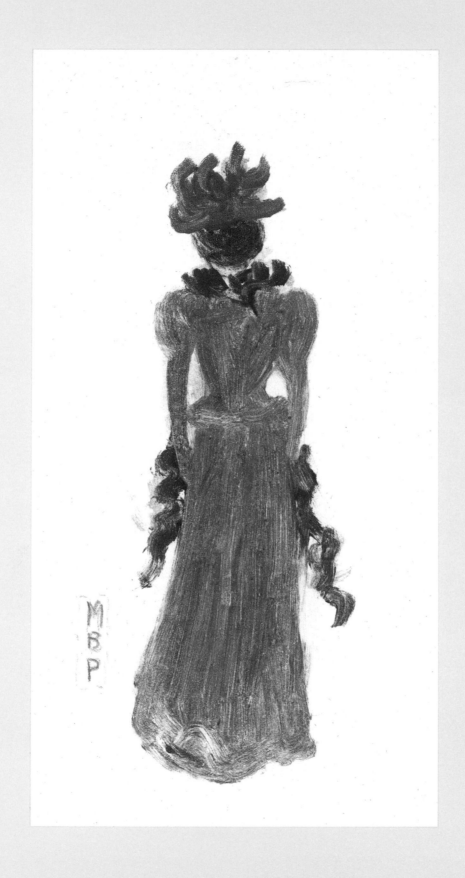

6. *Red Haired Lady with Hat*

13¾ x 9¼ inches (34.9 x 23.5 cm.) (sight)
Signed (at lower left, in the plate): MBP (monogram)
Probably executed about 1891–1894

Exhibited: Davis & Long Company, New York, 1977, *Maurice Prendergast: Art of Impulse and Color* (lent by Mr and Mrs Ralph Spencer, not in catalogue); Davis & Long, 1979, no. 8, illus. on p. 42, illus. in color on p. 18 (as collection of Mr and Mrs Ralph Spencer)

Possibly exhibited: Cincinnati, 1901–1902, as no. 61, 62, or 63 (as *Girl in Green*)

Ex coll: estate of the artist, until 1977; to Davis & Long Company, New York, 1977; to Mr and Mrs Ralph Spencer, from 1977 until 1982; to Davis & Langdale Company, New York, 1982; to Daniel J. Terra

This is probably the second pull and another monotype of the same title[1] is probably the first pull from the same plate.

In *Red Haired Lady with Hat*, the subject is yet again a single standing figure silhouetted against a plain background. This figure is larger in scale than that in *Green Dress* (no. 5), but the two pictures are similar in palette. Here, the woman's dress is painted in two shades of green, one rather bright, the other slightly darker; her hair is red; the floral ornaments on her lavish hat are red and orange; and her buckled shoes are dark green. Her figure has a particular air of animation, afforded it by her gesture of gathering up her skirt in both hands preparatory to walking. Like *Green Dress*, this monotype bears a distinct general resemblance to a number of Prendergast's pictures of the early 1890s; it is especially like the watercolor *Lady in a Green Dress*[2] and the monotype *Lady in Purple*[3]; in those three pictures, the scale and pose of the figures and placement of those figures on the sheets are comparable; even the form and positioning of the signature monograms are the same.

Red Haired Lady with Hat is one of two impressions from the same plate. It is so strong that, without evidence to the contrary, one would probably assume it to be a first pull. In fact, the two pictures are not very different in intensity; presumably this equality of strength was achieved by varying the amount of pressure applied to the plate during the transfer processes: i.e., very little during the first, and rather more during the second, printing.

1. present location unknown, sale, Sotheby Parke Bernet, Inc., November 13-14, 1979, illus. as lot 489 and in color as frontispiece. That the Terra Museum picture is the second pull and the Sotheby picture the first is only supposition because the two impressions have never actually been examined together.

2. private collection, illus. in *Davis & Long 1979* as fig. 2, p. 39.

3. *Ibid.*, illus. as no. 5, collection of Robert Brady.

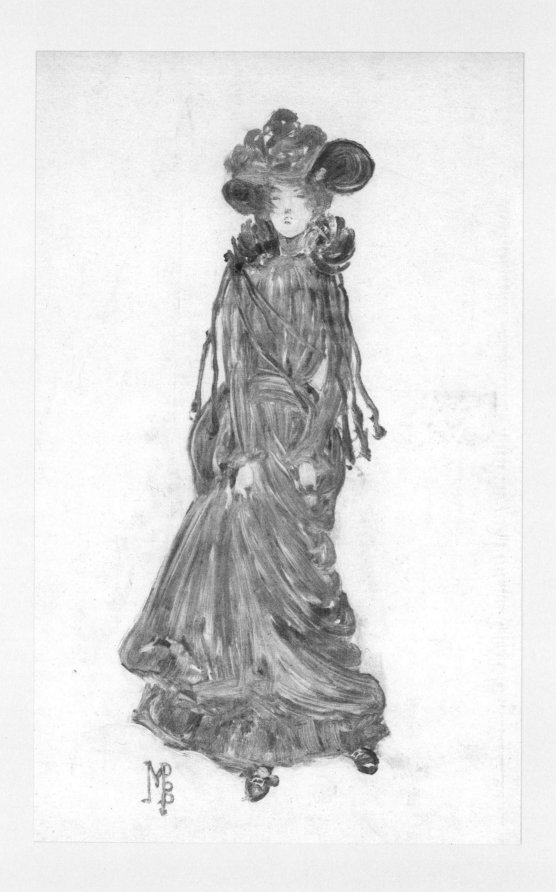

7. *Primrose Hill*

7⅜ x 5⁹⁄₁₆ inches (18.7 x 14.1 cm.) (image)
Signed and inscribed (at bottom, in the plate): Primrose Hill Prendergast
Probably executed about 1891–1894

Exhibited: Addison, 1938, no. 104 (as lent by C.W. Kraushaar Art Galleries, New York)

Probably exhibited: Kraushaar, 1936, no. 1; Corcoran, 1937, no. 27

Possibly exhibited: Cincinnati, 1901–1902, no. 46, 47, or 48 (as *Primrose Hill*)

Ex coll: estate of the artist, until 1938; via C.W. Kraushaar Art Galleries, New York, to Sidney Licht, from 1938; to private collection, by descent, until 1982; to Davis & Langdale Company, New York, 1982; to Daniel J. Terra

 This is the first pull and *Primrose Hill No. 2* (no. 8) is the second pull from the same plate.

 The combination of a carefully detailed architectural backdrop with an animated crowd of foreground figures is one favored by the artist; it is a theme which recurs time and again in his work. Prendergast's original inspiration may well have been that group of pictures painted by James McNeill Whistler in the 1880s and 1890s known as the "shopfront" series, one of which is *A Chelsea Shop* (fig. 3); *Primrose Hill* shares many of the characteristics of that painting.

 The palette of this monotype is a rich, warm one, composed of earth colors: reds and browns, accented with touches of black and green. In the foreground of the picture is a cluster of little girls; behind them is the façade of a red brick building, its surface enlivened by the geometrical patterns of its windows and doors.

 Prendergast did several prints which he titled *Primrose Hill*.[1] One of that group[2] is more fully inscribed "Primrose Hill London," an indication that all these pictures are views of the area of that city just north of Regent's Park. The artist's first European trip in the summer of 1886 was to England but these pictures are probably evidence of a later, unrecorded visit, presumably made during the course of Prendergast's 1891–1894 residence in France. (Another hint of such a trip is his drawing titled *A Street Scene in London*, which was reproduced in 1893 in *The Studio*.)

 Touches of pencil define the skirt and the left arm of the child in spotted dress in the foreground of *Primrose Hill*; no such additions have been made to its second pull, *Primrose Hill No. 2* (no. 8).

1. among them *The Lady with Dog—Primrose Hill*, collection of Mr and Mrs Ira Glackens, illus. in *Davis & Long 1979* as no. 12; and *Primrose Hill*, collection of Mr and Mrs Joseph T. Meals, illus. as no. 13, *Ibid.*.
2. present location unknown, illus. in *Prints*, vol. 7 (June 1937), on p. 267.

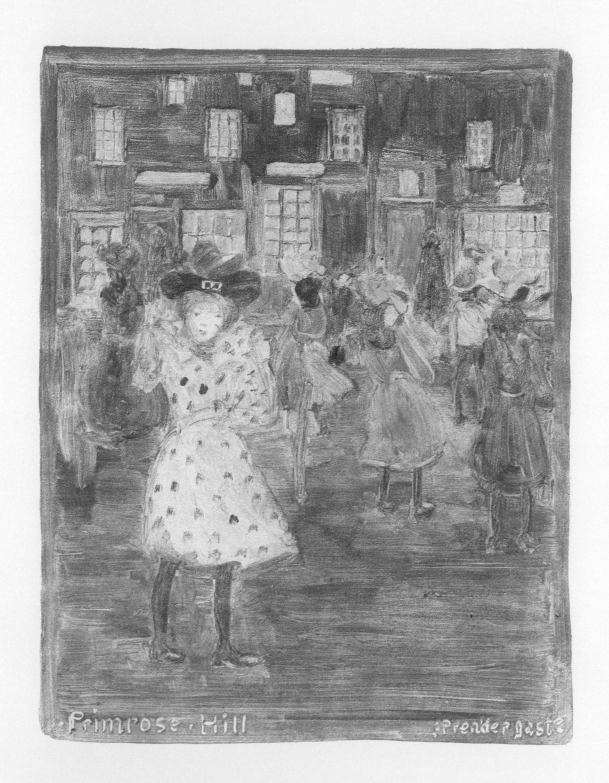

Primrose·Hill ·Prendergast·

8. *Primrose Hill No. 2*

7⅜ x 5⁹⁄₁₆ inches (18.7 x 14.1 cm.) (image)
Signed and inscribed (at bottom, in the plate): Primrose Hill Prendergast
Probably executed about 1891–1894

Exhibited: Bard, 1967, no. 7 (as collection of Mr and Mrs Walter Ress); Davis & Long, 1979, no. 14, illus. on p. 48 (as collection of Miriam and Walter Ress)

Possibly exhibited: Cincinnati, 1901–1902, no. 46, 47, or 48 (as *Primrose Hill*); Kraushaar, 1956 (catalogue unnumbered)

Ex coll: Kraushaar Galleries, New York, to Mr and Mrs Walter Ress, until 1982; to Davis & Langdale Company, New York, 1982; to Daniel J. Terra

This is the second pull and *Primrose Hill* (no. 7) is the first pull from the same plate.
See note to no. 7.

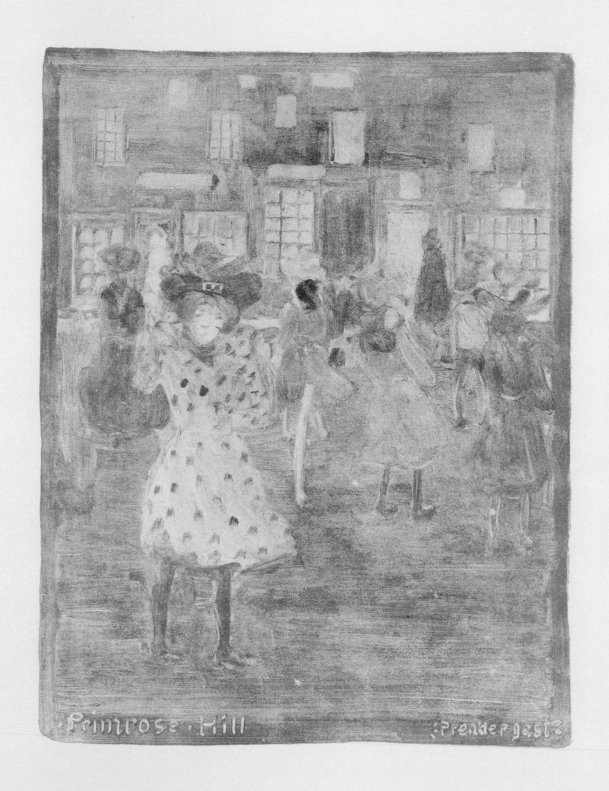

Primrose Hill Prendergast

9. *Children in Street*

8⅝ x 5¾ inches (21.9 x 14.6 cm.) (image); 8¹⁵⁄₁₆ x 5⅞ inches (22.7 x 14.9 cm.) (plate); 13⅛ x 9⅝ inches (33.3 x 24.4 cm.) (paper)
Signed (at lower left, in the plate): M/B/P
Probably executed about 1891–1894

Exhibited: Davis & Long, 1979, no. 15, illus. on p. 15 (as collection of Mr and Mrs Sanford I. Feld); Museum of Art, The Pennsylvania State University, University Park, Pennsylvania, and Aspen Center for the Visual Arts, Colorado, 1981, *Selections from the Collection of Mimi and Sanford Feld*, no. 23, illus.

Ex coll: Mrs Winthrop Bushnell, New Haven, Connecticut; to private collection, by descent, until 1978; to Davis & Long Company, New York, 1978; to Mimi and Sanford Feld, from 1978 until 1982; to Davis & Langdale Company, New York, 1982; to Daniel J. Terra

This is the first pull and *Going to School* (no. 10) is the second pull from the same plate.

This monotype is rather similar in palette to *Primrose Hill* (no. 7) and *Primrose Hill No. 2* (no. 8); it is painted in rich earth tones of red and brown, enlivened by accents of white and of green. Based on its great likeness to yet another print so inscribed by the artist[1], this too is probably a view of that London area known as Primrose Hill.

A sheet in the *Boston Sketchbook*[2] may have served as the prototype for *Children in Street*. The relationship between the sketch and the monotype is too general to term the former a study for the latter; it is not nearly as close, for example, as that between p. 57 of the same sketchbook and *Crescent Beach* (no. 22). The exigencies of monotype making impose certain limitations upon the artist; Prendergast probably had to work in his studio because of the celerity with which paint dries outdoors. As he could not work from life, he presumably referred to his source material—that is, his sketchbooks—for points of departure. That may be what he did here. The sketchbook watercolor is a night view of a street, populated by figures in black. It utilizes the extreme one-point perspective seen in this monotype; furthermore, one of its figures is virtually identical in both posture and placement to the running child in the far left foreground here.[3]

Children in Street is artfully organized. The insistent one-point perspective combines with the zigzag arrangement of the figures to compel the viewer's eye to move up the picture. The verticality of the composition, its abstract patterning, and the simplification of its palette all testify to Prendergast's familiarity with Japanese prints.

There is a very considerable amount of "back of the brush" drawing in *Children in Street*; that is, the artist created fine negative lines by removing paint with the sharp point of his brush handle. Almost all of the figures and trees here are so outlined.

The second pull from the same plate, *Going to School* (no. 10), differs from *Children in Street* in two respects; it is perceptibly paler and it has a pencil border added by the artist on the sheet itself to define its periphery.

1. *Primrose Hill*, collection of Mr and Mrs Joseph T. Meals, illus. in *Davis & Long 1979* as no. 13.

2. p. 18.

3. This kind of figure might almost be said to be a convention of the time; a similar running child appears in the Toulouse-Lautrec lithograph *Cover for "L'Étoile Rouge" by Paul Leclerc* (illus. in *Toulouse-Lautrec* as p. 298). That lithograph was executed in 1898 and hence postdates *Children in Street* by several years.

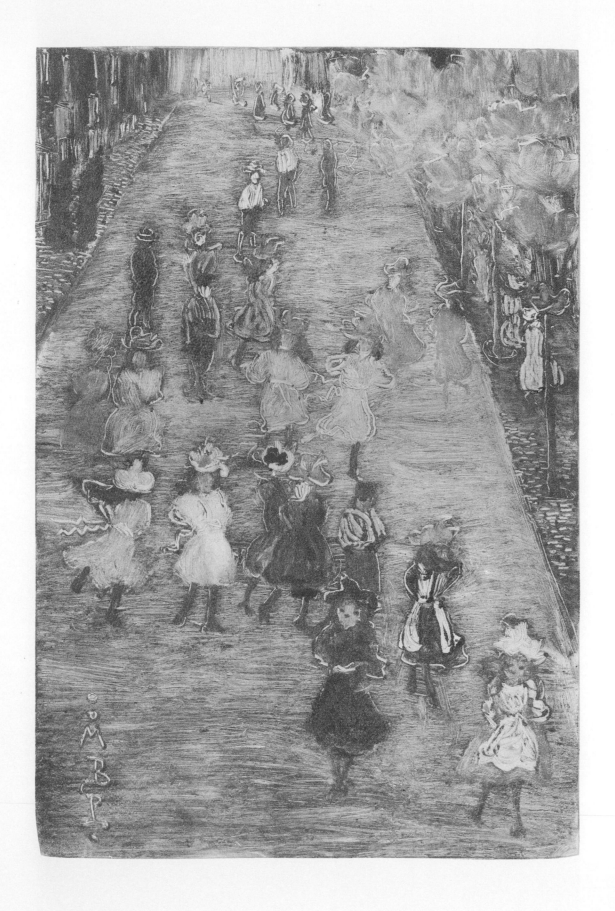

10. *Going to School*

8⅝ x 5¾ inches (21.9 x 14.6 cm.) (image)
Signed (at lower left, in the plate): M/B/P
Probably executed about 1891–1894

Exhibited: Bard, 1967, no. 16 (as lent by Mr and Mrs Matthew Phillips); Davis & Long, 1979 (as private collection, not in catalogue)

Ex coll: Mr and Mrs Matthew Phillips, as of 1967; to Kraushaar Galleries, New York; to private collection, from about 1972 until 1980; Joshua Strychalski, New York, 1980; to Hom Gallery, Washington, D.C., from 1980 until 1982; to Daniel J. Terra

 This is the second pull and *Children in Street* (no. 9) is the first pull from the same plate. See note to no. 9.

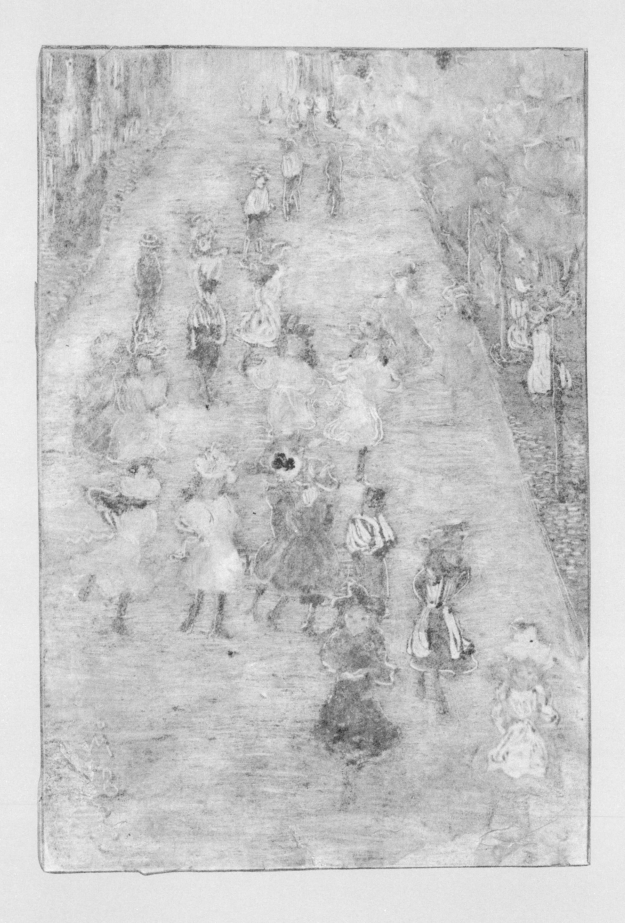

11. *Street Scene*

8⁹⁄₁₆ x 12³⁄₈ inches (21.8 x 31.4 cm.) (image)
Signed (at center, in lintel of window, in the plate): M B Prendergast
Probably executed about 1891–1894

Recorded: David Tunick, Inc. (1977), *Nineteenth and Twentieth Century Prints* (catalogue no. 9), no. 182, illus., detail illus. in color on cover

Exhibited: Davis & Long, 1979, no. 16, illus. on p. 16, illus. in color on p. 20 (as collection of David Tunick); The Metropolitan Museum of Art, New York and Museum of Fine Arts, Boston, Massachusetts, 1980–1981, *The Painterly Print: Monotypes from the Seventeenth to the Twentieth Century*, no. 53, illus. (as collection of Mr and Mrs David Tunick)

Ex coll: Macbeth Gallery, New York; Robert H. Tannahill, Detroit, Michigan; Hirschl & Adler Galleries, Inc., New York, as of about 1975; to David Tunick, until 1984; to Davis & Langdale Company, New York, 1984; to Daniel J. Terra

This is the first pull and *Street Scene, Boston*[1] is the second pull from the same plate. However, because the artist reworked the plate before making the second impression, the two pictures vary quite considerably in their details.

Street Scene is executed in rich tones of red, brown, and green, accented with touches of white. Like *Primrose Hill* (no. 7) and *Primrose Hill No. 2* (no. 8)[2], this monotype in its composition is rather reminiscent of the shopfront pictures of James McNeill Whistler (see fig. 3). A throng of figures congregates in a rather shallow space before a red brick building, the façade of which is enlivened by the counterplay of the vertical and horizontal lines of its door and many windows. In the foreground, further vertical accents are provided by a street lamp and two trees.

1. private collection, illus. in *Davis & Long 1979* as no. 17.
2. Dr Richard Wattenmaker has kindly pointed out its relationship to the Prendergast monotype *Horseback Riders*, no. 25, illus. in color as pl. II, p. 27, in Alain G. Joyaux, *The Elisabeth Ball Collection of Paintings, Drawings, and Watercolors: The George and Frances Ball Foundation* (1984).

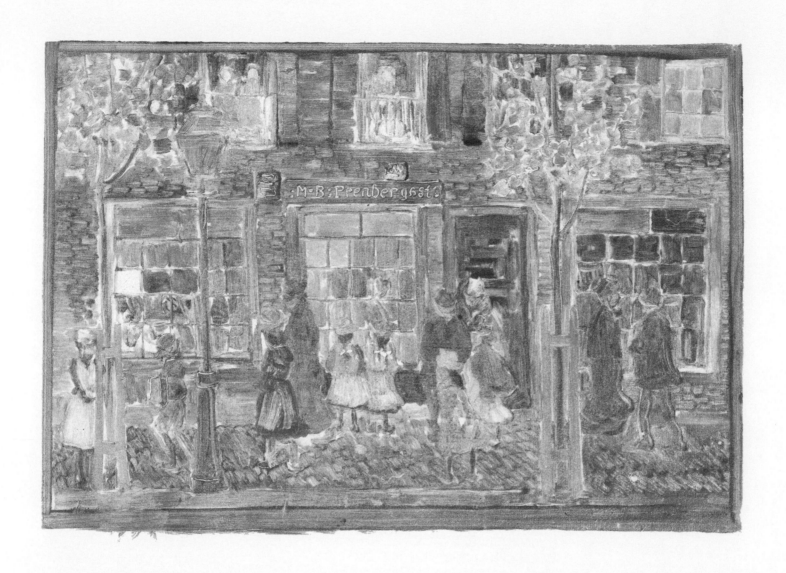

12. *Skipping Rope*

5¹¹⁄₁₆ x 10⅛ inches (12.9 x 25.7 cm.) (image)
Signed (at lower left, in the plate): M B P
Probably executed about 1892–1895

Exhibited: Davis & Long Company, New York, 1976, *American Painting* (not in catalogue); Davis & Long, 1979, no. 23, illus. on p. 57 (as private collection)

Ex coll: estate of the artist; via Kraushaar Galleries, New York, to Margarett Sargent McKean; Davis & Long Company, New York, 1976; to private collection, until 1982; to Davis & Langdale Company, New York, 1982; to Daniel J. Terra

This is the second pull and another monotype of the same name[1] is the first pull from the same plate. One or the other was almost certainly exhibited: Boston, 1898, no. 87; Corcoran, 1937, no. 1; Addison, 1938, no. 111.

In its limited palette composed of red and black, and in its decorative, flattened forms, *Skipping Rope* is clearly Nabiesque; perhaps its strongest affinity is to the work Bonnard was doing at precisely the same time.

There is surprisingly little variation in intensity between the two impressions of this monotype; both are comparatively muted. The appreciable difference between them is a result of the considerable amount of pencil work on the sheet of this, the second, pull (there is none on the first). Some of the graphite additions are for the purpose of redefining forms lost after the first transfer—in other words, to make the cognate look more like the first pull; the reinforcements of the children's faces and of the hair of the third and fourth figures from the right are in this category. However, there are also actual alterations made in pencil: for example, in the first pull, the second little girl from the right wears a red frock; in the cognate, that frock has become black. As a consequence, the weight of the central cluster of figures is perceptibly increased, changing the balance of the composition.

1. collection of Mr and Mrs Paul Mellon, illus. in *Davis & Long 1979* as no. 22.

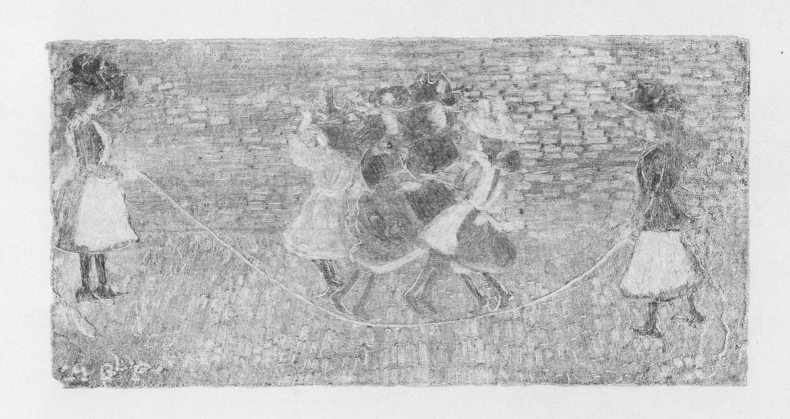

13. *Jumping Rope*

6⁹⁄₁₆ x 5³⁄₁₆ inches (16.7 x 13.2 cm.) (image); 11³⁄₄ x 10¼ inches (29.8 x 26 cm.) (paper)
Inscribed (at lower left, in red crayon, probably in a later hand): M B P
Probably executed about 1892–1895

Exhibited: Bard, 1967, no. 5, illus. (as lent by Mr and Mrs Matthew Phillips); Davis & Long, 1979, no. 26, illus. on p. 60, illus. in color on p. 21 (as Davis and Long Company)

Ex coll: Mr and Mrs Matthew Phillips, as of 1967; William Zierler, Inc., New York; private collection, New York, from about 1972 until 1978; to Davis & Long Company, New York, from 1978 until 1979; to private collection, from 1979 until 1982; to Davis & Langdale Company, New York, 1982; to Daniel J. Terra

While *Jumping Rope* is reminiscent of *Skipping Rope* (no. 12) because of their communality of subject matter, the two are quite unlike in color. *Skipping Rope* is noticeably muted, its palette limited to red and black. In this monotype, the little girl is attired in a white dress, a yellow hat with blue green ribbon, and bright blue green stockings; the building behind her is brown heightened with white, and the tree trunk is red. A considerable amount of pigment has been wiped away—for example, in the areas of the façade and the pavement—revealing the paper underneath. Much of the white is the paper itself and the balance is opaque pigment; the combination confers an unusual luminosity to *Jumping Rope*.

A figure very similar indeed to this child appears in the Toulouse-Lautrec lithograph *Au Bois*[1]; that picture was executed in either 1897 or 1899, thus postdating *Jumping Rope* by at least several years.

1. illus. in *Toulouse-Lautrec* on p. 255.

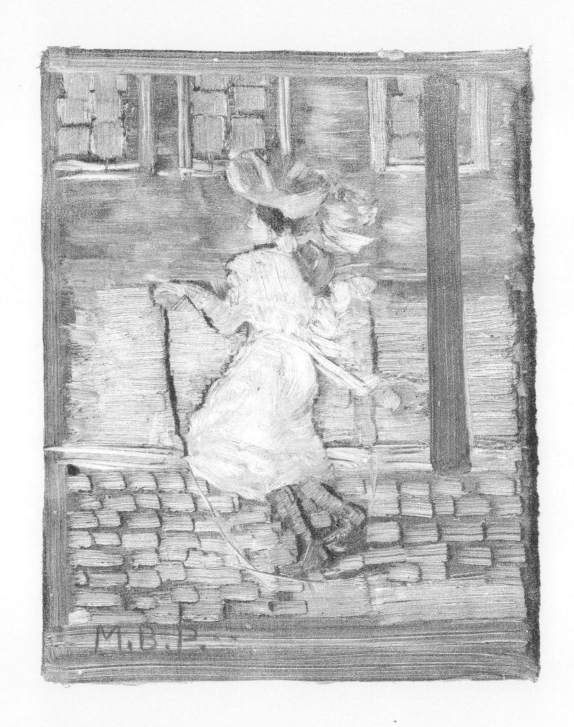

14. *Figures Along the Shore*

6⅞ x 4⅞ inches (17.5 x 12.4 cm.) (image); 11¼ x 10 inches (28.6 x 25.4 cm.) (paper)
Signed and dated (at lower right, in the plate): M B P 1895

Exhibited: Bard, 1967, no. 2, illus. on cover (as lent by Babcock Galleries, New York); Davis & Long, 1979, no. 33, illus. on p. 67 (as collection of Mildred and Howard Leeds)

Ex coll: Kraushaar Galleries, New York; private collection, until 1966; to Babcock Galleries, New York, from 1966 until 1967; to Jerome Hill; Davis & Long Company, New York, from 1975 until 1977; to Mildred and Howard Leeds, from 1977 until 1981; to Davis & Langdale Company, New York, from 1981 until 1982; to Daniel J. Terra

This is almost certainly the monotype listed in the Whitney papers as *Nahant*, in the collection of M.D.C. Crawford of New York, as of about 1946.

Figures Along the Shore, inscribed 1895 in the plate, is one of Prendergast's relatively rare dated monotypes. Its color is notably intense and its composition radically simplified and flattened: sky, sea, and shore are indicated by horizontally arranged bands of green and blue green. In its degree of abstraction it is strongly reminiscent of certain paintings by James McNeill Whistler, among them *Battersea Reach from Lindsey Houses*[1] and *Harmony in Blue and Silver: Trouville.*[2]

1. collection of the Hunterian Museum and Art Gallery, University of Glasgow, illus. in *Whistler 1980* as no. 55, pl. 33.
2. *Ibid.*, illus. as no. 64, pl. 38, collection of Isabella Stewart Gardner Museum.

15. *Children in Red Capes*

5^{11}/$_{16}$ x 6 inches (14.5 x 15.2 cm.) (image)
Signed and dated (at lower left, in the plate): M/B/P 1895

Exhibited: Davis & Long, 1979, no. 28, illus. on p. 62 (as Davis and Long Company)

Ex coll: estate of the artist, until 1978; to Davis & Long Company, New York, from 1978 until 1980; to private collection, from 1980 until 1982; to Davis & Langdale Company, New York, 1982; to Daniel J. Terra

This is the second pull and *Children in Red* (also known as *Three Little Girls in Red*)[1] is the first pull from the same plate. One or the other was exhibited: Boston, 1898, no. 85 (as *Three Little Girls in Red*).

Children in Red Capes is inscribed in the plate with the date 1895; of the very few monotypes by Prendergast that are dated, more come from that year than from any other (see also nos. 14, 16, and 19). Both in its composition and in its severely restricted palette of red, brown, and black, this picture is reminiscent of *Skipping Rope* (no. 12). Its patterns of carefully organized flattened shapes make it one of the most Nabiesque of Prendergast's prints. It is very particularly like some of Bonnard's work of the same time, especially his lithograph *The Laundry Girl* (fig. 18)[2] (which was executed the year after this monotype) and his tempera *Children Leaving School.*[3]

In *Children in Red Capes*, Prendergast has strengthened the man's top hat with pencil; otherwise it is identical to, except for being more muted than, the first pull from the same plate, *Children in Red.*

1. collection of the Museum of Fine Arts, Boston, illus. in *Davis & Long 1979* as no. 27.
2. collection of The Museum of Modern Art.
3. illus. in *Bonnard 1964* on p. 30, as collection of Lauder Greenway.

16. *Spring in Franklin Park*

10 x 7⅞ inches (25.4 x 20 cm.) (image)
Signed and dated (at bottom, in the plate): M B Prendergast 1895

Exhibited: Hirschl & Adler Galleries, New York, 1981, *America in Print: 1796–1941*, no. 83, pp. 85-86, illus. in color on p. 86

Probably exhibited: Addison, 1938, no. 120 (as lent by Charles Prendergast)

Ex coll: private collection, until 1981; to Sotheby Parke Bernet, Inc., sale, February 18-20, 1981, lot 655, illus. on page 279, detail illus. in color on cover; to Hirschl & Adler Galleries, New York, from 1981 until 1982; to Daniel J. Terra

This is the first pull and *Picnic in the Park*[1] is the second pull from the same plate.

According to the Sotheby catalogue, the consignor of *Picnic in Franklin Park* acquired the picture directly from the artist's brother Charles Prendergast.

Picnic in Franklin Park is notably strong in color (as, indeed, is even the second pull from the same plate); in it, the vivid greens of the grass and trees are accented by the brownish black trunks and pink blossoms of those trees, and by the black, brown, and white dresses and hats of the little girls. In this monotype, Prendergast has relied to an unusual degree upon the "back of the brush" technique; most of the figures are outlined and much of the foliage delineated in that manner.

1. private collection, illus. in *Davis & Long 1979* as no. 29.

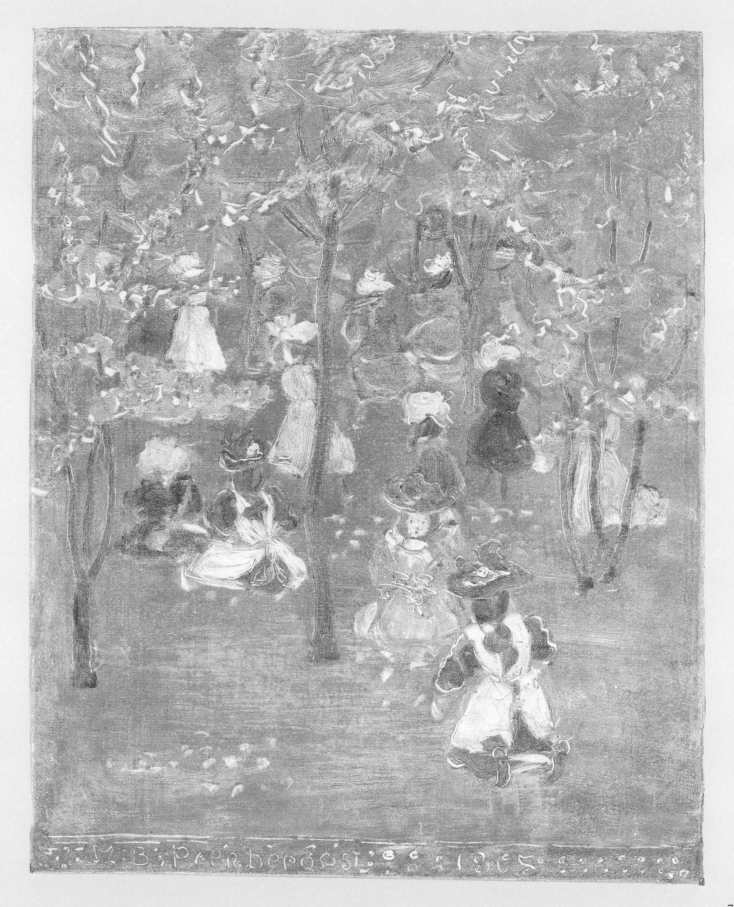

17. *Three Sketches: Springtime, Lady in Red, Little Girl in Red*

13¼ x 10¼ inches (33.6 x 26 cm.) (sight)
Signed (at lower right of *Springtime*, in the plate): M/B/P; (at upper right of *Lady in Red*, in the plate): M/B/P
Probably executed about 1895

Ex coll: estate of the artist, until 1983; to Daniel J. Terra

This picture is a second pull; a first pull of the image on the left, *Springtime*, known by the same title, is in a private collection.[1] The first impressions of *Lady in Red* and *Little Girl in Red* (assuming they were not discarded by the artist) have not yet been located.

On this sheet, there are three quite discrete images: *Springtime*, *Lady in Red*, and *Little Girl in Red*. In Prendergast's monotype *œuvre*, *Six Sketches of Ladies*[2] is the only other known example of his treating the plate in this fashion, that is, as if it were a sketchbook page. The question arises of the artist's intention: was it to keep such sheets intact, or was it to separate them? In each of these two instances, the composition certainly appears to have been conceived as a whole, for its various components form a pleasingly balanced arrangement on the sheet. There are, however, multiple signatures: three monograms on the Sturgis monotype (one linked to each of the upper figures), and two here (one on *Springtime*, the other on *Lady in Red*). Furthermore, while *Six Sketches of Ladies* and this picture are both intact, the artist did cut up another pull from this plate; a separate first impression of *Springtime*[3] is in a private collection. Neither a first pull of *Lady in Red* nor one of *Little Girl in Red* has been located; those may well have been discarded by Prendergast. Just as, without knowledge of the Terra Museum picture, one would never have suspected the other *Springtime* of having been separated by the artist from a bigger page, so may other known monotypes have once been part of larger sheets.

Although undated, *Three Sketches* was surely executed about 1895, for the *Springtime* component is very closely related to two dated prints of that year, *Children Playing in the Park*[4] and *Spring in Franklin Park* (no. 16).

1. illus. in *Davis & Long 1979* as no. 32.
2. *Ibid.*, illus. as no. 9, collection of Katharine Sturgis.
3. *Ibid.*, illus. as no. 32.
4. *Ibid.*, illus. as no. 30, present location unknown.

18. *Children at Play*

6^{13}/$_{16}$ x 4^{15}/$_{16}$ inches (17.4 x 12.5 cm.) (image); 9^{7}/$_{8}$ x 7^{7}/$_{8}$ inches (25.1 x 20 cm.) (plate); 15^{1}/$_{2}$ x 11 inches (39.4 x 27.9 cm.) (paper)
Signed (at upper left, in the plate): MBP (monogram); inscribed (at bottom center, in pencil, in the hand of either the artist or of his brother Charles Prendergast): Children at Play
Executed about 1895

Exhibited: Bard, 1967, no. 38 (as *Children Playing in the Park*)

Ex coll: estate of the artist, probably until about 1950; to Kraushaar Galleries, New York; to private collection, until 1983; to Davis & Langdale Company, New York, 1983; to Daniel J. Terra

This picture is the second pull and *Children in the Park*[1] is the first pull from the same plate.

Although itself undated, *Children at Play* is so extremely similar in both palette and composition to a dated monotype of 1895, *Children Playing in the Park*[2], that it may be confidently ascribed to the same time. This impression is slightly more muted than, but otherwise unchanged from, *Children in the Park*, the first pull from the same plate.

The composition of *Children at Play* is reminiscent of that of *Children in Street* (no. 9); as in that picture, here, too, the figures are deployed in a subtle zigzag formation which is calculated to draw the viewer's eye from the bottom to the top of the sheet. Its flattened, decorative patternings, its vertical format, even its intricate signature monogram, are evidence of the inspiration of Japanese prints.

1. collection of Mrs Jacob M. Kaplan, illus. in *Davis & Long 1979* as no. 31.
2. *Ibid.*, illus. as no. 30, present location unknown.

19. *Circus Scene with Horse*

4¾ x 6½ inches (12 x 16.5 cm.) (image)
Signed, dated, and inscribed (at lower right, in the plate): 1895 The Circus MBP (monogram)

Exhibited: Davis & Long, 1979, no. 36, illus. on p. 70 (as private collection)

Possibly exhibited: Cincinnati, 1901–1902, as no. 41, 42, 43, or 44 (as *The Circus*)

Ex coll: estate of the artist; to Kraushaar Galleries, New York; private collection, until 1965; to Davis Galleries, New York, 1965; to private collection, from 1965 until 1982; to Davis & Langdale Company, New York, 1982; to Daniel J. Terra

This is the first pull and another monotype of the same title[1] is the second pull from the same plate.

Circus Scene with Horse is one of the relatively rare dated monotypes; like nos. 14, 15, and 16, it comes from the year 1895. As a rule, the subjects of Prendergast's prints are those of his paintings and watercolors; that of the circus is unique to the medium of monotype.[2] There is a substantial body of prints with this motif; it includes *Bareback Rider* (no. 20); *Nouveau Cirque (Paris)* (no. 52); *Le Cirque*[3]; *Bareback Rider*[4]; *Circus Audience*[5]; *Circus Band*[6]; and *The Girl with the Drum*.[7] Because one of the pictures is so inscribed, we may perhaps assume that the Cirque Nouveau in Paris was the inspiration for the entire series. All of these monotypes are variations on a theme; in them, the same elements—horses, balloons, drums, cymbals, clowns, girls in tutus—recur, each time deployed in slightly different relationships to each other.

The palette of *Circus Scene with Horse* is a relatively restricted one, composed of whites and rich reds and browns accented with touches of green. This print and the second pull from the same plate differ from each other only in degree of strength.

1. present location unknown, sale, Sotheby Parke Bernet, Inc., November 13-14, 1979, illus. as lot 490.

2. the only other subject restricted to monotype appears to be that of an ocean liner at night, known as *The Ocean Palace*, of which there are only two treatments, one in the collection of The University of Iowa Museum of Art, illus. in *Davis & Long 1979* as no. 34, the other in the collection of Grey Art Gallery and Study Center, New York University Art Collection, illus. as no. 35, *Ibid.*.

3. *Ibid.*, illus. as no. 38, collection of the Museum of Fine Arts, Boston.

4. *Ibid.*, illus. as no. 39, collection of The Cleveland Museum of Art.

5. *Ibid.*, illus. as no. 40, collection of The Baltimore Museum of Art.

6. *Ibid.*, illus. as no. 41, private collection.

7. present location unknown.

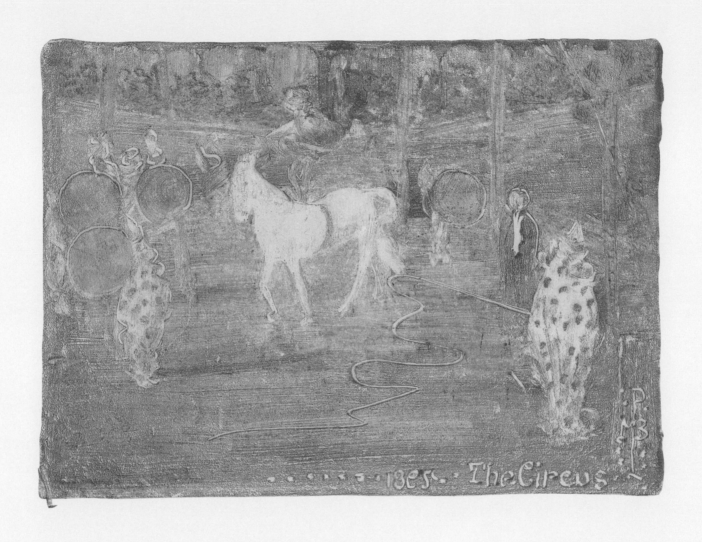

20. *Bareback Rider*

11¾ x 7½ inches (29.8 x 19 cm.) (image); 12⅜ x 8 inches (31.4 x 20.3 cm.) (sight)
Signed (at lower left): M B Prendergast
Probably executed about 1895

Exhibited: Davis, 1963, no. 41 (as lent by Mrs. Charles Prendergast)

Ex coll: estate of the artist, until 1983; to Daniel J. Terra

Like *Circus Scene with Horse* (no. 19), *Bareback Rider* is one of Prendergast's series of circus monotypes; it is a subject he treats only in that medium. As is that of no. 19, the palette of this picture is one of rich browns, reds, and greens. That composition is horizontal in shape while this is vertical; however, the two are created out of the same elements: a bareback rider on a white horse, clowns in voluminous costumes, flagpoles, an audience. *Bareback Rider* is even more closely related to another print of the same title.[1] Those two are akin in size, shape, and composition; in the Cleveland version, a clown with large drum replaces the standing girl in tutu seen in the foreground here. A pencil sketch in the *Large Boston Public Garden Sketchbook*[2], its orientation reversed, is the basis for the horse and rider in both these pictures.

1. collection of The Cleveland Museum of Art, illus. in *Davis & Long 1979* as no. 39.
2. Robert Lehman Collection, The Metropolitan Museum of Art, illus. in *Boston Public Garden Sketchbook* as p. 33.

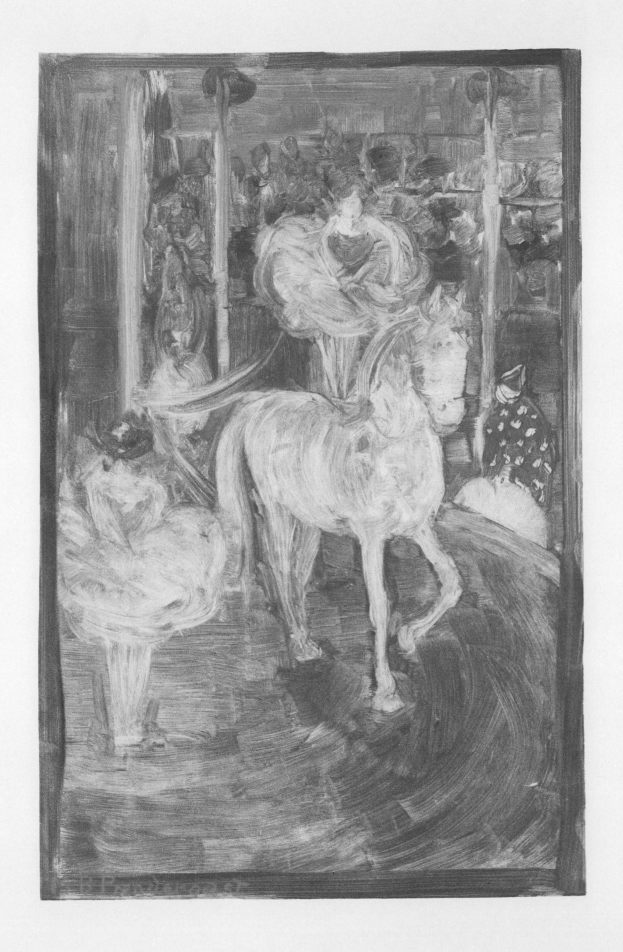

21. *Dress Rehearsal*

12¼ x 9 inches (31.1 x 22.8 cm.) (image); 13 x 9⅝ inches (33 x 24.4 cm.) (sight)
Signed and inscribed (at bottom, in the plate): Drees Rehersal [*sic*] M B Prendergast
Probably executed about 1895

Recorded: Davis & Long, 1979, no. 43, illus. on p. 77 (as private collection)

Exhibited: Boston, 1960–1961, no. 134, illus. (as collection of Ethel Reiner)

Ex coll: Ethel Reiner, as of 1961; R.M. Light and Company, Boston, Massachusetts, as of 1971; private collection, until 1982; to Davis & Langdale Company, New York, 1982; to Daniel J. Terra

Dress Rehearsal, unlike *Circus Scene with Horse* (no. 19), *Bareback Rider* (no. 20) and *Nouveau Cirque (Paris)* (no. 52), is not, strictly speaking, a circus picture; however, it certainly may be seen as an extension of that category, for it shares compositional elements—girls in tutus, flagpoles—with those monotypes. This is one of only two known prints of ballet dancers; the other, to which it is extremely closely related, is *Rehearsal*.[1] As similar as these two pictures are, there are still perceptible differences between them for the figures have been shifted about slightly, changing the relationships among them. *Dress Rehearsal* is virtually monochromatic; it is executed almost entirely in tones of rusty red, with only the addition of touches of brown.

1. collection of The Museum of Modern Art, illus. in *Davis & Long 1979* as no. 42.

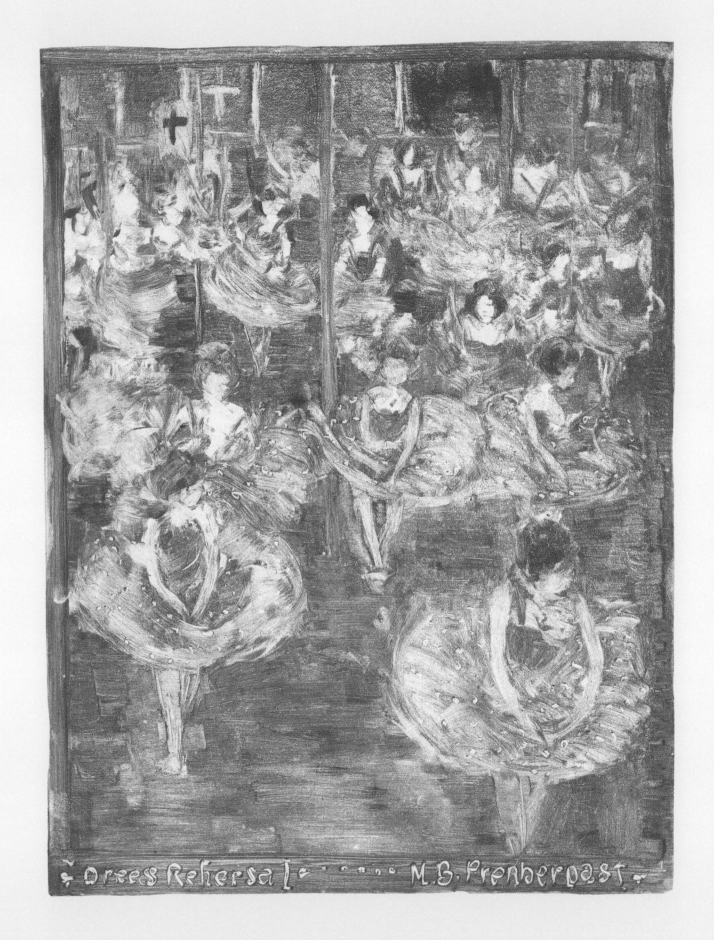

Dress Rehersal · · · · · · M. B. Prenderpast ·

22. *Crescent Beach*

10 x 4⅜ inches (25.4 x 11.1 cm.) (plate and image)
Signed (at lower left): M Prendergast
Probably executed about 1895–1896

Exhibited: Bard, 1967, no. 9; Davis & Long, 1979, no. 45, illus. on p. 79 (as private collection)

Probably exhibited: Kraushaar, 1936, no. 21; Addison, 1938, no. 91; Kraushaar, 1956 (catalogue unnumbered)

Ex coll: estate of the artist; to C.W. Kraushaar Art Galleries, New York, until at least 1944; to private collection, until 1982; to Davis & Langdale Company, New York, 1982; to Daniel J. Terra

According to the Whitney papers, this picture was in the possession of Kraushaar Galleries in January 1944, when it was examined there.

A sheet in the *Boston Sketchbook* (fig. 8)[1] is the basis for the composition of *Crescent Beach*. That watercolor sketch is taken from life and the monotype corresponds to it in virtually every detail. Several minor differences between the two pictures do exist: the monotype orientation is the reverse of that of the watercolor (that reversal having occurred, of course, in the transfer from plate to paper); the little girl's hand, here shown resting in her lap, is raised to her lips in the study; and the palette has altered slightly, the girl's dress, lavender in the watercolor, becoming red in the monotype.

On the basis of stylistic evidence, it seems reasonable to assume that the monotype was done not long after the watercolor, and the watercolor can be firmly dated to about 1895–1896. A *terminus ante quem* is supplied by the artist's Paris sojourn, which did not end until either late 1894 or early 1895; and a *terminus post quem* is provided by the geography of the beach, which in about 1896 was altered by the construction of a new esplanade.[2]

1. p. 57.
2. Peter Wick, "Critical Note" in *Boston Sketchbook*, p. 16.

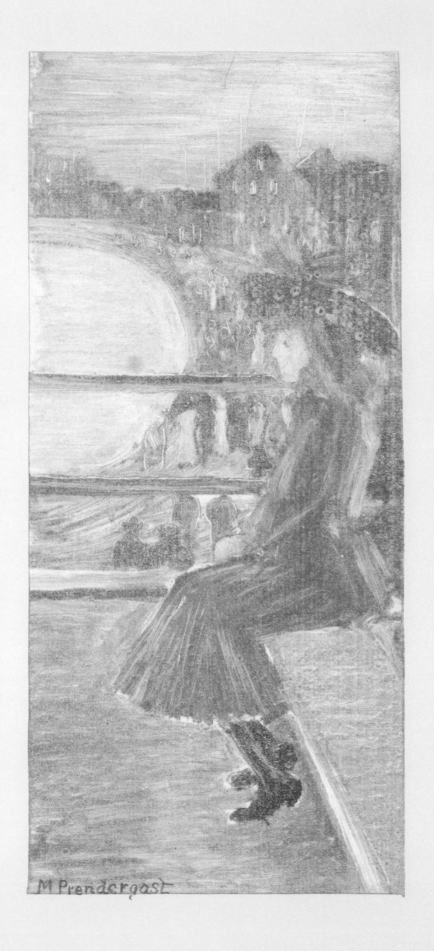

23. *Evening, South Boston Pier*

10 x 5 inches (25.4 x 12.7 cm.) (image); 14⁷⁄₁₆ x 8¹⁵⁄₁₆ inches (36.7 x 22.7 cm.) (paper)
Signed (at lower right, in the plate): MBP (monogram); signed and inscribed (at bottom, in ink over pencil): EVENING SOUTH BOSTON PIER M B P
Probably executed about 1895–1896

Exhibited: Davis & Long, 1979, no. 46, illus. on p. 81 (as Davis and Long Company)

Probably exhibited: Cincinnati, 1901–1902, as no. 33, 34, or 57 (as *Evening on the Pier*)

Possibly exhibited: Addison, 1938, no. 114 (as *South Boston Pier*)

Ex coll: private collection, until 1978; to Kraushaar Galleries, New York, 1978; to Davis & Long Company, New York, from 1978 until 1979; to private collection, from 1979 until 1982; to Davis & Langdale Company, New York, 1982; to Daniel J. Terra

Evening, South Boston Pier may be compared to two watercolor views of the same serpentine pier, one of which (fig. 6) is dated 1896[1], and to a pastel of the subject dated 1895.[2] The four compositions vary considerably in detail, but their general similarity is surely sufficient to insure that the second, undated watercolor[3] and this monotype must come from much the same time. In all four pictures there is a calculated balance of round (the curve of the pier) and vertical (the lampposts and the bridge struts) forms. *Bareback Rider* (no. 20), as dissimilar as it is to these pictures in subject matter, has much the same kind of compositional organization; there, the round forms of the circus ring itself (echoed by the circular tutus, and by the clown's drums) are counterpoised by the insistent verticals of the flagpoles.

The female figure in the foreground of the pastel *South Boston Pier: Sunset* is in precisely the pose of the woman in this monotype (though reversed); the two may well derive from a common prototype.

1. *South Boston Pier*, collection of the Smith College Museum of Art.
2. *South Boston Pier: Sunset*, illus. in *Boston 1960–1961*, as no. 57, collection of Mr and Mrs Donald G. Crowell.
3. private collection, illus. in *Davis & Long 1979* as fig. 4, p. 80.

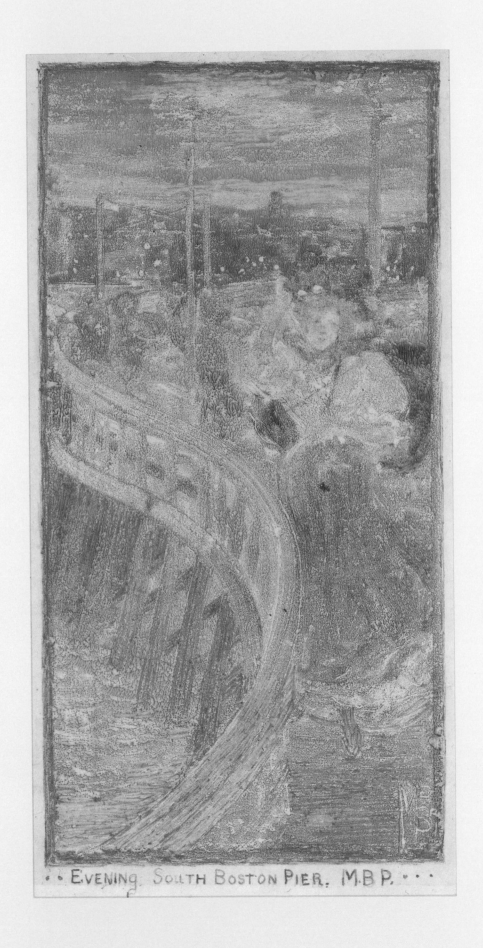

· · EVENING SOUTH BOSTON PIER. M.B.P. · · ·

24. *Lady with Umbrella*

9⅛ x 6⅛ inches (23.2 x 15.5 cm.) (image); 9⅜ x 6⁵⁄₁₆ inches (23.8 x 16 cm.) (sight)
Inscribed (at lower left, in pencil, probably in a later hand): M B P
Probably executed about 1895–1897

Exhibited: Bard, 1967, no. 33 (as collection of Mr and Mrs George Lewis); Davis & Long, 1979, no. 47, illus. on p. 82 (as collection of Mr and Mrs George Lewis)

Probably exhibited: Kraushaar, 1956 (catalogue unnumbered)

Ex coll: estate of the artist; to Kraushaar Galleries, New York, until 1957; via Walden School, New York, to Mr and Mrs George Lewis, from 1957 until 1982; to Davis & Langdale Company, New York, 1982; to Daniel J. Terra

The pervasive tonality of *Lady with Umbrella*, a rich greenish blue, is one which establishes its nocturnal mood. In this picture, Prendergast reverts to the subject matter of his first monotype, *Esplanade* (no. 1), of half a dozen years earlier; certainly, it is far more sophisticated in execution than that print, but this, too, is a night view of a woman on an esplanade, a railing behind her, and light-reflecting water beyond that railing. Here, the artist has drawn a blue black line around the composition to contain it; then, in an unexpected and charming gesture, he has broken that border by sweeping the woman's skirt across it at right.

Lady with Umbrella was probably done at much the same time as *Evening, South Boston Pier* (no. 23), and in certain respects is reminiscent of it. Both monotypes are thematic in color; that picture is a pervasive greyish blue, evocative of the twilight hour there depicted. Their compositions are similar, and the scale and placement of the large figures alike.

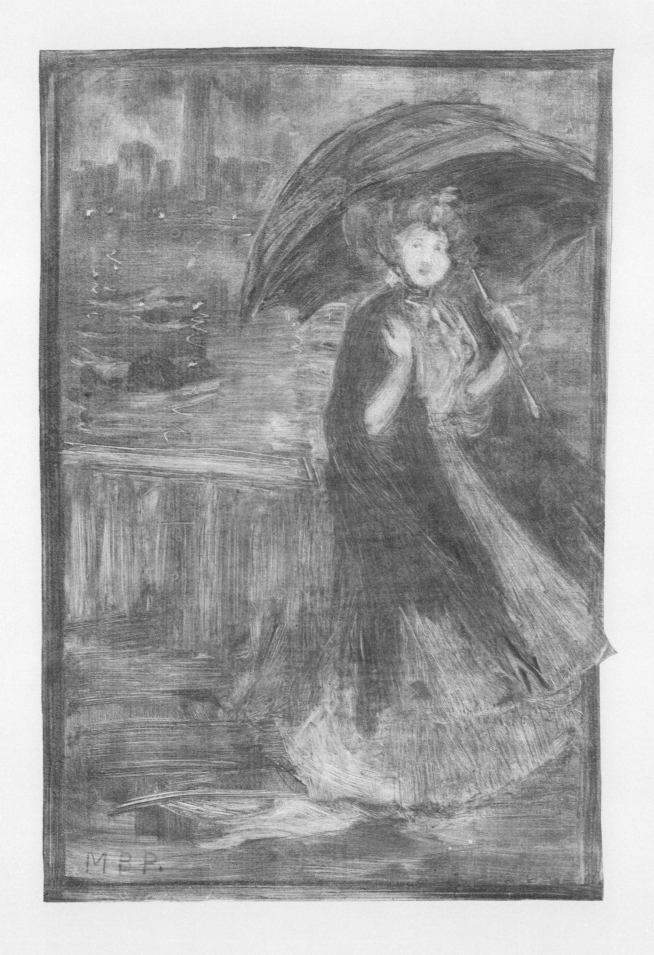

25. *Street Scene*

6⅜ x 10³/₁₆ inches (16.2 x 25.9 cm.) (sight)

Signed (at lower right, in the plate): M/B/P
Probably executed about 1895–1897

Exhibited: Davis Galleries, 1963, no. 44 (as lent by Mr and Mrs Walter Fillin); Bard, 1967, no. 46 (as lent by Mr and Mrs Walter Fillin); Smithsonian, 1972, no. 3 (as lent by Mr and Mrs Walter Fillin); Davis & Long Company, New York, 1976, *American Painting*, no. 27, illus.; Davis & Long, 1979, no. 48, illus. on p. 83 (as Davis and Long Company)

Probably exhibited: Kraushaar, 1956 (catalogue unnumbered)

Ex coll: estate of the artist; Kraushaar Galleries, New York, until 1956; to Mr and Mrs Walter Fillin, from 1956 until 1975; to Davis & Long Company, New York, from 1975 until 1979; to private collection, until 1982; to Davis & Langdale Company, New York, 1982; to Daniel J. Terra

Like *Evening, South Boston Pier* (no. 23) and *Lady with Umbrella* (no. 24), this Boston street scene is thematic in color. In this instance, the pervasive tonality is a rich brown, which is accented by the warmth of the yellow trolley lights and the yellow and orange illuminated windows at right.

The subject of this monotype—a strictly frontal view of a street—is one shared with an earlier picture, *Children in Street* (no. 9) (and its cognate, *Going to School* [no. 10]). However, the two are entirely different in execution. The earlier print is vertical in shape, and its verticality echoes and emphasizes its one-point perspective. This is a more traditional composition, the horizontal orientation of which counterbalances that same perspective, lessening its insistence. Furthermore, *Street Scene* displays none of the abstract patterings and flattening of forms characteristic of *Children in Street*.

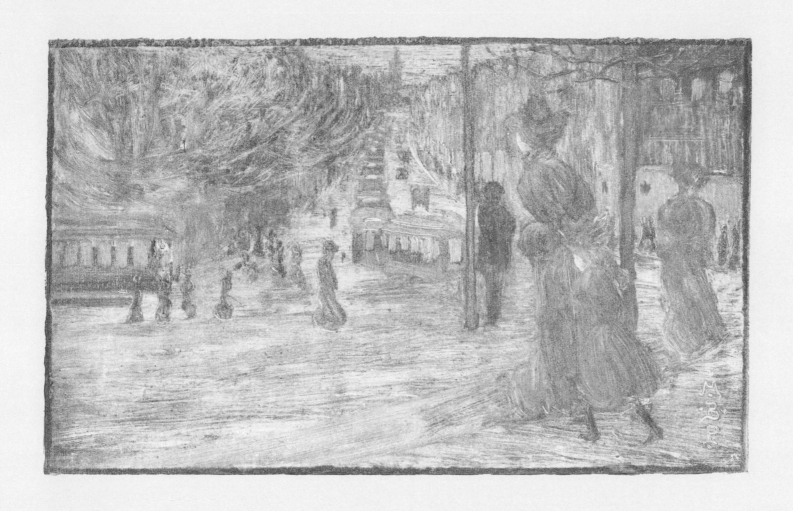

26. *Windy Day*

6¹⁄₁₆ x 9¹⁄₁₆ inches (15.4 x 23 cm.) (image and paper)
Signed (at lower left, in the plate): M/B/P; inscribed (at lower left, in red crayon, probably in a later hand): M B P
Probably executed about 1895–1897

Exhibited: Davis & Long, 1979, no. 49, illus. on p. 84 (as lent by the Rudin collection)

Probably exhibited: Kraushaar, 1956 (catalogue unnumbered)

Ex coll: Peter H. Deitsch, New York, as of 1956; to private collection; to the Rudin collection, until 1982; to Davis & Langdale Company, New York, 1982; to Daniel J. Terra

Windy Day is not dissimilar to *Street Scene* (no. 25) in its general conception, and it undoubtedly dates from about the same time as that monotype. The large foreground women are alike in scale and in their conveyance, by their postures, of a sense of incipient movement; the handling of the smaller background people is also much the same. The lady with boa in *Windy Day* is a familiar sight; comparable figures appear in several rather earlier prints, among them *Lady with Umbrella* (no. 3) and, even more particularly, *Gust of Wind*[1] and *The Black Cape*.[2]

Despite its traditional title, this picture is, in fact, a snowscape and, as such, is extremely unusual in Prendergast's *œuvre*. Its palette, presumably dictated by its subject, is also quite out of the ordinary, including as it does, whites and touches of bright blue, greenish yellow, and orange. In most of Prendergast's monotypes, whatever white is visible is usually that of the paper itself; here, he has used white pigment, which imparts an atypical opacity to *Windy Day*.

1. collection of Mr and Mrs Martin Atlas, illus. in *Davis & Long 1979* as no. 4.
2. *Ibid.*, illus. as no. 10, private collection.

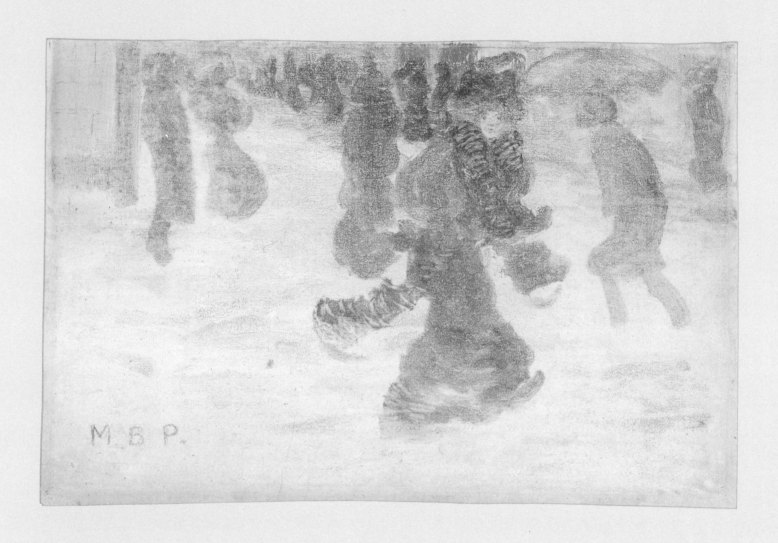

27. *Promenade*

7½ x 11⅝ inches (19 x 29.5 cm.) (image); 11¹⁄₁₆ x 14½ inches (28.1 x 36.8 cm.) (paper)
Signed (at lower left, in the plate): MBP (monogram)
Probably executed about 1895–1897

Exhibited: Bard, 1967, no. 22; Davis & Long, 1979, no. 53, illus. on p. 88, illus. in color on p. 23 (as private collection)

Possibly exhibited: Kraushaar, 1936, no. 11; Corcoran, 1937, no. 17; Addison, 1938, no. 97

Ex coll: estate of the artist; to Kraushaar Galleries, New York, until about 1948; Davis Galleries, New York; to private collection, from about the mid 1950s until 1979; to Davis & Long Company, New York, 1979; to private collection, New York, from 1979 until 1982; to Davis & Langdale Company, New York, 1982; to Daniel J. Terra

This is the first pull and *Afternoon Promenade*[1] is the second pull from the same plate.

In *Promenade*, women and children are seen idling on a shore, their figures disposed in a frieze-like order in the foreground, with water and sailboats behind. Those figures are large in scale in relation to the size of the sheet and each overlaps or is linked by gesture to the next. In its arrangement, this picture is quite unlike any other of Prendergast's monotypes. It is, however, an odd prefigurement of the late "tapestry" paintings (see, for example, fig. 15[2]), for its composition is precisely the one characteristic of those works. The palette of *Promenade* is a particularly colorful one of greens, reds, blues, and lavenders.

1. private collection, Amon Carter Museum of Western Art (1978), *American Impressionist and Realist Paintings and Drawings from the William Marshall Fuller Collection*, illus. as no. 46.
2. *The Grove*, collection of the Terra Museum of American Art.

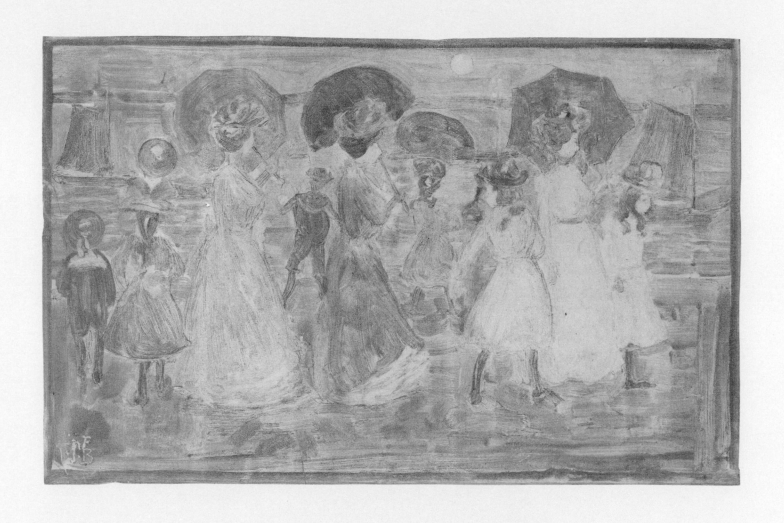

28. *The Breezy Common*

8⅟₁₆ x 6⅜ inches (21.1 x 15.7 cm.) (image); 10¹⁵⁄₁₆ x 8 inches (27.8 x 20.3 cm.) (paper)
Signed (at lower right, in the plate): Prendergast; inscribed (at lower left, in the plate): The Breezy
Common; signed and inscribed (in bottom margin, in pencil): To Walt Kuhn/from his friend/
Maurice Prendergast/Jan 1st 1921
Probably executed about 1895–1897

Exhibited: Bard, 1967, no. 30 (as lent by Dr and Mrs Irving Levitt)

Ex coll: the artist, until 1921; to Walt Kuhn, from 1921 until 1949; to estate of Walt Kuhn; to
Maynard Walker Gallery, New York; Dr and Mrs Irving Levitt, until 1982; to Kraushaar Galleries,
New York, 1982; to Davis & Langdale Company, New York, 1982; to Daniel J. Terra

The Breezy Common is one of a group of related monotypes, each of which bears the same title,
and each of which is so inscribed. That group includes no. 29 and its cognate, no. 30; other versions
are in the collections of Mr and Mrs Raymond J. Horowitz[1] and of the Philadelphia Museum of Art.[2]
The basic components are the same in all these pictures: a group of large figures in the foreground—
either two women and a child or one woman and a child—and a flock of little girls in the
background, all silhouetted against green grass and a sliver of blue sky. Although the components
remain more or less the same, the relationships among them shift slightly from picture to picture.

This monotype is the only one of the series in which the foreground group is composed of but a
pair of figures, those of a little girl and a woman. The woman is almost a replica of the two large
female figures at left in *Promenade* (no. 27). The bevy of children also reappears in several
monotypes outside this series, among them *Children at Play* (no. 18), a different work of the same
title[3], and *Balloons: Park on Sunday*.[4]

The prototype for all the Breezy Common pictures is a page in the *Boston Sketchbook*[5] which
was, of course, drawn from life.

1. *The Breezy Common*, illus. in *Davis & Long 1979* as no. 59.
2. *Ibid.*, *The Breezy Common*, illus. as no. 60.
3. *Ibid.*, illus. as no. 57, collection of The Brooklyn Museum.
4. *Ibid.*, illus. as no. 61, private collection.
5. p. 43; information kindly provided by Dr David Sellin.

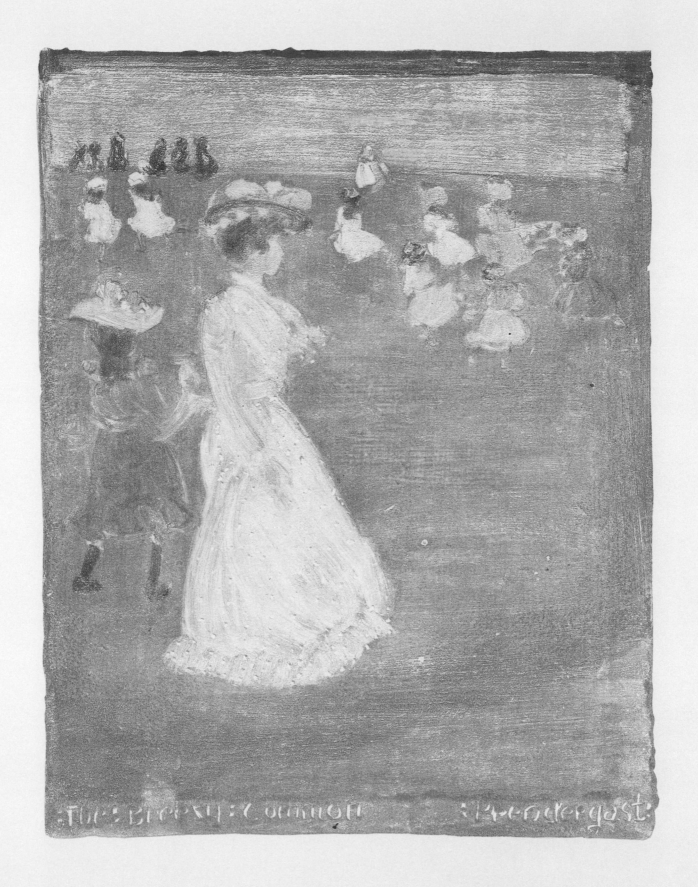

29. *The Breezy Common*

7 x 9 inches (17.8 x 22.8 cm.) (sight)
Signed (at lower right, in the plate): Prendergast; inscribed (at lower left, in the plate): The Breezy Common
Probably executed about 1895–1897

Exhibited: Smithsonian Institution Traveling Exhibition Service, 1976, *American Art in the Making: Preparatory Studies for Masterpieces of American Painting 1800–1900*, no. 68, illus.; Davis & Long Company, 1979, no. 58, illus. on p. 93 (as collection of Dr and Mrs David Sellin)

Ex coll: Mrs George W. (Sara Gilfey Ward) Knapp, Jr., Baltimore, Maryland, from at least 1924 until about 1962; Samuel T. Freeman and Company, Philadelphia, Pennsylvania, about 1962; to Dr and Mrs David Sellin, from about 1962 until 1982; to Davis & Langdale Company, New York, 1982; to Daniel J. Terra

This is the first pull and *The Breezy Common* (no. 30) is the second pull from the same plate. See note to no. 28.

Like no. 28, this is one of the series of Breezy Common monotypes. While it is patently closely related to that picture, this version varies from it in several respects, the most obvious of which is the shape of its composition; that picture is vertically and this one horizontally oriented. In no. 28, the foreground assemblage is composed of only two figures; here it is increased to three, a little girl and two women.

There are touches of pencil in the face of the woman on the right; there are no such pencil additions made to the cognate. The two also differ in degree of strength; the cognate is noticeably more muted than the extremely strong first pull.

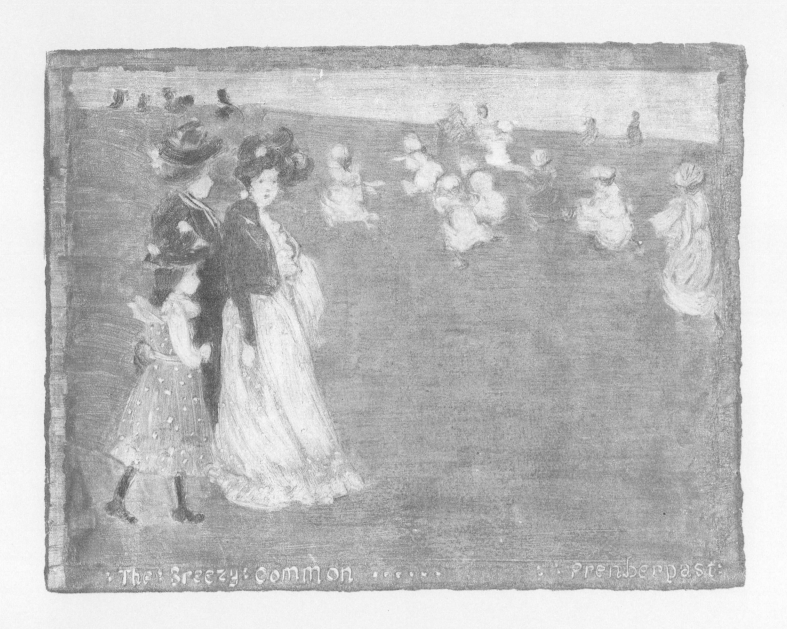

30. *The Breezy Common*

7 x 8¾ inches (17.8 x 22.2 cm.) (image)
Signed (at lower right, in the plate): Prendergast; inscribed (at lower left, in the plate): The Breezy
Common
Probably executed about 1895–1897

Recorded: Associated American Artists (1976), *American Master Prints IV, Bicentennial Collection, 1728–1910*

Exhibited: Maryland, 1976, no. 9, illus. on p. 91 (as lent by Associated American Artists, New York); Davis & Long, 1979, no. 107, illus. on p. 143 (as private collection, courtesy of Associated American Artists, Inc.)

Ex coll: Associated American Artists, Inc., New York, as of 1976; to private collection, until 1982; to Davis & Langdale Company, New York, 1982; to Daniel J. Terra

> This is the second pull and *The Breezy Common* (no. 29) is the first pull from the same plate. See notes to no. 28 and no. 29.

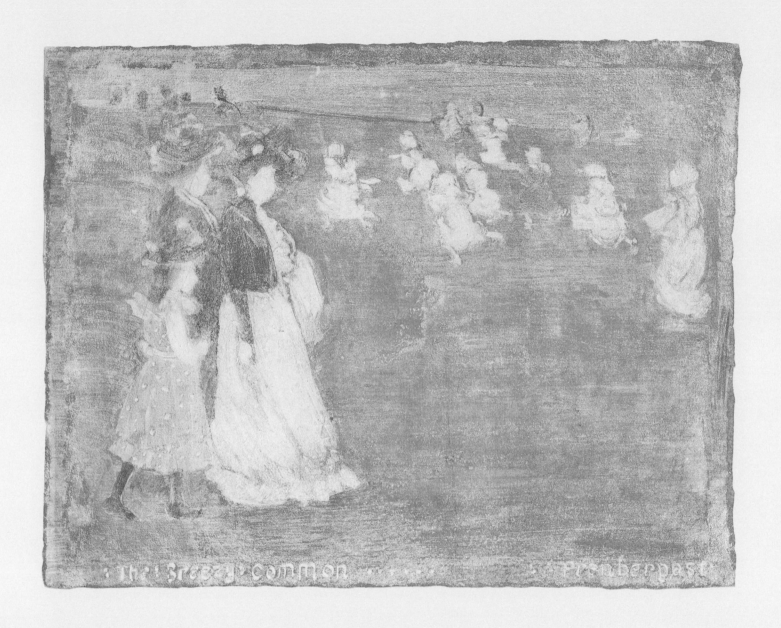

31. *Telegraph Hill*

14 x 14⅜ inches (35.5 x 36.5 cm.) (paper)
Signed (at lower left, in the plate): Prenbergast [*sic*]
Probably executed about 1895–1897

Possibly exhibited: Boston, 1901, no. 58 (as *Telegraph Hill I*); Cincinnati, 1901–1902, no. 39

Ex coll: Grace Nichols Strong and Charlotte Nichols Greene, Boston, Massachusetts; to a descendant, until 1982; to Sotheby Parke Bernet, Inc., sale, November 18, 1982, lot. 301, illus., and illus. in color on cover; to Daniel J. Terra

This view of Telegraph Hill and the Old Harbor in South Boston is the largest known monotype by Prendergast[1] and it is also one of the most polychromatic; its palette is made up of vivid reds, greens, blues, whites, yellows, and browns.

It is virtually identical both in composition and in palette to the painting *Telegraph Hill* (fig. 10)[2]; the only compositional difference between the two is that the sailboat in the center of the monotype exists but has been painted over (except for its upper sails) in the oil. Because its orientation is the same, the painting is certainly based upon the print.

The Shannon monotype of the same title is a closely related variant of this picture; the two were doubtlessly executed at very much the same time and were almost certainly exhibited together by the artist in 1901.[3] They are alike in size and in color and they are quite similar in composition. Both are views of a shore populated by women and children; a flagpole with American flag and other pennants stands behind those figures and in the water beyond are a number of square rigged boats. The Shannon print differs in several details: in it, there is a bench with seated figures in the foreground and a small building in the middle ground. Both monotypes relate to, and the Shannon monotype is surely directly based upon, the watercolor known as *Excursionists, Nahant*[4] which, judged on stylistic grounds, dates from about 1895–1897.

Telegraph Hill may also be compared to the monotype *The Pretty Ships*[5]; either that print or the painting of the same name upon which its composition is based[6] was exhibited in 1898[7], further evidence supporting the date assigned to this group of pictures.

1. It is equalled, but not surpassed, in size by two prints, *Telegraph Hill*, collection of Mr and Mrs Ogden K. Shannon, illus. in *Davis & Long 1979* as no. 105, and *Nouveau Cirque (Paris)* (no. 52). Because all three pictures have the same dimensions and proportions, it may be assumed that they were all done on the same plate.

2. collection of the Terra Museum of American Art.

3. *Boston 1901*, as no. 58, *Telegraph Hill I* and no. 73, *Telegraph Hill II*.

4. collection of The Metropolitan Museum of Art.

5. collection of the Museum of Fine Arts, Boston, illus. in *Davis & Long 1979* as no. 62.

6. *Ibid.*, illus. as fig. 6, p. 97, collection of the Museum of Fine Arts, Boston.

7. *Boston 1898*, no. 83.

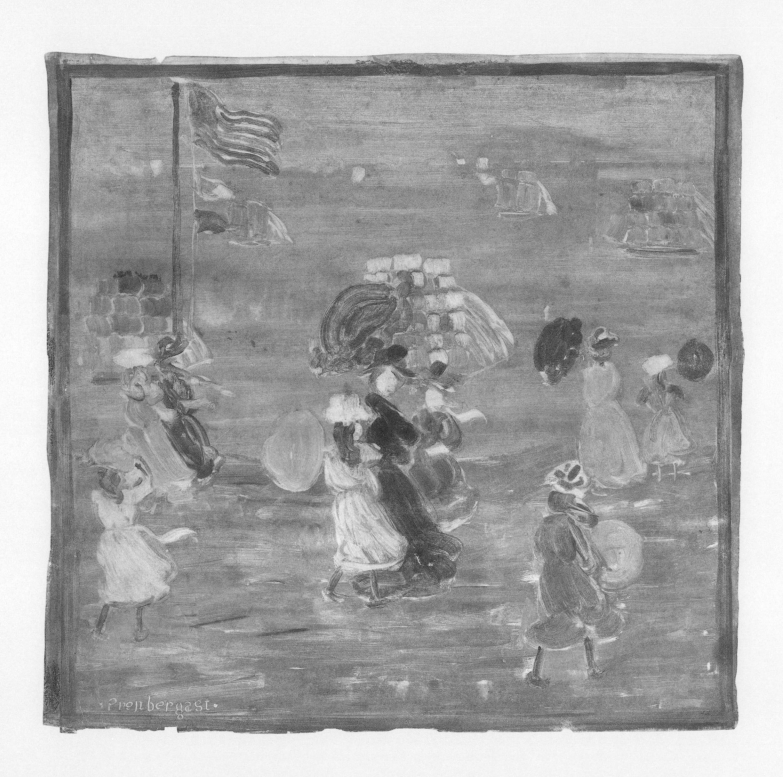

32. *Marine Park*

7⁷⁄₁₆ x 10⅛ inches (18.4 x 25.7 cm.) (sight)
Signed (at lower left, in the plate): MBP (monogram)
Probably executed about 1895–1897

Recorded: David Tunick, Inc. (1977), *Nineteenth and Twentieth Century Prints* (catalogue no. 9), no. 191, illus. in color

Exhibited; Davis & Long, 1979, no. 54, illus. on p. 89, illus. in color on p. 24 (as collection of David Tunick, Inc.)

Probably exhibited: Macbeth, 1900, no. 36 (as *Afternoon*); Chicago, 1900, no. 84 (as *Afternoon*); Kraushaar, 1936, no. 24; Corcoran, 1937, no. 15; Addison, 1938, no. 95

Ex coll: estate of the artist; Kraushaar Galleries, New York; Steven Straw Company, Inc., Newburyport, Massachusetts; David Tunick, Inc., New York, as of 1979; to private collection, from 1979 until 1984; to Davis & Langdale Company, New York, 1984; to Daniel J. Terra

This is probably the picture exhibited as no. 36, *Afternoon*, at Macbeth in 1900; although a catalogue for that show has not been found, a critic described *Afternoon* as being a view of "women and children on a bench" and having a "restful atmosphere." It is almost certainly the *Marine Park* listed in the Whitney papers as having been examined at Kraushaar in 1944. A monotype of this title was exhibited at Bard in 1967 as no. 13, collection of Mrs George L. Batchelder; however, that picture is catalogued as being signed at the lower right.

The palette of *Marine Park* is a notably bright one. Several figures are seen in profile, seated on a park bench: nearest are a little girl in white and a woman in black holding a brilliant red parasol; beyond this pair are two other women tending a wicker baby carriage which is shielded by another red umbrella. In the background, the deep blue water is dotted with white sail boats.

The composition of this monotype is very like that of a painting of several years earlier, *The Tuileries Gardens, Paris* (fig. 1).[1] There are also three similar watercolors on pp. 11, 21, and 28 of the *Boston Public Garden Sketchbook*.

1. collection of the Terra Museum of American Art.

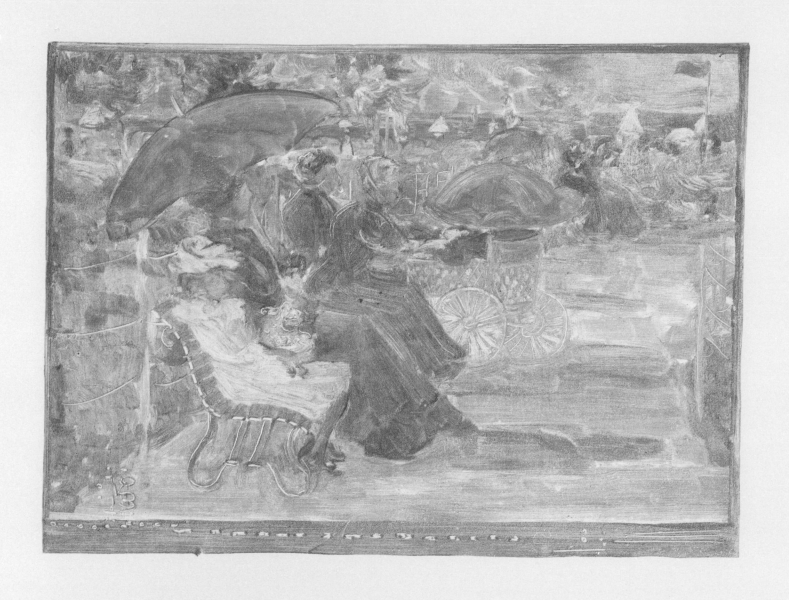

33. *The Opera Cloak*

8 x 4 inches (20.3 x 10.1 cm.) (image); 8¾ x 4⅞ inches (22.2 x 12.4 cm.) (sight)
Signed and inscribed (at bottom, in the plate): The Opera Cloak MBP (monogram)
Probably executed about 1898

Exhibited: Utah Museum of Fine Arts, University of Utah, Salt Lake City, 1976, *Graphic Styles of the American Eight*, no. 91, illus.; Maryland, 1976, no. 1, illus. on p. 12; Neuberger Museum, College at Purchase, State University of New York, 1977, *American Drawings and Watercolors*, no. 34, illus.; Davis & Long, 1979, no. 65, illus. on p. 101

Ex coll: estate of the artist; James U. Smith, Jr., Louisville, Kentucky; Kraushaar Galleries, New York, as of 1975; to private collection, from 1975 until 1982; to Davis & Langdale Company, New York, 1982; to Daniel J. Terra

This is the first pull and another monotype of the same title[1] is the second pull from the same plate. One or the other of the two impressions was probably exhibited: Boston, 1898, no. 84; Cincinnati, 1901–1902, no. 29.

During the course of his monotype career, Prendergast did a number of prints of single female figures. As a rule (to which there are certainly exceptions), in the earlier pictures there are no backgrounds, and the figures are silhouetted against the paper itself; see, for example, *Lady with Umbrella* (no. 3); *Lady with Handkerchief* (no. 4); *Green Dress* (no. 5); and *Red Haired Lady with Hat* (no. 6). The later monotypes, of which *The Opera Cloak* is one, tend to have painted backdrops. It (or its cognate) is surely the work exhibited in 1898[2] and that exhibition provides it with a *terminus post quem*. There are several dated monotypes to which *The Opera Cloak* may be compared, including *Lady with a Muff* (no. 45) of 1900; *Woman with Parasol*[3] of 1901; *Lady in Blue*[4] of 1901; and *The Red Jacket*[5] of 1901. It is also very like a more elaborate composition, *On the Corso, Rome* (no. 40); that print, like this one, is undated, but has to have been executed in about 1898–1899, when Prendergast was in Italy.

The palette of *The Opera Cloak* is a relatively subdued one: the yellow haired model stands before a grey background; she wears a grey dress, red cloak, green umbrella, and black hat. Her features have been defined on the sheet in graphite. Those features, as is almost always the case in Prendergast's work, are extremely stylized (indeed, they are indicated by a kind of personal shorthand), expressing neither individuality nor emotion.

1. collection of A. Maynard, illus. in *Davis & Long 1979* as no. 66.
2. *Boston 1898*, no. 84.
3. collection of The Museum of Modern Art, illus. in *Davis & Long 1979* as no. 88.
4. *Ibid.*, illus. as no. 89, collection of the Museum of Fine Arts, Boston.
5. *Ibid.*, illus. as no. 90, private collection.

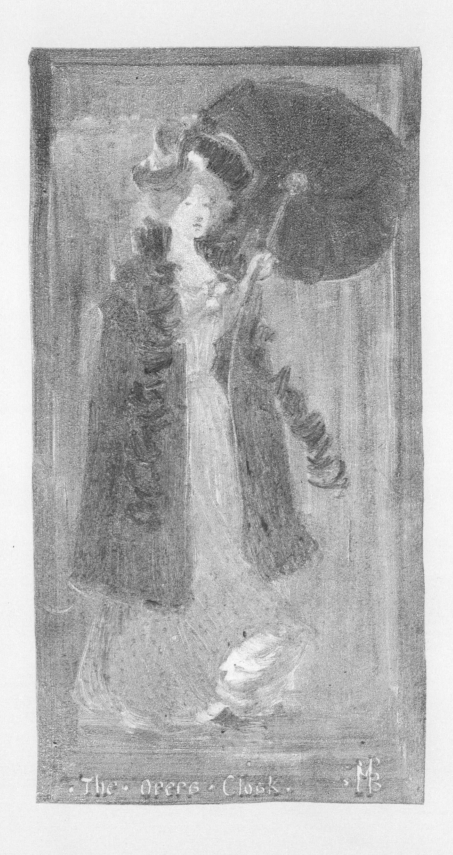

· The · Opera · Cloak · ⟨MB monogram⟩

34. *Venice*

10 x 7¾ inches (26 x 19.7 cm.) (image)
Signed (at lower left, in the plate): Prendergast
Executed about 1898–1899

Exhibited: Lowe Art Museum, University of Miami, Coral Gables, Florida, 1973, *In Search of the Present: The American Prophets*, no. 34; M.H. de Young Memorial Museum, San Francisco, California, 1977, *Inaugural Exhibition of the American Galleries*; Davis & Long, 1979, no. 68, illus. on p. 103 (as private collection, San Francisco)

Possibly exhibited: Kraushaar, 1936, no. 5

Ex coll: Mrs Grace LeRoy; Hirschl & Adler Galleries, Inc., New York; to Main Street Galleries, Chicago, Illinois; to private collection, San Francisco, California, from at least 1977 until at least 1979; to Joseph Faulkner, Chicago, Illinois, as of 1982; to Daniel J. Terra

This may be the monotype exhibited as *Calle dei Orbe* at Boston, 1899, as no. 107; and as *Calle dei Orbi* at Macbeth, 1900, as no. 11; Gedney Bunce purchased that picture from the latter exhibition.

Prendergast's first Italian sojourn of 1898–1899 is happily documented in monotype by a small group of Venetian and Roman subjects[1]; among those pictures are *Venetian Well* (no. 35); *Venetian Court* (no. 36); *Bella Ragazza: Merceria* (no. 37); *Festa del Redentore* (no. 38); *Monte Pincio (The Pincian Hill)* (no. 39); and *On the Corso, Rome* (no. 40).

It was in Venice that Prendergast stayed longest, and this monotype is an evocative view of an as yet unidentified but utterly characteristic calle in that city. *Venice* is a notably strong impression; its palette is composed predominantly of greens, which are accented by touches of yellow, brown, and red.

The shawled lady who appears twice here is almost a convention in Prendergast's Venetian pictures; she is seen, in varying poses, in both the monotypes—e.g., *Venetian Well* (no. 35) and *Bella Ragazza: Merceria* (no. 37)—and in the watercolors—for example, the Terra Museum *The Grand Canal, Venice* (fig. 12)—of this period. That figure does not occur in later Venetian pictures, nor even in other Italian views from this trip. The costume is presumably one particular to Venice and, indeed, Venetian women so garbed feature prominently in pictures of this era by other artists, among them *A Street in Venice*[2] and *Venetian Bead Stringers*[3] by John Singer Sargent.

1. although he certainly visited other Italian cities during this trip, Prendergast's monotypes are all of either Roman or Venetian subjects; there appears to be only one exception to this rule: *Girl from Sienna* (private collection, illus. in *Davis & Long 1979* as no. 67).

2. collection of The National Gallery of Art, Washington, D.C., illus. in Richard Ormond, *Sargent* (1970), as no. 28.

3. *Ibid.*, illus. as no. 21, collection of the Albright-Knox Art Gallery.

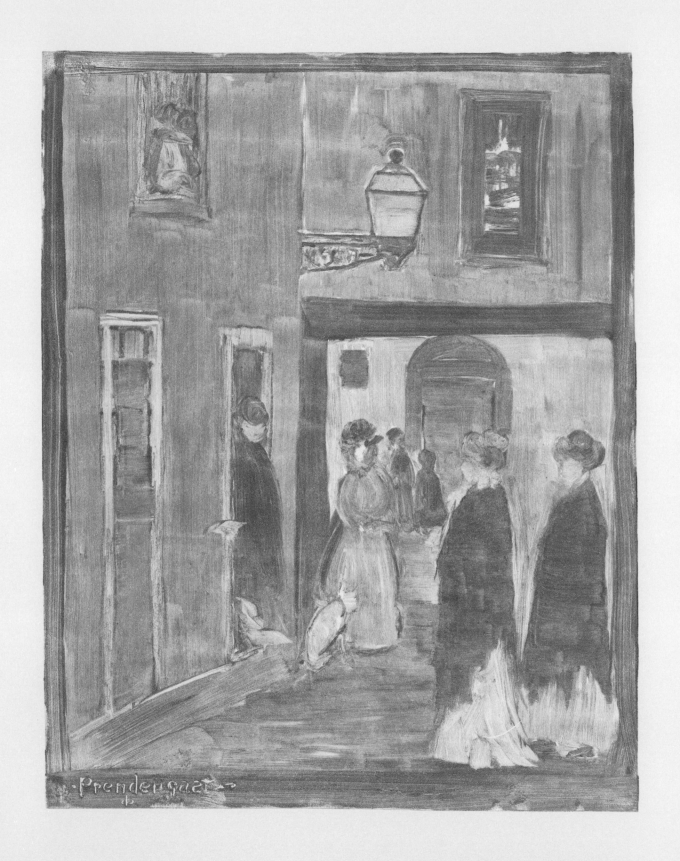

35. *Venetian Well*

7⅜ x 5¹¹⁄₁₆ inches (18.7 x 14.2 cm.) (image)
Inscribed (at lower right, in pencil, probably in a later hand): M/B/P
Executed about 1898–1899

Exhibited: Davis & Long, 1979, no. 69, illus. on p. 104 (as Davis and Long Company)

Ex coll: estate of the artist, until 1976; to Davis & Long Company, New York, from 1976 until 1980; to private collection, from 1980 until 1982; to Davis & Langdale Company, New York, 1982; to Daniel J. Terra

Like *Venice* (no. 34), this picture dates from (or, conceivably, from just after) Prendergast's first Italian trip of 1898–1899; and, like that picture, this view of a piazza records a typical but as yet unidentified corner of that city. It is relatively subdued in color, executed primarily in tones of brown, with touches of reddish brown and green. The shawled and pompadoured Venetian lady so prominent in no. 34 is seen here as well.

A brown painted border encloses this composition on three sides, but is lacking on the fourth, at right. *Venetian Well* is the left half of a composition the right portion of which survives in *Venetian Court* (no. 36). The two monotypes, when placed side by side (fig. 20), form a virtually continuous picture, only a tiny central sliver of which has been lost in the division. However, *Venetian Court* is probably a third pull and, as such, is a rather faint impression. *Venetian Well* is slightly stronger, and is obviously an earlier (the second) pull. A complete sheet combining the two halves has not been found nor is either the right side of the second impression or the left side of the third known to have survived. The brown border of *Venetian Court* is continuous, and is fully executed in the plate; hence, one may perhaps assume that the artist wiped away the left part of the composition and added the left border before pulling that impression.

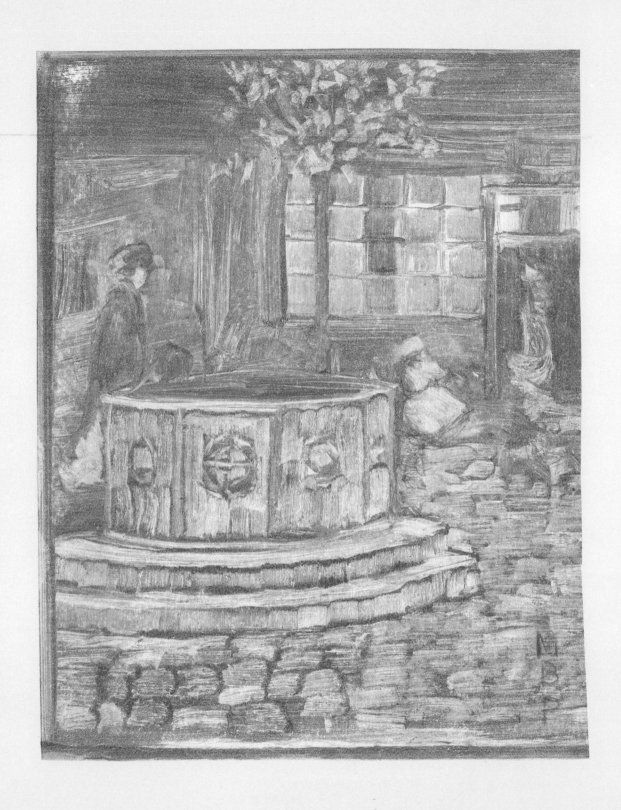

36. *Venetian Court*

7⅜ x 5⅞ inches (18.7 x 14.9 cm.) (image); 11 x 10 inches (27.9 x 25.4 cm.) (paper)
Illegibly inscribed (at lower left, in pencil)
Executed about 1898–1899

Ex coll: estate of the artist, until 1984; to Daniel J. Terra

See note to no. 35.
In this view of an unidentified Venetian street, several children stand in the foreground on a cobblestone pavement; at left is a little girl in red; at center is another small figure in black; and at right is a red haired child in black. In the background is the façade of a building with paned windows at left and right and a doorway between them. In that doorway stands a black garbed female figure, and to her left is a tree.

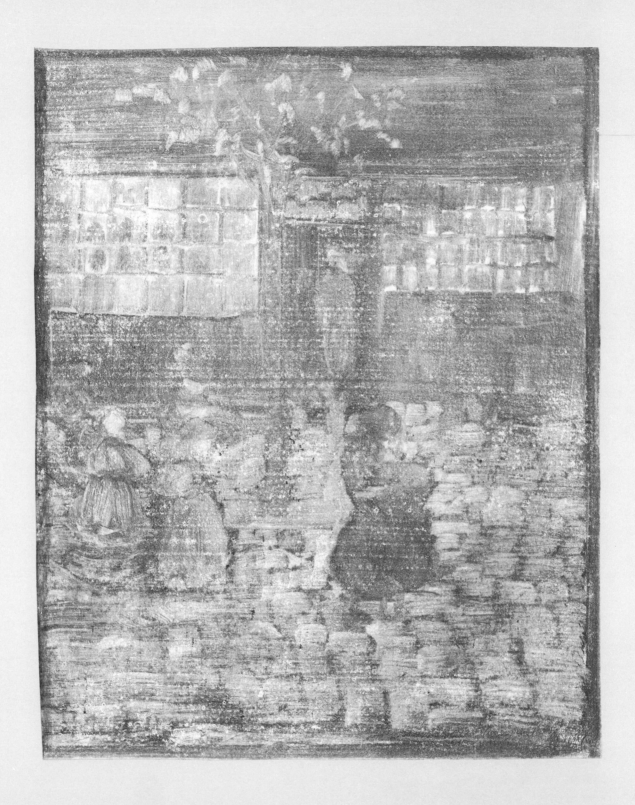

37. *Bella Ragazza: Merceria*

6 x 7¹⁄₁₆ inches (15.2 x 17.9 cm.) (image); 9 x 9⅞ inches (22.9 x 25.1 cm.) (paper)
Signed (at bottom center, in the plate): MBP (monogram); inscribed (at lower left, in the plate): Bella Regazza [*sic*]; (at lower right, in the plate): Merceria
Executed about 1898–1899

Ex coll: estate of the artist, until 1984; to Daniel J. Terra

Like nos. 34–36 and nos. 38–40, *Bella Ragazza: Merceria* dates from (or perhaps immediately after) Prendergast's Italian sojourn of 1898–1899. The setting is Venice: the Merceria was and is the main thoroughfare of that city, leading as it does from the Torre dell'Orologio (clock tower) of the Piazza San Marco directly to the Rialto Bridge.

The two figures in the foreground—the "beautiful girl" of the title at right and the person with her back turned at left—both wear the long black shawl seen so often on women in the Venetian pictures done on this trip. Between these two stand two little girls, their backs turned, one wearing a white frock and the other a red one. In the background is a frieze of black garbed figures behind which is the façade of a building, its many windowpanes executed in tones of orange and green.

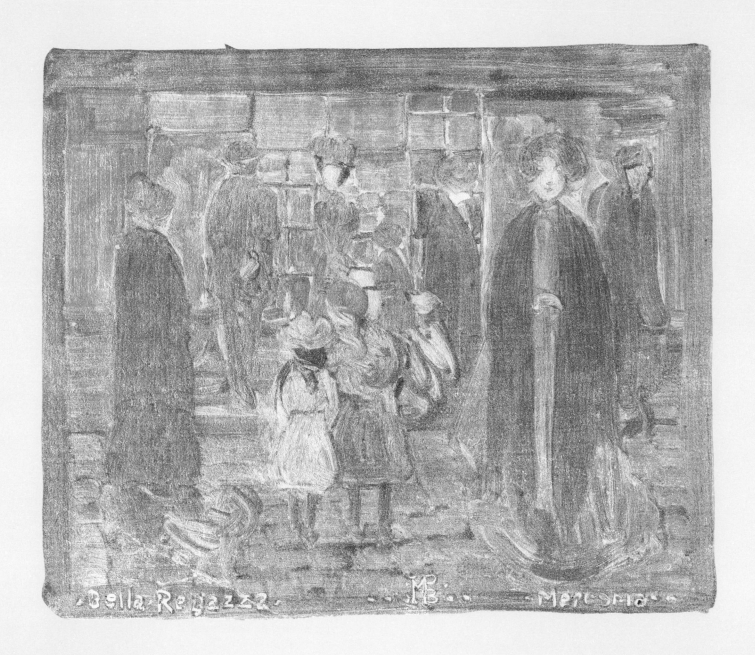

38. *Festa del Redentore*

12¼ x 7⅜ inches (31.1 x 18.7 cm.) (image); 13 x 7⅞ inches (33 x 19.7 cm.) (sight)
Inscribed (at lower right, in pencil, probably in a later hand): M B P
Executed about 1899

Ex coll: estate of the artist, until 1983; to Daniel J. Terra

The Festa del Redentore is one of the most joyous of Venetian holidays. Occurring each year on the third Sunday in July, it celebrates the city's liberation from the great plague epidemic of 1576. Two temporary bridges, supported by boats, are erected: one leads from San Marco to the famous Longhena church, Santa Maria della Salute (Saint Mary of Health, built to commemorate the same event), and the other from the Salute to the Giudecca. A fireworks display is held at night, and the canals are thronged with lanterned boats.

In this monotype, two women—one standing, the other seated—are in the foreground; behind them is one of the temporary bridges. The form of that pontoon bridge is taken directly from a pencil sketch, which was undoubtedly drawn from life.[1]

Prendergast did several other works titled *Festa del Redentore*, all of which are interrelated, and none of which is akin to this monotype. All of them are nocturnal views of lantern-illuminated boats on a canal. That group includes a monotype[2], a watercolor[3], and a mosaic[4]; another watercolor called *Festival Night, Venice*[5] also belongs to that series. A monotype titled *Fiesta, Venice*[6], of a fireworks display, surely as well depicts the Festa del Redentore.

Prendergast applied for a passport on June 29, 1898[7], and left for Europe (first France and then Italy) soon thereafter. Hence, it is perhaps more likely that all these pictures are based upon the Festa of 1899 rather than the one of 1898 which the artist may well not have arrived in Venice in time to see.

1. collection of Robert Brady, illus. in *Venice 1983* as no. 60 (as *Festa della* [sic] *Redentore*).

2. collection of John Brady, Jr., illus. in *Davis & Long 1979* as no. 73.

3. collection of Mrs Charles Prendergast, illus. in *Venice 1983* as no. 58 (as *Festa della* [sic] *Redentore*).

4. *Ibid.*, illus. as no. 59, collection of Mrs Charles Prendergast (as *Festa della* [sic] *Redentore*).

5. private collection, illus. in *Clark 1978* as no. 18.

6. private collection, illus. in *Davis & Long 1979* as no. 74.

7. *Maryland 1976*, p. 38.

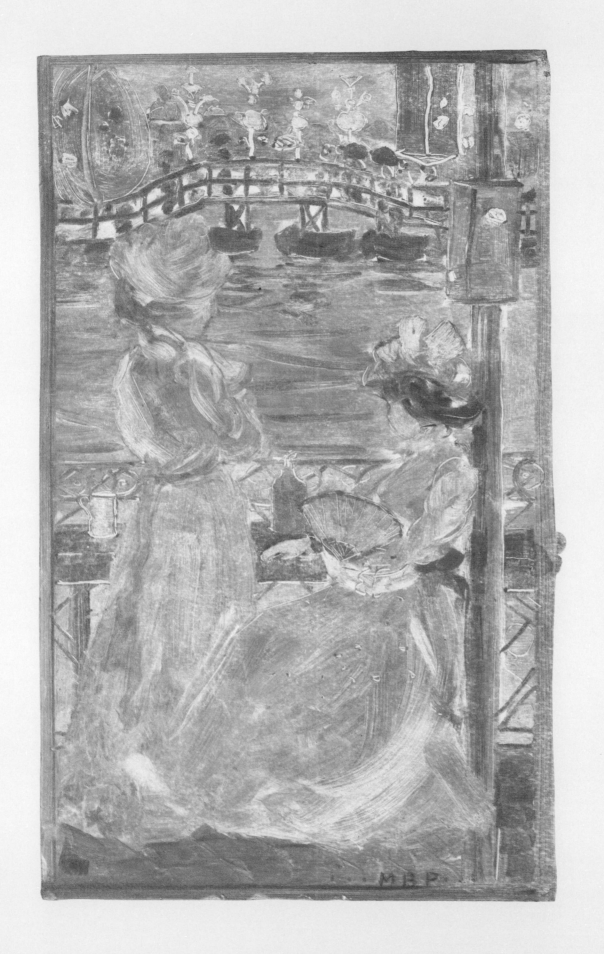

39. *Monte Pincio (The Pincian Hill)*

7½ x 9¼ inches (19 x 23.5 cm.) (image); 10⁷⁄₁₆ x 13½ inches (26.6 x 34.3 cm.) (paper)
Signed (at lower left, in the plate): M B P; inscribed (at bottom, in the plate): Monte Pincio The Pincian Hill
Executed about 1898–1899

Exhibited: Maryland, 1976, no. 23, illus. on p. 96 (as collection of Mr and Mrs William Anthony Hogan); Davis & Long, 1979, no. 77, illus. on p. 113 (as collection of Mr and Mrs William Anthony Hogan)

Ex coll: E. and A. Milch, New York, as of 1925; to Thalia Westcott (Mrs Donald C.) Malcolm, from 1925; to Colonel Stephen C. Millett, Jr. (her son), Washington, D.C., as of 1969; to Associated American Artists, Inc., New York; to Mr and Mrs William Anthony Hogan, from at least 1976 until 1983; via Associated American Artists, Inc., New York, to Davis & Langdale Company, New York, 1983; to Daniel J. Terra

Executed during (or after) Prendergast's first Italian trip of 1898–1899, this is a view of a fashionable promenade in Rome, the Pincian Hill. It is a particularly colorful monotype, to which touches of watercolor have been added on the sheet; the palette is composed of rich browns (the brickwork), reds (the robes of the ecclesiastics, one parasol, and the traces and carriage wheels), greens (the large umbrella and carriage body), blacks (the costumes of the coachman and his women passengers), and whites (the horse, the nearer parasol, the baby's robe, and the little girls' hats).

There are three watercolors to which this monotype is closely related: *Afternoon, Pincian Hill*[1], which is dated 1898, and the undated *Afternoon, Pincian Hill*[2], and the Terra Museum *Monte Pincio, Rome* (fig. 11).

The composition of the monotype is a simplified version of those of the watercolors (a simplification undoubtedly necessitated by the speed with which a monotype must be finished). In the latter, there are gaily attired strollers in the foreground and background, and a carriage in the middle ground; in the print, the focus is upon the landau, while the foreground figures have been eliminated, and the background figures transmuted into uniformly garbed ecclesiastics. (A similar parade of red robed clergy appears in another Roman monotype, *The Spanish Steps* [*Rome*].[3]) The carriage faces in the same direction in monotype and watercolors, but the slant of the brick retaining wall of the road to the Pincian Gardens is different; it leads up to the right in the monotype, and up to the left in the other pictures.

1. The Phillips Collection, illus. in *Davis & Long 1979* as fig. 8, p. 112.
2. *Ibid.*, illus. as fig. 7, p. 112, collection of Honolulu Academy of Arts.
3. *Ibid.*, illus. as no. 76, collection of The Cleveland Museum of Art.

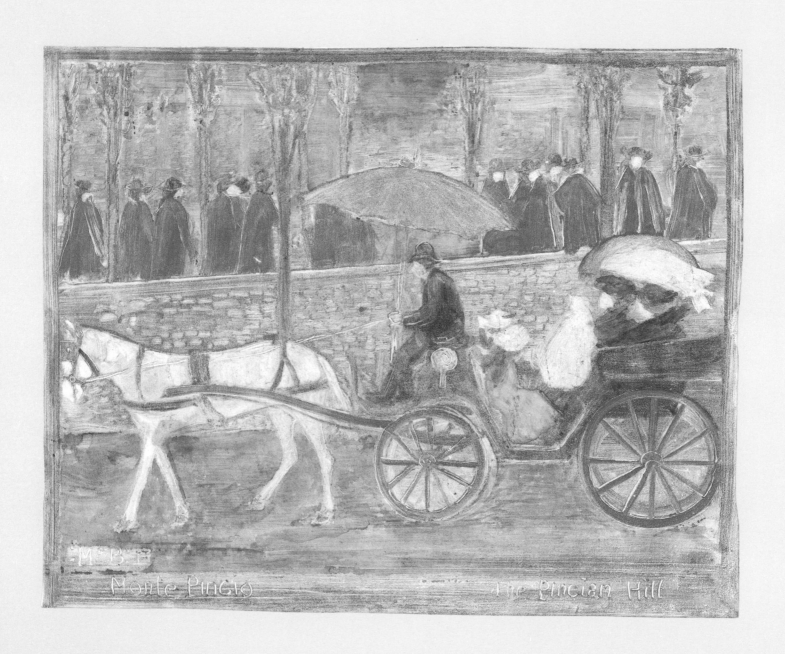

Monte Pincio The Pincian Hill

40. *On the Corso, Rome*

11⁷⁄₁₆ x 7⅛ inches (29.1 x 18.1 cm.) (sight)
Signed and inscribed (at bottom, in the plate): Via Delle [*sic*] Corso ROME M B P
Executed about 1898–1899

Exhibited: Kraushaar, 1956 (catalogue unnumbered); Boston, 1960, no. 132, illus. (as collection of Mr and Mrs Melvin Schifter); Bard, 1967, no. 19 (as *On the Corso*, collection of Mrs Margaret H. Schifter)

Ex coll: Kraushaar Galleries, New York, as of 1956; Mr and Mrs Melvin Schifter, as of 1960; Mrs Margaret H. Schifter, as of 1967; Hirschl & Adler Galleries, Inc., New York, as of 1983; to Daniel J. Terra

Like nos. 34–39, *On the Corso, Rome* dates from (or, at the latest, from soon after) Prendergast's first stay in Italy, in 1898–1899. Although this monotype is called after one of Rome's most famous streets, its focus is upon the large foreground figure of a fashionable woman. All that is really seen of the via del Corso itself are some lights and a carriage with several occupants. While its composition is more elaborate than theirs, because of its cloaked lady the picture is not unlike *The Opera Cloak* (no. 33) and *Lady in Hat and Green Cape* (no. 43), in both of which there are very similar figures. The palette of *On the Corso, Rome* is a predominantly green one, with touches of orange and yellow.

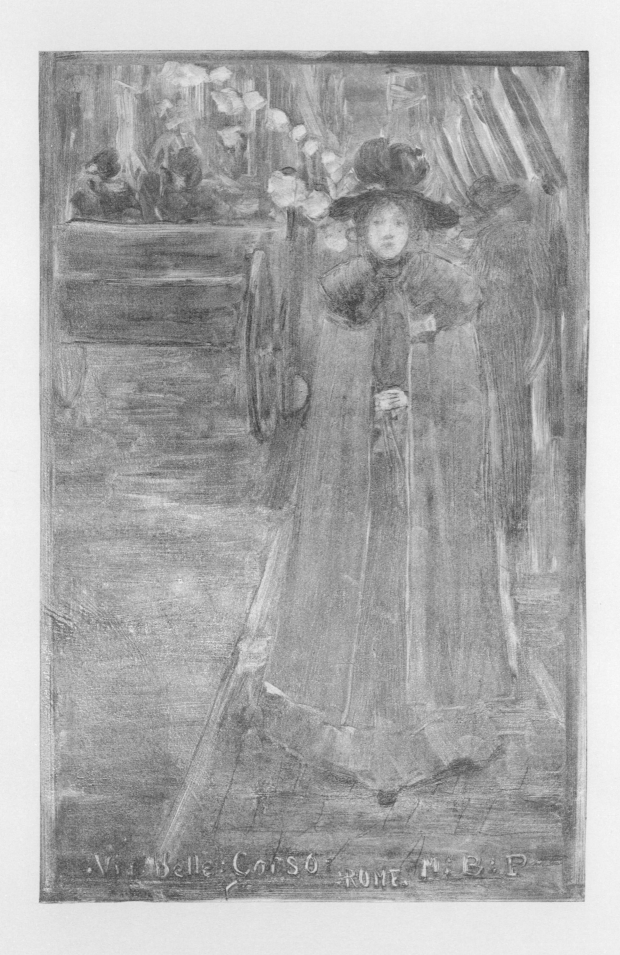

41. *Two Ladies*

5¾ x 3½ inches (14.6 x 8.9 cm.) (image); 8⅝ x 6⅝ inches (21.9 x 16.4 cm.) (paper)
Signed (at lower right, in the plate): MBP (monogram)
Probably executed about 1898–1901

Exhibited: Bard, 1967, no. 28 (as *Two Girls*, collection of Mr and Mrs Matthew Phillips); Davis & Long, 1979, no. 83, illus. on p. 119 (as lent by the Rudin collection)

Ex coll: Kraushaar Galleries, New York; Mr and Mrs Matthew Phillips, as of 1967; the Rudin collection, as of at least 1979 until 1983; to Davis & Langdale Company, New York, 1983; to Daniel J. Terra

This is a second pull; there is a first pull, the present whereabouts of which is unknown, from the same plate. One or the other of the two impressions was possibly exhibited: Cincinnati, 1901–1902, as no. 40 (as *Early Moon*).

Two Ladies is the smallest of all Prendergast's recorded monotypes. It is relatively muted in color; the background is blueish green, the ladies' hair brown, the dress on the left pink, and the one on the right white with a pink sash. It may be compared to *Woman in White Muslin Dress* (no. 42); the compositions are somewhat different—here there are two women and a crescent moon in the sky behind them, there a single figure and a full moon above—but the handling is quite similar.

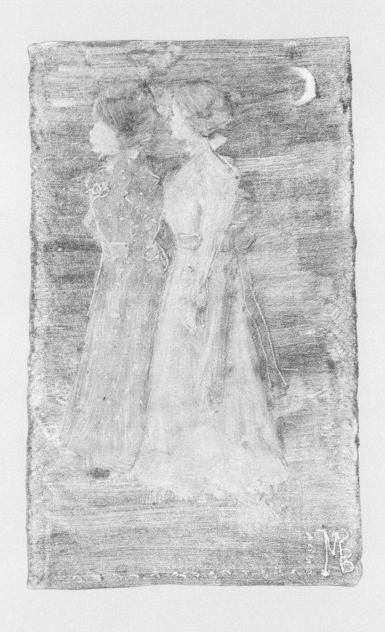

42. *Woman in White Muslin Dress*

9⅞ x 4 inches (25.1 x 10.2 cm.) (plate)
Signed (at lower right, in the plate): MBP (monogram); inscribed (at lower left, in the plate):
[spott?]ed Muslin
Probably executed about 1898–1901

Ex coll: estate of the artist, until 1983; to Daniel J. Terra

 In *Woman in White Muslin Dress*, the lady stands before a lavender sky in which a yellow full
moon hangs. The monotype is subdued in color, surely intentionally so, for the effect is a lovely,
evanescent one, reminiscent of a moonlit night. In this regard it is rather like *Two Ladies* (no. 41),
and one may assume that the two pictures were executed at much the same time.

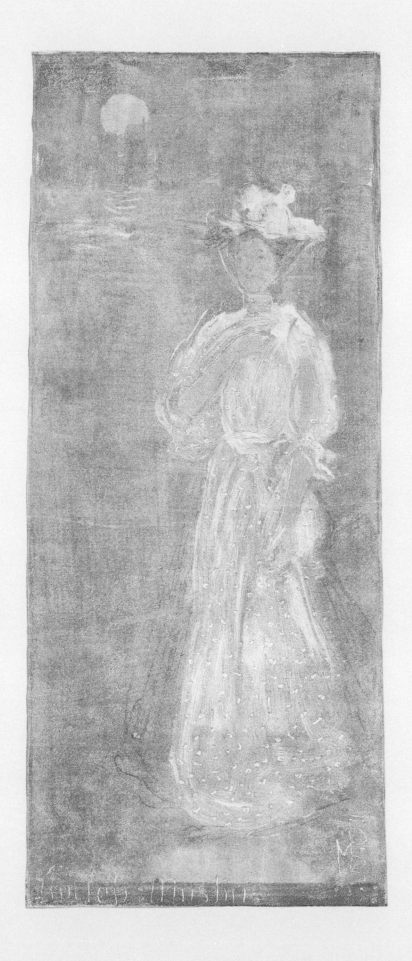

43. *Lady in Hat and Green Cape*

9½ x 4⅜ inches (24.1 x 11.1 cm.) (image); 10 x 5 inches (25.4 x 12.7 cm.) (plate); 13¾ x 7⅜ inches (34.9 x 18.7 cm.) (paper)
Probably executed about 1898–1901

Exhibited: Davis & Long, 1979, no. 84, illus. on p. 120 (as Davis and Long Company)

Ex coll: Mrs Winthrop Bushnell; to private collection, by descent, until 1978; to Davis & Long Company, New York, from 1978 until 1979; to private collection, New York, from 1979 until 1982; to Davis & Langdale Company, New York, 1982; to Daniel J. Terra

This picture may possibly have been exhibited: Cincinnati, 1901–1902, as no. 61, 62, or 63 (as *Girl in Green*).

Lady in Hat and Green Cape is thematic in color, executed primarily in tones of green: the woman's hat and dress are dark green and her cape bright green; she stands on a curb, which is summarily indicated, before a brownish black background. Her facial features are defined in pencil on the paper. Although it is not itself dated, this work may be compared to *Lady with a Muff* (no. 45) of 1900; *Woman with a Parasol*[1] of 1901; *Lady in Blue*[2] of 1901; and *The Red Jacket*[3] of 1901; as well as with *The Opera Cloak* (no. 33) which, while not dated, must have been done in about 1898, the year in which it was first exhibited.

This picture is also very closely related to another monotype, also undated, *Lady with Feathered Hat*[4]; there an identically attired woman, now holding a muff, stands turned to the right rather than to the left.

1. collection of The Museum of Modern Art, illus. in *Davis & Long 1979* as no. 88.
2. *Ibid.*, illus. as no. 89, collection of the Museum of Fine Arts, Boston.
3. *Ibid.*, illus. as no. 90, private collection.
4. *Ibid.*, illus. as no. 85, collection of A.F. Biggs.

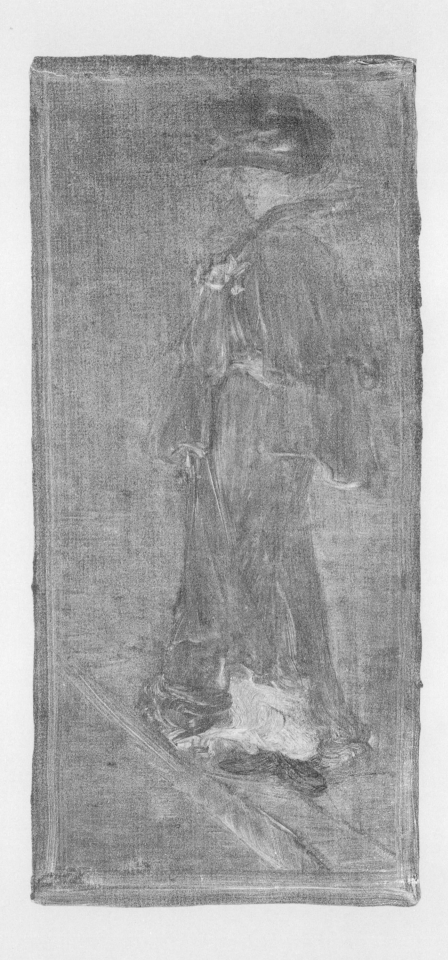

44. *Woman in Blue Dress with White Boa and Large Red Hat*

9⅞ x 5 inches (25.1 x 12.7 cm.) (image); 14⁷⁄₁₆ x 10⅝ inches (36.6 x 27 cm.) (paper)
Signed (at lower left, in the plate): M B Prendergast; signed and inscribed (in bottom margin, in
pencil): To my friend Mrs. A. Higginson/Maurice B. Prendergast
Probably executed about 1898–1901

Ex coll: the artist; to Mrs A. Higginson; private collection, New York, until 1982; to Davis &
Langdale Company, New York, 1982; to Daniel J. Terra

Like *Lady in Hat and Green Cape* (no. 43), this picture is undated but is sufficiently like several
dated single figure compositions that one may comfortably assume it to come from the same time;
those pictures include *Lady with a Muff* (no. 45) of 1900; *Woman with a Parasol*[1] of 1901; *Lady in
Blue*[2] of 1901; and *The Red Jacket*[3] of 1901. It is rather a colorful monotype: the woman is attired in a
blue dress, a white boa, and elaborate flowered red hat; she lifts her skirt, preparatory to moving, to
reveal a pink petticoat; and the background behind her is greenish grey.

1. collection of The Museum of Modern Art, illus. in *Davis & Long 1979* as no. 88.
2. *Ibid.*, illus. as no. 89, collection of the Museum of Fine Arts, Boston.
3. *Ibid.*, illus. as no. 90, private collection.

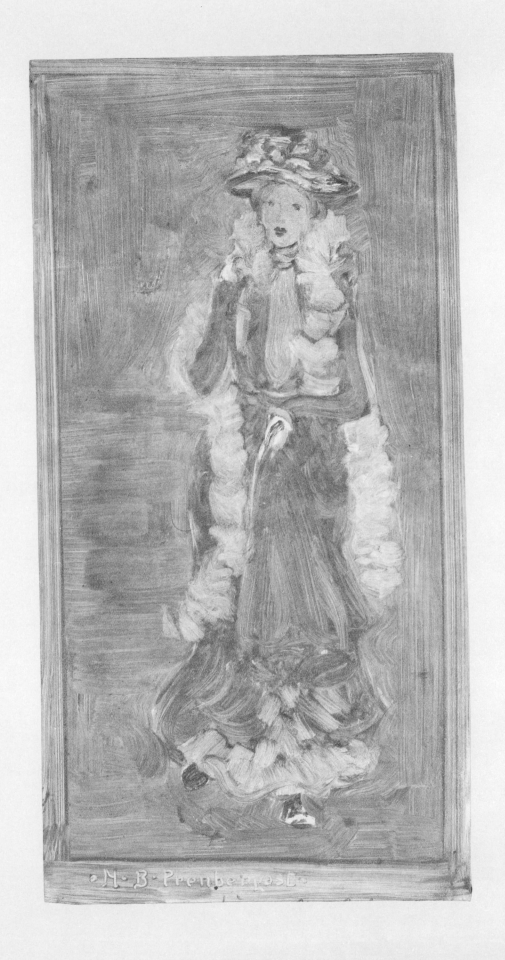

45. *Lady with a Muff*

10 x 4⅜ inches (25.4 x 11.1 cm.) (image); 15½ x 9⅝ inches (39.3 x 24.4 cm.) (paper)
Signed (at lower left, in the plate): Prendergast; dated (at lower right, in the plate): 1900

Exhibited: Addison, 1938, no. 88 (as *Lady with Muff*)

Probably exhibited: Kraushaar, 1936, no. 16 (as *Lady with Muff*); Corcoran, 1937, no. 12 (as *Lady with Muff*)

Ex coll: estate of the artist, until at least 1944; Kraushaar Galleries, New York; Christie's, New York, sale, September 24, 1980, lot 439, illus.; to Davis & Long Company, New York; to Meredith Long and Company, Houston, Texas, until 1982; to Daniel J. Terra

According to the Whitney papers, this picture was in the possession of Kraushaar Galleries in 1944, when it was examined there.

Lady with a Muff is one of Prendergast's relatively rare dated monotypes. Its palette is rather subdued: the woman's dress is green, her hat red and brown, and her muff red, and she stands before a brown background. It may be compared to two similar, undated monotypes of the same title in the collections of The Metropolitan Museum of Art[1] and of Yale University Art Gallery[2], which were presumably done at much the same time.

1. illus. in *Davis & Long 1979* as no 81.
2. *Ibid.*, illus. as no. 82, as *Lady with Muff*.

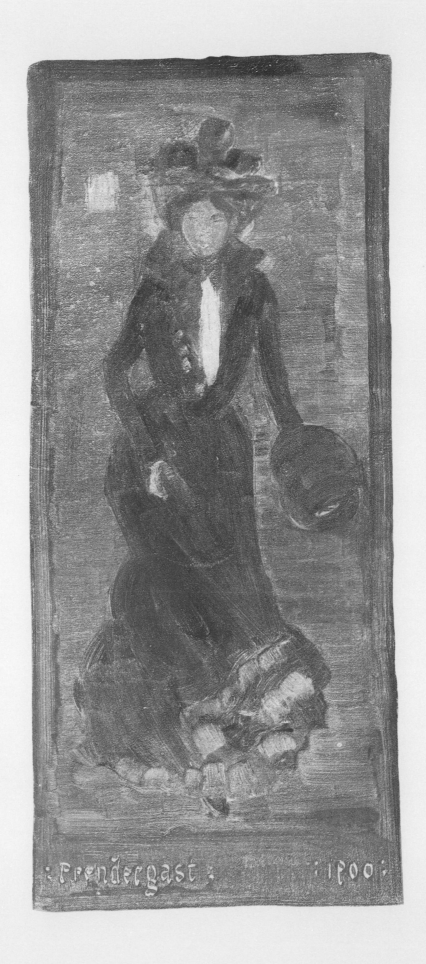

46. *Watching The Races*

8 x 6¹³⁄₁₆ inches (20.3 x 17.3 cm.) (image); 9⅞ x 7¹⁵⁄₁₆ inches (25.1 x 20.2 cm.) (plate); 11¾ x 10½ inches (29.8 x 26.6 cm.) (paper)
Signed (at lower left, in the plate): M B P
Probably executed about 1900–1902

Exhibited: Bard, 1967, no. 15 (as lent by Mr and Mrs David M. Vogel); Davis & Long, 1979, no. 94, illus. on p. 130 (as collection of Mr and Mrs David M. Vogel)

Ex coll: Kraushaar Galleries, New York, until 1960; to Mr and Mrs David M. Vogel, from 1960 until 1982; to Davis & Langdale Company, New York, 1982; to Daniel J. Terra

This is the second pull and *Girls on Esplanade* [1] is the first pull from the same plate.

Although it is undated, there can be little doubt that *Watching the Races* was executed toward the end of Prendergast's monotype career, in about 1900-1902. It bears strong similarities to such dated prints as the 1901 *Summer Day* (no. 49) and *Park Promenade* [2] of the same year. Like them, this composition is characterized by active, swirling forms which flow one into another; shapes are not as carefully plotted nor as clearly defined as they are in the earlier monotypes, while the brushwork is now far more apparent than it once was.

The picture is rather muted, executed in tones of greenish blue, pink and white; except insofar as it is paler, it does not differ from the first pull from the same plate.

1. collection of the Museum of Fine Arts, Boston, illus. in *Davis & Long 1979* as no. 93.
2. *Ibid.*, illus. as no. 92, collection of Mr and Mrs Meyer P. Potamkin.

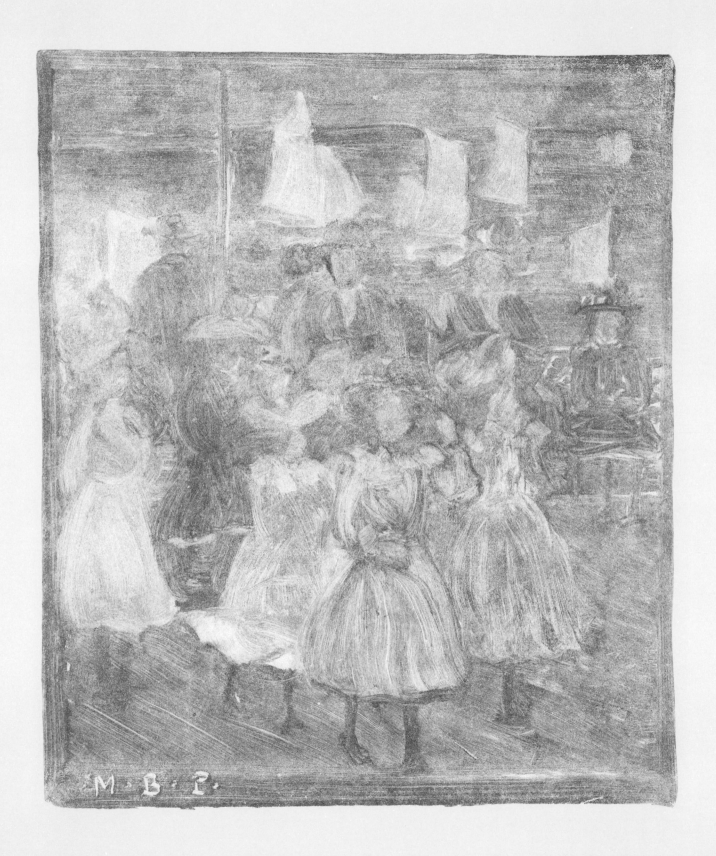

139

47. *In The Park*

9⅞ x 7¹³⁄₁₆ inches (25.1 x 19.8 cm.) (image); 10³⁄₁₆ x 8⅛ inches (25.9 x 20.6 cm.) (sight)
Signed (at lower right, in the plate): MBP (monogram)
Probably executed about 1900–1902

Exhibited: Kraushaar, 1950, no. 39; Bard, 1967, no. 32 (as lent by Mr and Mrs George Gianis); Davis & Long, 1979, no. 95, illus. on p. 131, illus. in color on p. 29 (as collection of Mr and Mrs. S. George Gianis)

Probably exhibited: Kraushaar, 1936, no. 26; Corcoran, 1937, no. 6; Addison, 1938, no. 119

Ex coll: estate of the artist; to Kraushaar Galleries, New York, until at least 1950; Peter H. Deitsch, New York; to Mr and Mrs S. George Gianis, until 1982; to Davis & Langdale Company, New York, 1982; to Daniel J. Terra

This picture is listed in the Whitney papers as in the possession of Kraushaar Galleries as of January 1944, when it was examined there.

Like a number of Prendergast's monotypes, *In the Park* is thematic in color; its palette is composed primarily of greens, accented by touches of pink and white. Although undated, it surely comes from much the same time as *Summer Day* (no. 49) of 1901; both pictures are characterized by flowing, interlocking forms.

This monotype is also closely related to a number of watercolors of about 1901–1902, among them such Central Park views as the 1902 *Maypole* [1]; *May Day, Central Park* [2], and *May Day, Central Park.* [3]

1. collection of Allen Memorial Art Museum, illus. in *Allen 1982–1983* as fig. 1, p. 26.
2. *Ibid.*, illus. as fig. 2, p. 27, collection of Yale University Art Gallery.
3. *Ibid.*, illus. as fig. 3, p. 27, collection of Whitney Museum of American Art.

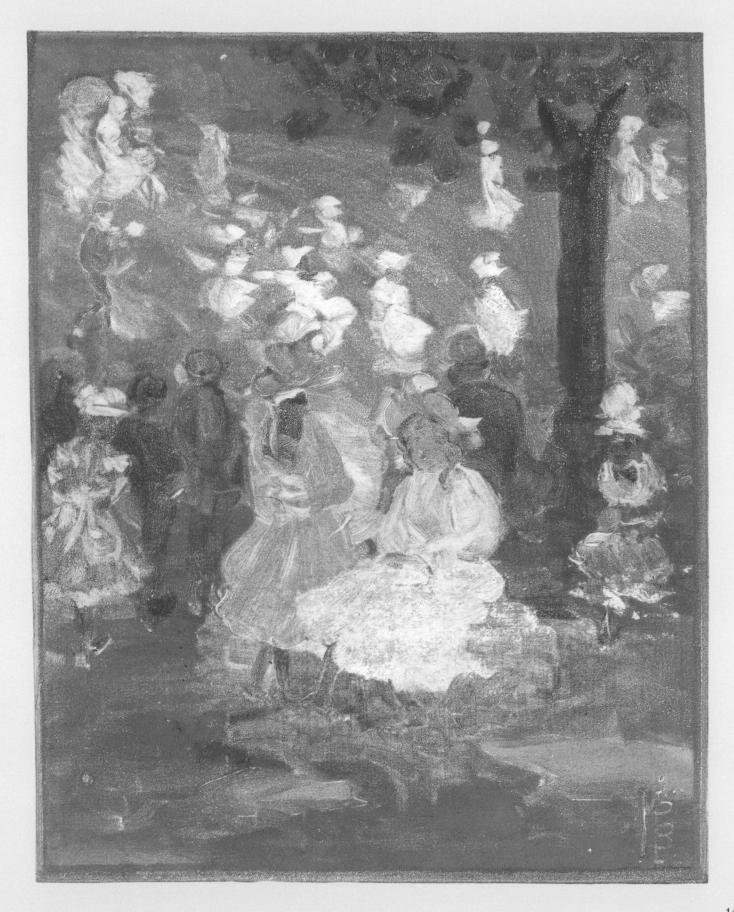

48. *Reflection (Fishing Party)*

9⅞ x 7⅞ inches (25.1 x 20 cm.) (image)
Signed (at lower left, in the plate): MBP (monogram)
Probably executed about 1900–1902

Exhibited: Bard, 1967, no. 35 (as lent by Mr William Kienbusch); Smithsonian, 1972, no. 2 (as lent by William A. Kienbusch)

Ex coll: William A. Kienbusch, from at least 1967 until 1980; to private collection, from 1980 until 1983; to Davis & Langdale Company, New York, 1983; to Daniel J. Terra

This is the second pull and *Fishing Party*[1] is the first pull from the same plate. One or the other of the impressions was almost certainly exhibited as *Fishing Party*: Kraushaar, 1936, no. 13; Corcoran, 1937, no. 2; Addison, 1938, no. 121; Kraushaar, 1956 (catalogue unnumbered).

Reflection (Fishing Party) bears many similarities to *In the Park* (no. 47). They correspond in size, in composition, and in palette: both pictures are pervasively green, with touches of pink and white. The figure of the little girl at the lower left of this picture is almost a replica of that in the center of *In the Park*; their poses and blue green frocks are virtually identical. Like that print, this also is undated but sufficiently resembles the 1901 *Summer Day* (no. 49) to be assigned much the same date. It, too, may be compared to Prendergast's series of watercolors of Central Park from about 1901–1902.

1. collection of the Museum of Fine Arts, Boston, illus. in *Boston 1960–1961* as no. 141.

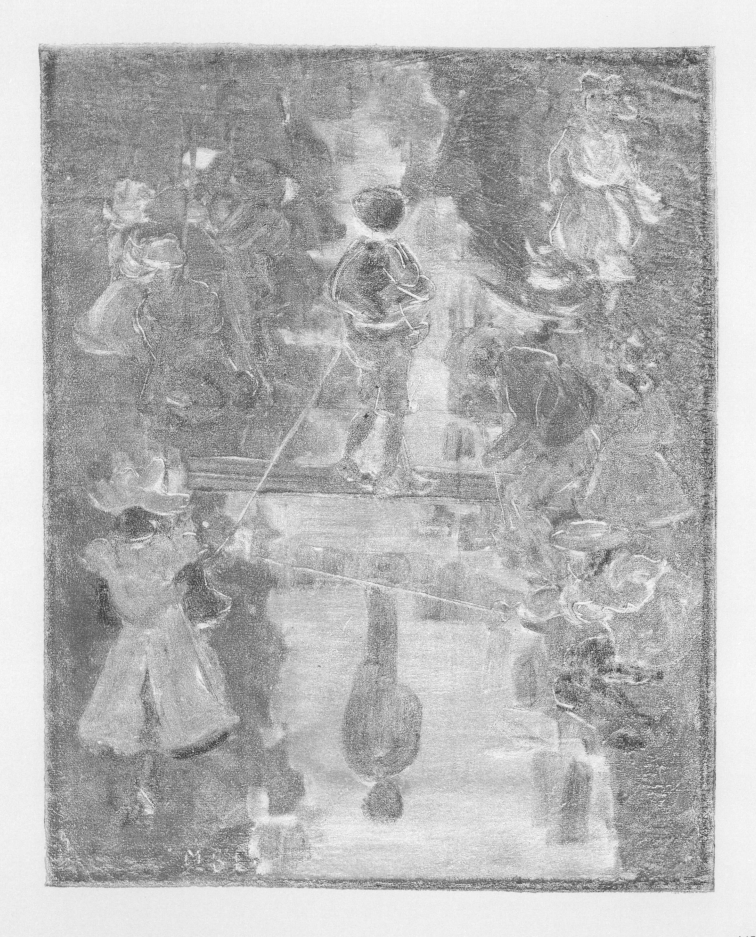

49. *Summer Day*

11½ x 14 inches (29.2 x 35.6 cm.) (sight)
Signed and dated (at lower right, in red pencil): M B P 1901

Exhibited: Kraushaar, 1936, no. 30; Boston, 1960–1961, no. 136, illus.; Bard, 1967, no. 42; Davis & Long, 1979, no. 98, illus. on p. 134 (as collection of Katharine Sturgis)

Probably exhibited: Corcoran, 1937, no. 17; Addison, 1938, no. 101

Ex coll: C.W. Kraushaar Art Galleries, New York; to Katharine Sturgis, until 1982; to Davis & Langdale Company, New York, 1982; to Daniel J. Terra

Summer Day, an unusually strong and colorful picture, is one of Prendergast's rather rare dated monotypes.[1] Done in 1901, it is one of his latest prints and it comes from the moment in the artist's career when he was just beginning to shift his primary attention from the medium of watercolor to that of oil. Typical of the late monotypes are this work's flowing, interwoven forms and its spontaneous execution, characteristics which also link it to such paintings of the same time as, for example, *Salem Willows*.[2]

1. he dated his prints only sporadically, most often in 1895—from which year there are nine examples—and again in 1901—from which there are eight.
2. collection of the Terra Museum of American Art, illus. in *Maryland 1976* on p. 22; *Salem Willows* was exhibited at the Society of American Artists in 1901.

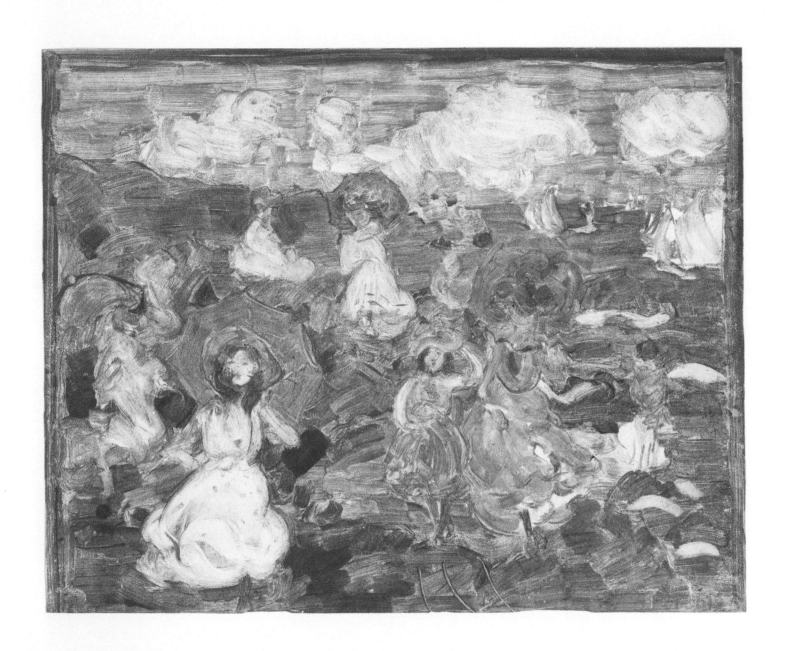

50. *Lighthouse*

9¼ x 14 inches (23.5 x 35.6 cm.) (image)
Signed (at lower right, in oil): M/B/P
Executed about 1901

Exhibited: Davis & Long, 1979, no. 99, illus. on p. 135, illus. in color on p. 30 (as collection of Daniel J. Terra)

Ex coll: estate of the artist, until 1978; to Davis & Long Company, New York, 1978; to Daniel J. Terra

This is the first pull and *Beach Scene with Lighthouse (Children at the Seashore)*[1] is the second pull from the same plate.

Lighthouse, although it is itself undated, is so unmistakably like *Summer Day* (no. 49) as to surely date from the same time; they are similar in palette, in size, and in composition. Indeed, one figure—that of the small girl with her arm raised—appears essentially unchanged (though reversed) in both pictures.

This print is unique in Prendergast's monotype *oeuvre* in that it has been extensively reworked on the sheet in watercolor.[2] Its cognate (which has been seen only in photograph) seems to have been left unaltered; a comparison with that cognate indicates that the reworkings on the first pull all occur within boundaries established on the plate. Those repainted areas include a good deal of the cloak of the woman at left; most of the boy at left; the dress, hat, and face of the small girl facing forward at right center; the hair and shirt of the little boy at right; the sailboats on the horizon, and essentially all of both trios of figures in the background.

1. collection of The Metropolitan Museum of Art.
2. there are touches of watercolor on *Monte Pincio (The Pincian Hill)* (no. 35), but nothing remotely approaching the amount on this sheet.

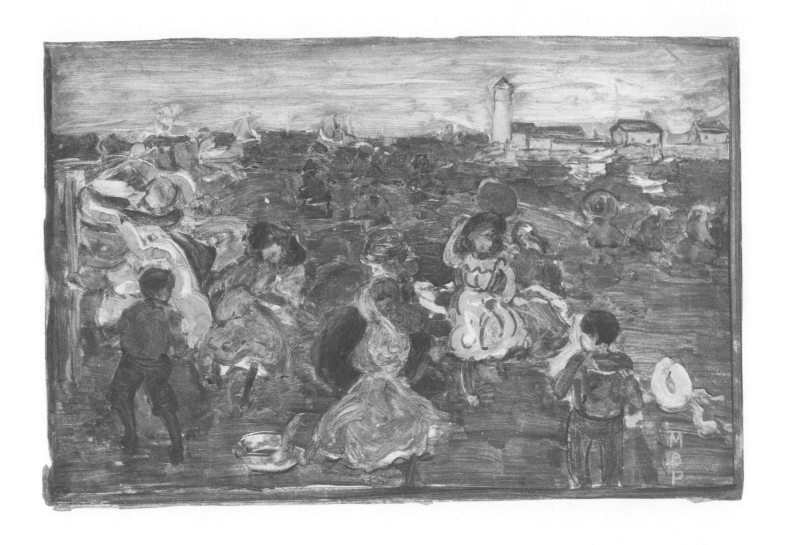

51. *Lady in Pink*

9⅞ x 4 inches (25.1 x 10.2 cm.) (image); 11¾ x 6 inches (29.8 x 15.2 cm.) (plate); 15¼ x 9⅞ inches (38.7 x 25.1 cm.) (paper)
Signed (at lower left, in the plate): MBP (monogram); dated, and inscribed (on an old label, probably in the artist's hand): LADY IN PINK, 1901 / BY/ MAURICE PRENDERGAST
Probably executed in 1901

Ex coll: private collection, Illinois, from at least the 1940s until 1984; to Daniel J. Terra

This is the second pull and *At Crescent Beach*[1] is the first pull from the same plate.

According to the Whitney papers, when this picture was examined in the 1940s it was in the possession of the Illinois private collector who owned it until 1984.

In this relatively subdued monotype, an auburn haired woman wears a pink dress and holds a deeper pink parasol in her grey gloved left hand. Behind her is a background of a mottled brownish green. Touches of pencil strengthen her face and areas of the background.

If, in fact, the old label is in the artist's hand, we may securely date *Lady in Pink* to 1901. It is, in any event, closely related stylistically to such dated prints of that year as *Woman with Parasol*[2] and *Lady in Blue*.[3]

1. private collection, illus. in *Davis & Long 1979* as no. 87.
2. *Ibid.*, illus. as no. 88, collection of The Museum of Modern Art.
3. *Ibid.*, illus. as no. 89, collection of Museum of Fine Arts, Boston.

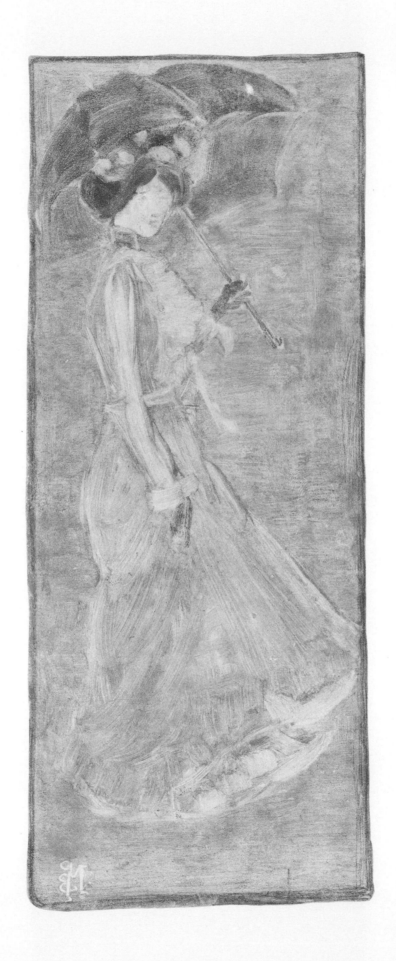

Addendum

52. *Nouveau Cirque (Paris)*

13⅞ x 13¾ inches (35.2 x 34.9 cm.) (image)
Signed (at lower right, in the plate): Prendergast; inscribed (at lower left, in the plate): Nouveau Cirque
Probably executed about 1895

Exhibited: Addison, 1938, no. 116; Boston, 1960–1961, no. 139, illus. (as collection of Mrs Charles Prendergast); Davis & Long Company, New York, 1977, *Maurice Prendergast: Art of Impulse and Color* (lent by Mrs Charles Prendergast, not in catalogue); Whitney Museum of American Art, New York, 1977, *Twentieth Century American Art from Friends' Collections* (no catalogue); Davis & Long, 1979, no. 37, illus. on p. 71, illus. in color on p. 22 (as private collection); The Metropolitan Museum of Art, New York, and Museum of Fine Arts, Boston, Massachusetts, 1980–1981, *The Painterly Print: Monotypes from the Seventeenth to the Twentieth Century*, no. 57, illus. in color on p. 165 (as *Nouveau Cirque*, collection of Mrs Charles Prendergast)

Ex coll: estate of the artist, until 1984; to Daniel J. Terra

Nouveau Cirque (Paris) is the largest of all Prendergast's monotypes, equalled by only two other prints, *Telegraph Hill* (no. 31) and another picture of the same title[1], both of which are precisely the size of this; the three were undoubtedly all done on the same plate. It is one of three circus pictures in the Terra Museum collection; the others are *Circus Scene with Horse* (no. 19), which is dated 1895, and *Bareback Rider* (no. 20). Because of the title of this monotype, it has been assumed that all the circus pictures had the Cirque Nouveau in Paris as their inspiration; the subject is one treated by Prendergast only in monotype.

This is the only known impression of the print, and it is an unusually strong and vibrant one. Like nos. 19 and 20, its palette is composed of rich browns, reds, greens, and whites. The same compositional elements recur as well: white horses with bareback riders in tutus; clowns in polka-dotted red and white costumes; flagpoles; a drum.

According to Mrs Charles Prendergast, *Nouveau Cirque (Paris)* was always her husband's favorite picture by his brother.

1. *Telegraph Hill*, collection of Mr and Mrs Ogden K. Shannon, illus. in *Davis & Long 1979* as no. 105.

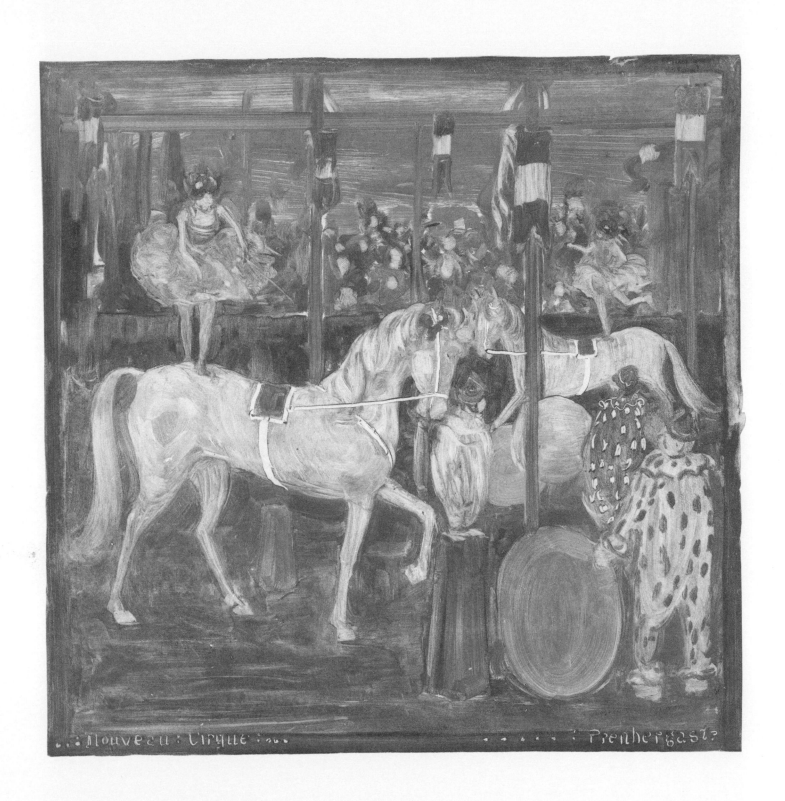

Abbreviations

AAA 1977	Associated American Artists, New York, 1977, *Milton Avery Monotypes* (exhibition catalogue by Sylvan Cole, Jr.)
Addison 1938	Addison Gallery of American Art, Phillips Academy, Andover, Massachusetts, 1938, *Retrospective Exhibition of the Work of Maurice and Charles Prendergast* (exhibition catalogue with "Anecdotes of Maurice Prendergast" by Van Wyck Brooks)
Allen 1982–1983	Richard J. Wattenmaker, "Maurice Prendergast" in Allen Memorial Art Gallery Bulletin, vol. XL, no. 1 (1982–1983)
Bard 1967	William Cooper Procter Art Center, Bard College, Annandale-on-Hudson, New York, 1967, *Maurice Prendergast: The Monotypes* (exhibition catalogue by Matthew Phillips)
Bonnard 1948	The Museum of Modern Art, New York, and The Cleveland Museum of Art, Ohio, 1948, *Pierre Bonnard* (exhibition catalogue by John Rewald)
Bonnard 1964	The Museum of Modern Art, New York, Los Angeles County Museum of Art, California, and The Art Institute of Chicago, Illinois, 1964, *Bonnard and His Environment* (exhibition catalogue by James Thrall Soby, James Elliott, and Monroe Wheeler)
Boston Sketchbook	Museum of Fine Arts, Boston, and Harvard University Press, Cambridge, Massachusetts (1960), *Maurice Prendergast Water-Color Sketchbook 1899* (with "Critical Note" by Peter A. Wick)
Boston Public Garden Sketchbook	Oklahoma Museum of Art, Oklahoma City, 1981, *Prendergast: The Large Boston Public Garden Sketchbook* (exhibition catalogue by Dr George Szabo)
Boston 1898	Boston Water Color Club, Massachusetts, 1898, *11th Annual Exhibition* (exhibition catalogue)
Boston 1899	Boston Water Color Club, Massachusetts, 1899, *12th Annual Exhibition* (exhibition catalogue)
Boston 1901	Boston Water Color Club, Massachusetts, 1901, *14th Annual Exhibition* (exhibition catalogue)
Boston 1960–1961	Museum of Fine Arts, Boston, Massachusetts, Wadsworth Atheneum, Hartford, Connecticut, Whitney Museum of American Art, New York, California Palace of the Legion of Honor, San Francisco, and The Cleveland Museum of Art, Ohio, 1960–1961, *Maurice Prendergast 1859–1924* (exhibition catalogue by Hedley Howell Rhys and Peter A. Wick)

Boston 1973 Museum of Fine Arts, Boston, Massachusetts, 1973, *Camille Pissarro: The Impressionist Printmaker* (exhibition catalogue by Barbara S. Shapiro)

Brinton 1910 Christian Brinton, "The Field of Art: Monotypes" in *Scribner's Magazine*, vol. XLVII-53 (April 1910)

Chicago 1900 The Art Institute of Chicago, Illinois, 1900, *Herman Dudley Murphy and Maurice B. Prendergast* (exhibition catalogue)

Cincinnati 1901–1902 Cincinnati Museum Association, Ohio, 1901–1902, *82nd Exhibition: Maurice Prendergast Watercolors and Monotypes* (exhibition catalogue)

Corcoran 1937 The Corcoran Gallery of Art, Washington, D.C., 1937, *Special Exhibition of Monotypes by Maurice Brazil Prendergast* (exhibition catalogue)

Davis 1963 Davis Galleries, New York, 1963, *Drawings by Maurice B. Prendergast* (exhibition catalogue with essay by Robert Brady)

Davis & Long 1975 Davis & Long Company, New York, 1975, *Charles Conder, Robert Henri, James Morrice, Maurice Prendergast: The Formative Years: Paris 1890s* (exhibition catalogue by Cecily Langdale)

Davis & Long 1979 Davis & Long Company, New York, 1979, *The Monotypes of Maurice Prendergast* (exhibition catalogue by Cecily Langdale)

Field 1978 Richard S. Field, "The Monotype: A Majority Opinion?" in *The Print Collector's Newsletter*, vol. IX, no. 5 (November–December 1978)

Fogg 1968 Fogg Art Museum, Harvard University, Cambridge, Massachusetts, 1968, *Degas Monotypes* (exhibition catalogue by Eugenia Parry Janis)

Kraushaar 1936 C.W. Kraushaar Art Galleries, New York, 1936, *Monotypes in Color by Maurice Prendergast* (exhibition catalogue)

Kraushaar 1950 Kraushaar Galleries, New York, 1950, *Maurice Prendergast: Retrospective Exhibition of Paintings, Water Colors, and Monotypes* (exhibition catalogue)

Kraushaar 1956 Kraushaar Galleries, New York, 1956, *Prendergast Monotypes* (exhibition catalogue)

Macbeth 1900 Macbeth Gallery, New York, 1900, *Exhibit of Watercolors and Monotypes in Color by Maurice B. Prendergast* (exhibition catalogue)

Maryland 1976 University of Maryland Art Gallery, College Park, University Art Museum, University of Texas, Austin, Des Moines Art Center, Iowa, Columbus Gallery of Fine Arts, Ohio, Herbert F. Johnson Museum of Art, Cornell University, Ithaca, New York, and Davis & Long Company, New York, 1976–1977, *Maurice Prendergast: Art of Impulse and Color* (exhibition catalogue by Eleanor Green, Ellen Glavin, S.N.D., and Jeffrey R. Hayes)

Metropolitan 1980 The Metropolitan Museum of Art, New York, and Museum of Fine Arts, Boston, Massachusetts, 1980–1981, *The Painterly Print: Monotypes from the Seventeenth to the Twentieth Century* (exhibition catalogue by Sue Welsh Reed, Eugenia Parry Janis, Barbara Stern Shapiro, David W. Kiehl, Colta Ives, and Michael Mazur)

Pearl 1979 — Marilyn Pearl Gallery, New York, 1979, *American Monotypes: 100 Years* (exhibition catalogue by Robert Flynn Johnson)

Philadelphia 1973 — Philadelphia Museum of Art, Pennsylvania, 1973, *Paul Gauguin: Monotypes* (exhibition catalogue by Richard S. Field)

Smithsonian 1972 — Smithsonian Institution Traveling Exhibition Service, 1972, *The Monotype: An Edition of One* (exhibition catalogue by Matt Phillips)

Toulouse-Lautrec — Jean Adhémar, *Toulouse-Lautrec: His Complete Lithographs and Drypoints* (New York: Harry N. Abrams, Inc., 1965)

Venice 1983 — Coe Kerr Gallery, New York, and The Boston Athenaeum, Massachusetts, 1983, *Americans in Venice 1879–1913* (exhibition catalogue)

Whistler 1971 — Wildenstein, New York, and Philadelphia Museum of Art, Pennsylvania 1971, *From Realism to Symbolism: Whistler and His World* (exhibition catalogue by Allen Staley and Theodore Reff)

Whistler 1980 — Andrew McLaren Young, Margaret MacDonald, Robin Spencer, and Hamish Myles, *The Paintings of James McNeill Whistler* (New Haven and London: Yale University Press, 1980)

Bibliography

Addison Gallery of American Art, Phillips Academy, Andover, Massachusetts, 1938, *Retrospective Exhibition of the Work of Maurice and Charles Prendergast* (exhibition catalogue with "Anecdotes of Maurice Prendergast" by Van Wyck Brooks)

Adhémar, Jean, *Toulouse-Lautrec: His Complete Lithographs and Drypoints* (New York: Harry N. Abrams, Inc., 1965)

American Art Research Council Papers, The Whitney Museum of American Art Papers, Archives of American Art, Smithsonian Institution

Amon Carter Museum of Western Art, Fort Worth, Texas, 1978, *American Impressionist and Realist Paintings and Drawings from the William Marshall Fuller Collection* (exhibition catalogue by Carol Clark)

Art Gallery of Ontario, Toronto, 1975, *Puvis de Chavannes and the Modern Tradition* (exhibition catalogue by Richard J. Wattenmaker)

The Art Institute of Chicago, Illinois, 1900, *Herman Dudley Murphy and Maurice B. Prendergast* (exhibition catalogue)

Associated American Artists, New York, 1976, *American Master Prints IV: Bicentennial Collection, 1728–1910* (exhibition catalogue)

Associated American Artists, New York, 1977, *Milton Avery Monotypes* (exhibition catalogue by Sylvan Cole, Jr.)

Barrie, Sir James M., *My Lady Nicotine* (Boston: Joseph Knight Company, 1896)

Boston Water Color Club, Massachusetts, 1898, *11th Annual Exhibition* (exhibition catalogue)

Boston Water Color Club, Massachusetts, 1899, *12th Annual Exhibition* (exhibition catalogue)

Boston Water Color Club, Massachusetts, 1901, *14th Annual Exhibition* (exhibition catalogue)

Breuning, Margaret, *Maurice Prendergast* (New York: Whitney Museum of American Art, 1931)

Brinton, Christian, "The Field of Art: Monotypes" in *Scribner's Magazine*, vol. XLVII-53 (April 1910)

Buchanan, Donald W., *James Wilson Morrice, A Biography* (Toronto: The Ryderson Press, 1936)

Cincinnati Museum Association, Ohio, 1901–1902, *82nd Exhibition: Maurice Prendergast Watercolors and Monotypes* (exhibition catalogue) (exhibition originated at Detroit Museum of Art, Michigan, 1901)

Coe Kerr Gallery, New York, and The Boston Athenaeum, Massachusetts, 1983, *Americans in Venice 1879–1913* (exhibition catalogue)

The Corcoran Gallery of Art, Washington, D.C., 1937, *Special Exhibition of Monotypes by Maurice Brazil Prendergast* (exhibition catalogue)

Davis Galleries, New York, 1963, *Drawings by Maurice B. Prendergast* (exhibition catalogue with essay by Robert Brady)

Davis & Long Company, New York, 1975, *Charles Conder, Robert Henri, James Morrice, Maurice Prendergast: The Formative Years: Paris 1890s* (exhibition catalogue by Cecily Langdale)

Davis & Long Company, New York, 1979, *The Monotypes of Maurice Prendergast* (exhibition catalogue by Cecily Langdale)

Earle, Joe, *An Introduction to Japanese Prints* (Warminster and London: The Compton Press, Ltd., and Pitman House, Ltd., 1980)

Esther Williams Papers, Archives of American Art, Smithsonian Institution

Field, Richard S., "The Monotype: A Majority Opinion?" in *The Print Collector's Newsletter*, vol. IX, no. 5 (November–December 1978)

Fogg Art Museum, Harvard University, Cambridge, Massachusetts, 1968, *Degas Monotypes* (exhibition catalogue by Eugenia Parry Janis)

Joyaux, Alain G., *The Elisabeth Ball Collection of Paintings, Drawings, and Watercolors: The George and Frances Ball Foundation* (Muncie: Ball State University Art Gallery, 1984)

C.W. Kraushaar Art Galleries, New York, 1936, *Monotypes in Color by Maurice Prendergast* (exhibition catalogue)

Kraushaar Galleries, New York, 1950, *Maurice Prendergast: Retrospective Exhibition of Paintings, Water Colors, and Monotypes* (exhibition catalogue)

Kraushaar Galleries, New York, 1956, *Prendergast Monotypes* (exhibition catalogue)

Macbeth Papers, Archives of American Art, Smithsonian Institution

Marilyn Pearl Gallery, New York, 1979, *American Monotypes: 100 Years* (exhibition catalogue by Robert Flynn Johnson)

The Metropolitan Museum of Art, New York, 1974, *The Great Wave: The Influence of Japanese Woodcuts on French Prints* (exhibition catalogue by Colta Feller Ives)

The Metropolitan Museum of Art, New York, and Museum of Fine Arts, Boston, Massachusetts, 1980–1981, *The Painterly Print: Monotypes from the Seventeenth to the Twentieth Century* (exhibition catalogue by Sue Welsh Reed, Eugenia Parry Janis, Barbara Stern Shapiro, David W. Kiehl, Colta Ives, and Michael Mazur)

Museum of Fine Arts, Boston, Massachusetts, and Harvard University Press, Cambridge, Massachusetts (1960), *Maurice Prendergast Water-Color Sketchbook 1899* (with "Critical Note" by Peter A. Wick)

Museum of Fine Arts, Boston, Massachusetts, Wadsworth Atheneum, Hartford, Connecticut, Whitney Museum of American Art, New York, California Palace of the Legion of Honor, San Francisco, and The Cleveland Museum of Art, Ohio, 1960–1961, *Maurice Prendergast 1859–1924* (exhibition catalogue by Hedley Howell Rhys and Peter A. Wick)

Museum of Fine Arts, Boston, Massachusetts, 1973, *Camille Pissarro: The Impressionist Printmaker* (exhibition catalogue by Barbara S. Shapiro)

The Museum of Modern Art, New York, and The Cleveland Museum of Art, Ohio, 1948, *Pierre Bonnard* (exhibition catalogue by John Rewald)

The Museum of Modern Art, New York, Los Angeles County Museum of Art, California, and The Art Institute of Chicago, Illinois, 1964, *Bonnard and His Environment* (exhibition catalogue by James Thrall Soby, James Elliott, and Monroe Wheeler)

Neuberger Museum, College at Purchase, State University of New York, 1977, *American Drawings and Watercolors* (exhibition catalogue)

Oklahoma Museum of Art, Oklahoma City, 1981, *Prendergast: The Large Boston Public Garden Sketchbook* (exhibition catalogue by Dr George Szabo)

Ormond, Richard, *Sargent* (London: Phaidon Press, Ltd., 1970)

Philadelphia Museum of Art, Pennsylvania, 1973, *Paul Gauguin: Monotypes* (exhibition catalogue by Richard S. Field)

Prints, vol. 7 (June 1937)

Robison, Andrew, "An Aesthetic History of Paper in Prints" in *World Print Council* (1979)

Smithsonian Institution Traveling Exhibition Service, 1972, *The Monotype: An Edition of One* (exhibition catalogue by Matt Phillips)

Smithsonian Institution Traveling Exhibition Service, 1976, *American Art in the Making: Preparatory Studies for Masterpieces of American Painting 1800–1900* (exhibition catalogue by David Sellin)

Sterling and Francine Clark Institute, Williamstown, Massachusetts, 1978, *Watercolors by Maurice Prendergast from New England Collections* (exhibition catalogue by Gwendolyn Owens)

Thomson, George, "The Sketchbook in the Street" in *The Studio* (1893)

University of Maryland Art Gallery, College Park, University Art Museum, University of Texas, Austin, Des Moines Art Center, Iowa, Columbus Gallery of Fine Arts, Ohio, Herbert F. Johnson Museum of Art, Cornell

University, Ithaca, New York, and Davis & Long Company, New York, 1976–1977, *Maurice Prendergast: Art of Impulse and Color* (exhibition catalogue by Eleanor Green, Ellen Glavin, S.N.D., and Jeffrey R. Hayes)

Utah Museum of Fine Arts, University of Utah, Salt Lake City, 1976, *Graphic Styles of the American Eight* (exhibition catalogue by Sheldon Reich)

Wattenmaker, Richard J., "Maurice Prendergast" in *Allen Memorial Art Gallery Bulletin*, vol. XL, no. 1 (1982–1983)

Wildenstein, New York, and Philadelphia Museum of Art, Pennsylvania, 1971, *From Realism to Symbolism: Whistler and His World* (exhibition catalogue by Allen Staley and Theodore Reff)

William Cooper Procter Art Center, Bard College, Annandale-on-Hudson, New York, 1967, *Maurice Prendergast: The Monotypes* (exhibition catalogue by Matthew Phillips)

Young, Andrew McLaren, Margaret MacDonald, Robin Spencer, and Hamish Myles, *The Paintings of James McNeill Whistler* (New Haven and London: Yale University Press, 1980)

Printed by Colorcraft Lithographers, Inc., N.Y.
Color separations by Spectra II Separations, Inc., N.Y.
Typography by Compo-Set, Inc., N.Y.
Bound by Sendor Bindery, Inc., N.Y.